W9-CSG-294

THE
STYLISH
LIFE

TENNIS

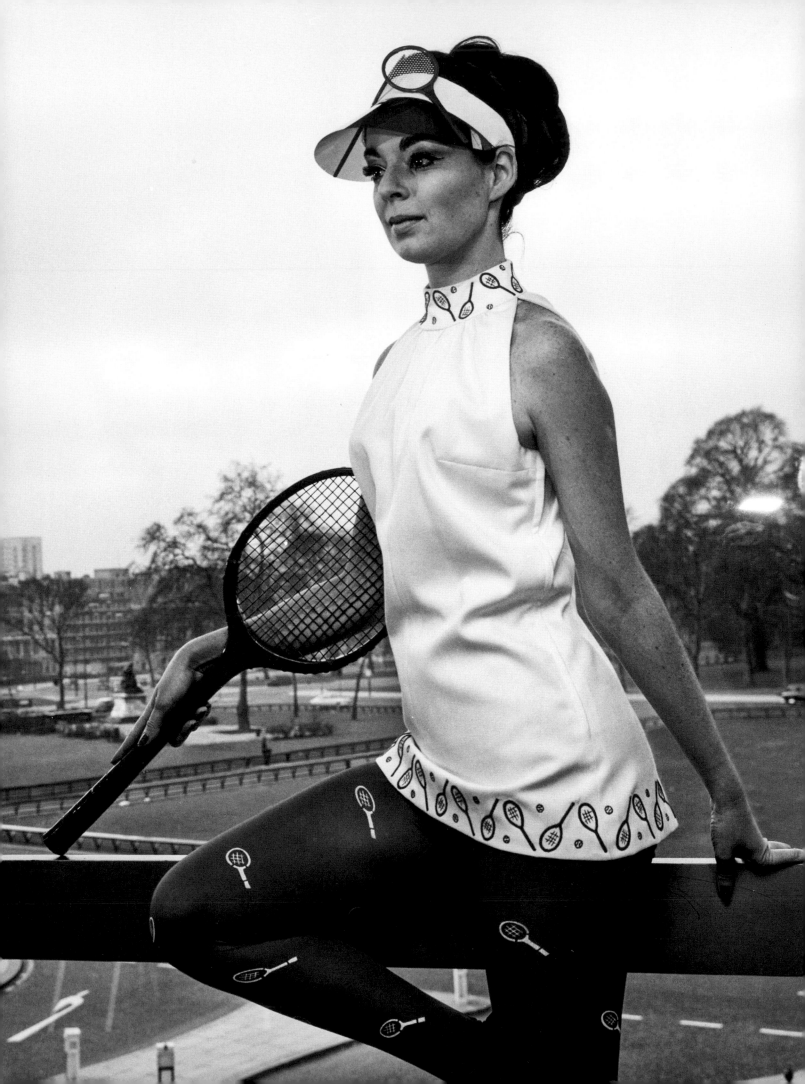

THE STYLISH LIFE

TENNIS

Texts by Ben Rothenberg

teNeues

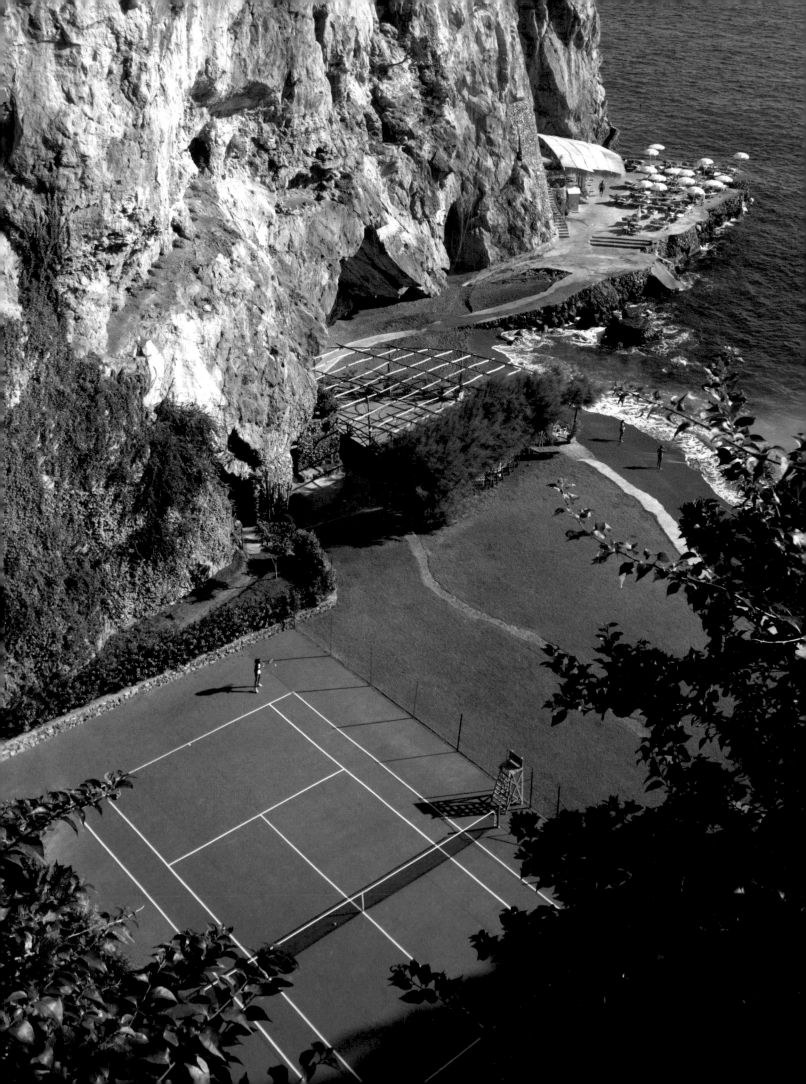

CONTENTS

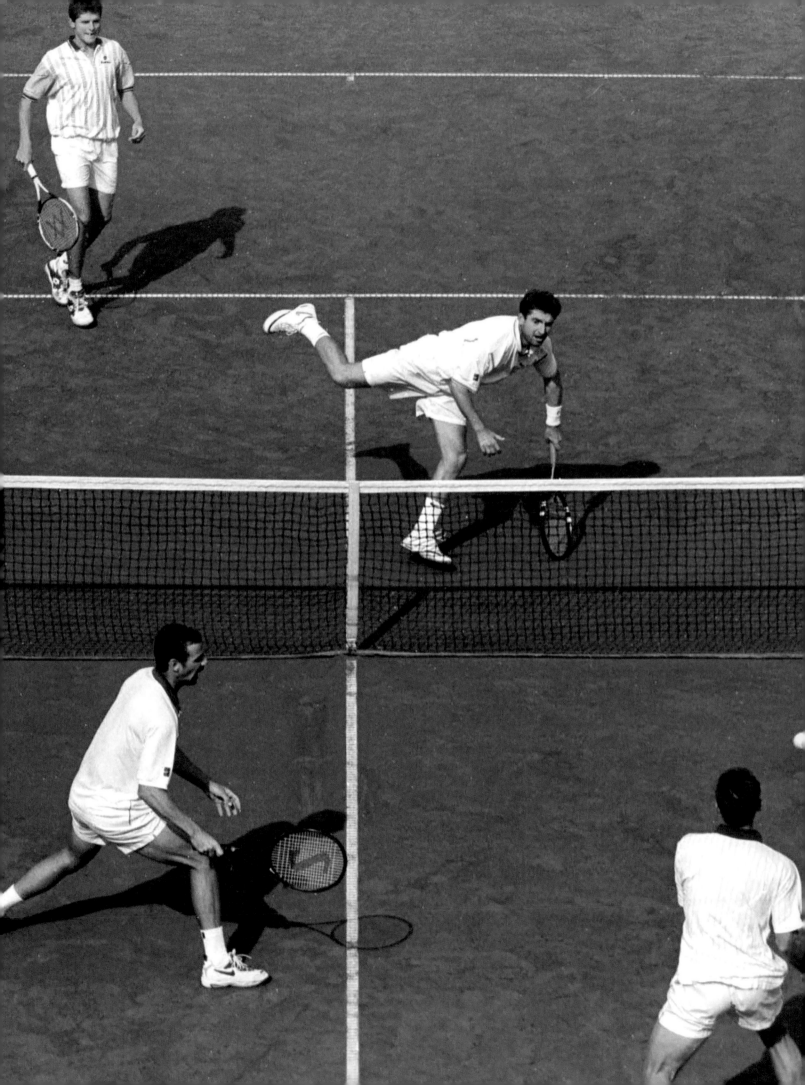

INTRODUCTION

BEN ROTHENBERG

Few accessories evoke a life of leisure and luxury as quickly as a tennis racquet. Ever since the sport rose to popularity in Victorian England, tennis and sophistication have been inexorably linked. Though it can be intensely competitive in certain settings, tennis is also one of the most social recreational activities. Be they young or old, amateur or veteran, tennis can be enjoyed by just about anyone—and it even allows for men and women to compete side-by-side.

From its modern origins as a sport for English elites, tennis has spread around the globe, and now all six inhabited continents on the planet have produced at least one Grand Slam champion. Tennis transcends boundaries and language: For example, around the world the court is always the same size and the ball can only bounce once.

Tennis balances the powerful and the delicate in a way few other endeavors do; it can be just as satisfying to win a point with the cathartic feeling of bludgeoning the ball across the net as it is to use a clever dropshot or slice. The idea of hitting a ball

Page 2: *Giovanna Caruso models a dress by the English fashion designer Ted Tinling in London, 1967.* Page 4: *Tennis courts at Italy's Il San Pietro di Positano resort are located next to pristine blue water.* Opposite: *Players trade volleys during a heated doubles match between the Czech Republic and South Africa at the Davis Cup qualifying match in Prague, 1998.*

back-and-forth over a net is simple, but the subtle complexities of the game allow for a lifetime of playing and learning.

Just as there is variety in tactics, tennis also offers many other choices for self-expression, notably through fashion. Throughout its history, tennis has influenced sportswear and general fashion perhaps more than any other sport. Many of the most ubiquitous staples of modern sportswear were born out of tennis necessity, even creating innovations as basic as the short-sleeved shirt. With many designers and labels still catering to a tennis-playing clientele, dressing for the sport continues to be an opportunity for remarkably timeless style, grace, and elegance. The only rule at select stricter settings is the simple request for classic all-white.

While staying true to its rich heritage, tennis continues to evolve and grow, shaped by pioneers and icons from around the world. No two tennis players are the same. But the rich beauty of the game—wherever it is played—is universal.

Opposite: *A woman sporting a tennis dress chooses between rackets, 1964.*

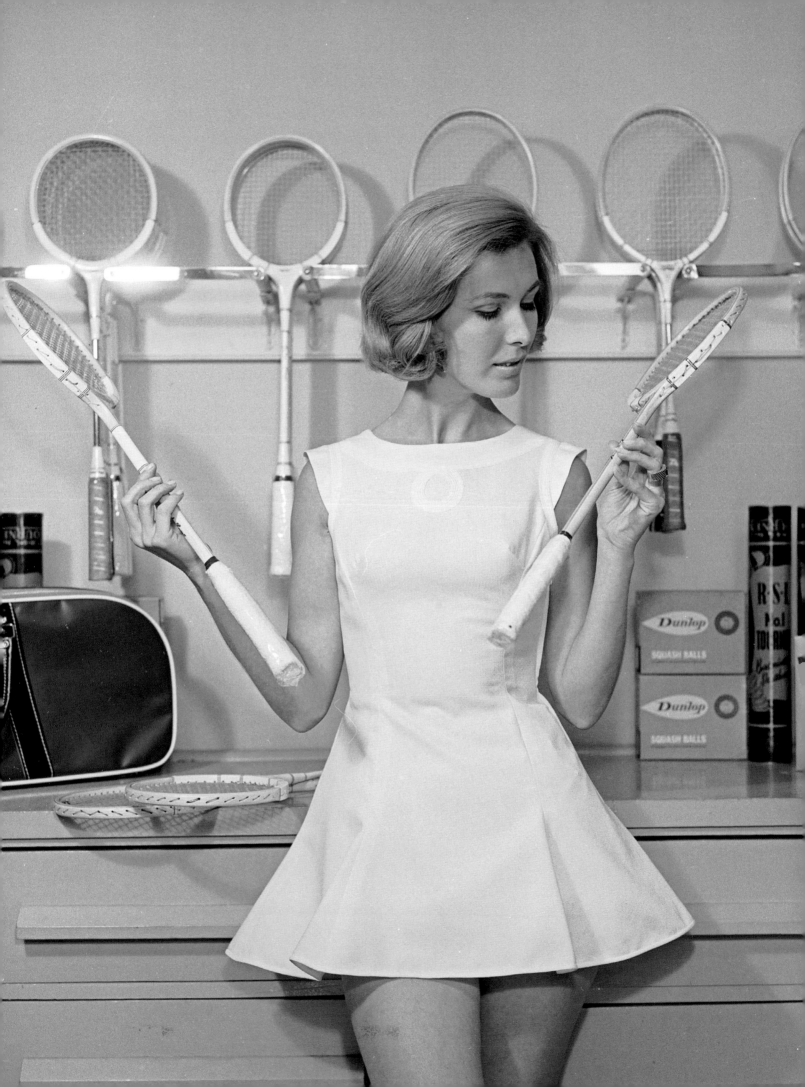

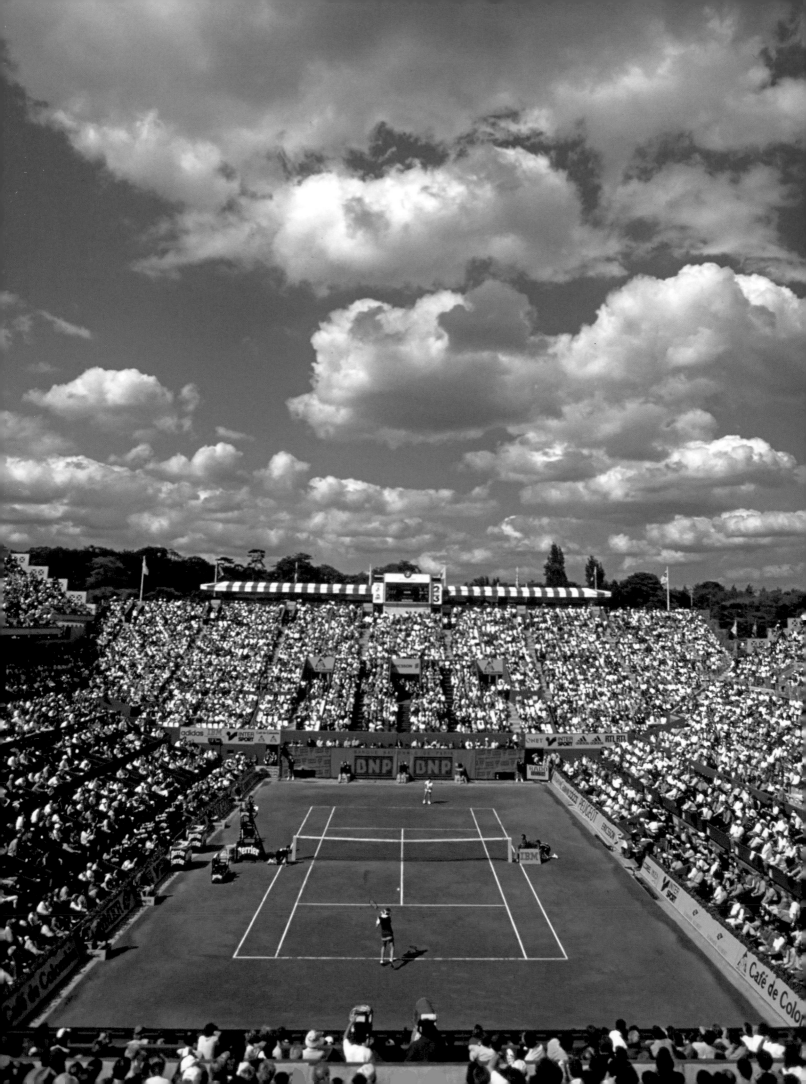

DESTINATIONS & EVENTS

WHERE TO BE AND BE SEEN

Grand Slams

Though its branches have spread widely around the world, there is no doubt that the roots of tennis remain anchored to the soft lawns of Wimbledon. Easily the oldest tournament in the world—with its start in 1877—Wimbledon remains intertwined with its traditions and history like nowhere else. With its meticulously manicured but living and tricky lawns, it is the only major tournament still played on traditional grass courts. The most famous patch of verdant green at Wimbledon is at Centre Court, the intimate stadium that serves as a cathedral to the sport. With players still required to dress in all-white and spectators maintaining reverent hushed silence throughout, tennis at Wimbledon still looks and sounds like it did a century ago.

History also echoes in the softened footsteps on the reddish-orange clay of Roland Garros, home to the French Open. Unlike the slick, low-bouncing lawns, the ball sits up after hitting the *terre battue* (beaten earth) in Paris, prolonging rallies and turning many points into protracted, physically punishing rallies, with players sliding from corner to corner for hours on end. Passionate about their tennis, crowds in Paris are spirited but fickle—quick to cheer and quick to jeer. Most of all they appreciate the show, which Roland Garros never fails to deliver.

Opposite: *The scenic main court at the 1998 French Open at Roland Garros.*

While Wimbledon and Roland Garros feel organic, the U.S. Open feels electric. Big, brash, and loud, the tournament soaks up the energy of New York and forces players to keep up with its intensity and insomnia, with matches often stretching well past midnight. The main Arthur Ashe Stadium is a colossal cavern, with seats at the top row feeling as close to the clouds as the court, offering as good a view of the tennis as they do of the sun setting over the Manhattan skyline miles to the west.

Dubbed the "Happy Slam," the Australian Open is a tournament rich in history but lacking pretense, with supportive and jovial crowds appreciative of good tennis and good sportsmanship. Though once only frequented by natives like the Australian champions Rod Laver and Margaret Court because of Melbourne's isolation from most of the world, the tournament is now one of the most popular destinations for escaping the worries of winter.

Indian Wells

Hidden in the desert of California's Coachella Valley, Indian Wells has quickly established itself as an alluring oasis for tennis. With warm, dry weather and sapphire skies prodded by snow-capped mountains enclosing the valley, Indian Wells provides an idyllic backdrop for tennis. Not only is it host to the annual BNP Paribas Open, one of the biggest tournaments outside of the Grand Slams, Indian Wells is also host to the elite La Quinta Resort & Club, which offers courts circled by towering palm trees through which the mountains and sky glimmer through.

Monte Carlo

Some of the most valuable real estate in tennis is found just outside of Monaco in the French commune of Roquebrune-Cap-Martin, home of the Monte Carlo Country Club. Nestled on a sliver of land just between the French Alps and Mediterranean Sea, the Club has hosted elite tennis for over a century, offering a staircase of courts between the rocky cliffs above and the cerulean water below. Nowhere else does tennis feel quite as delicately balanced between earth and sea, nor as cherished as part of the earth's landscape.

Rome

Though tennis courts are often sanctuaries of seclusion and separation from the outside world, a place in Rome combines the sport with a difficult period in Italian history, resulting in a remarkably beautiful outcome. Now named the Stadio Pietrangeli, the iconic tennis court at the Foro Italico was commissioned by the Fascist dictator Benito Mussolini, himself a dedicated player. Sunken into the earth with steep steps of white marble for spectators, the court was meant to imitate venues of ancient Rome. The court is lined with monolithic and muscly neo-Roman statues representing more modern pursuits than their ancient inspirations, including, yes, a tennis player.

Florida

If talent in tennis were a crop, the most fertile soil for it would be found on the Florida peninsula. With its warm weather year-round, the Sunshine State has become an outpost of choice for tennis players of all levels. Tennis resorts stretch from Amelia Island and Boca Raton on the Atlantic Coast, Saddlebrook on the Gulf Coast, to Key Biscayne near Miami. For travelers who take their tennis seriously, the IMG Academy Bollettieri Tennis Program in Bradenton is unparalleled, and offers a chance to train with the coaches who coached many of the modern era's best to the top.

Following pages: *A striking overhead view of the All England Lawn Tennis and Croquet Club during the Wimbledon Championships, 2006.*

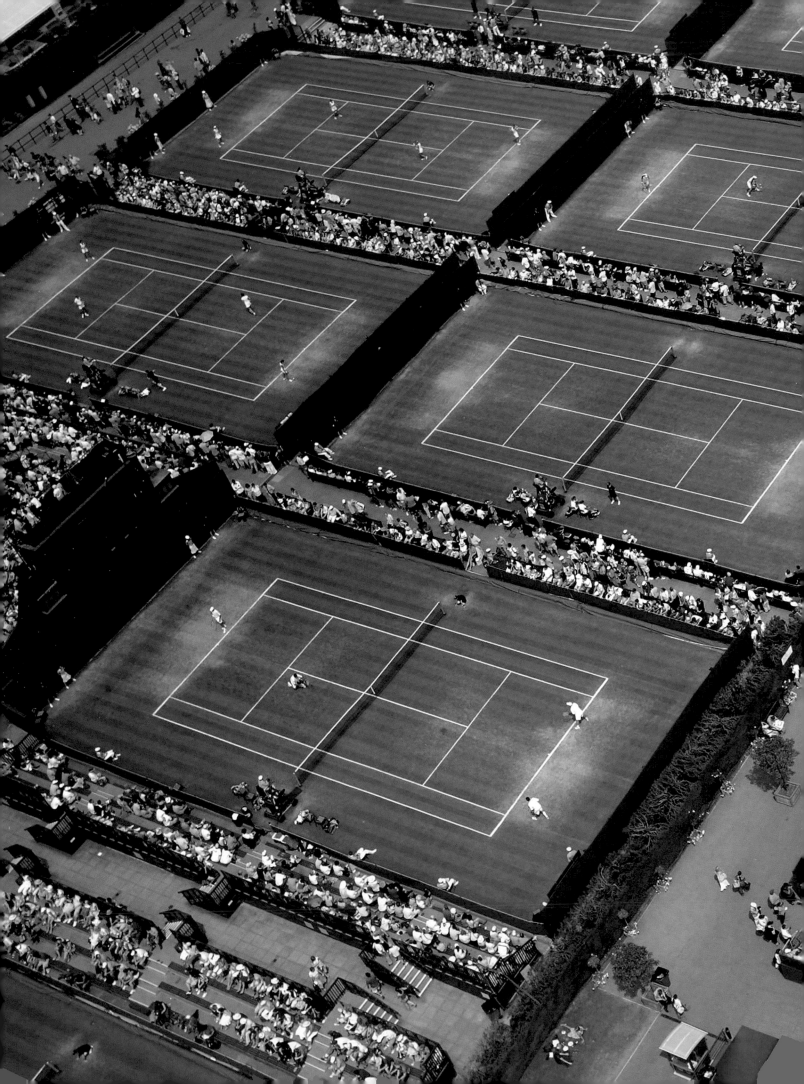

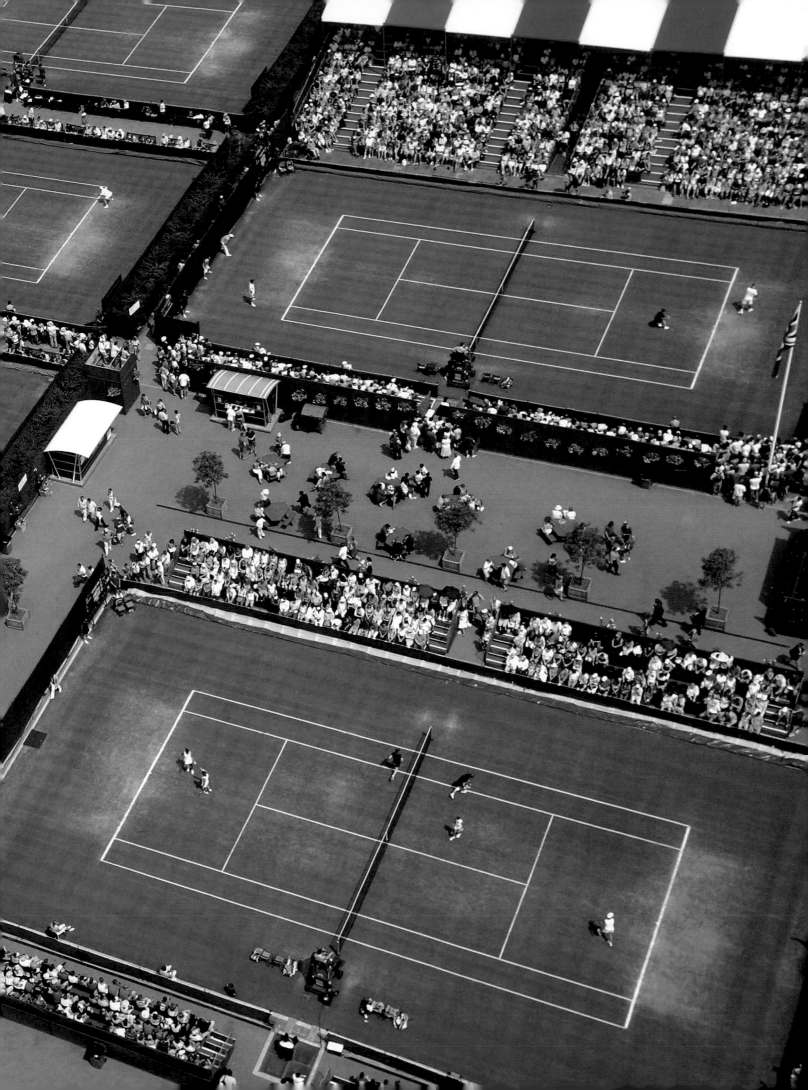

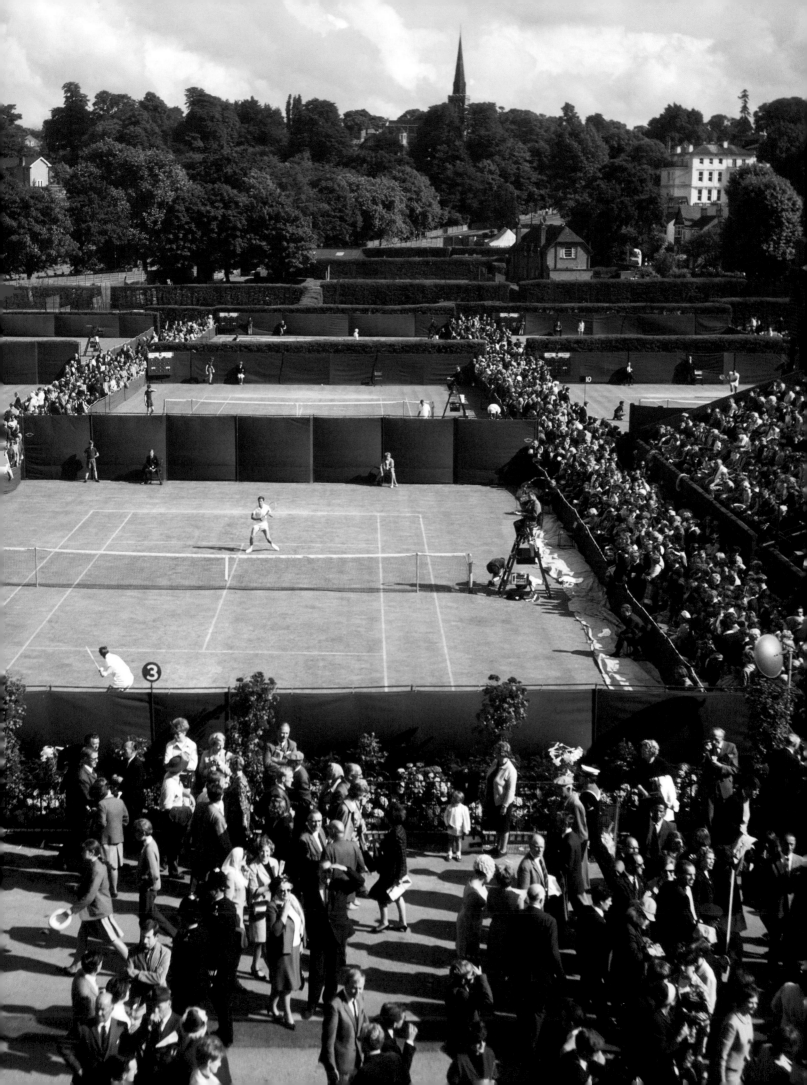

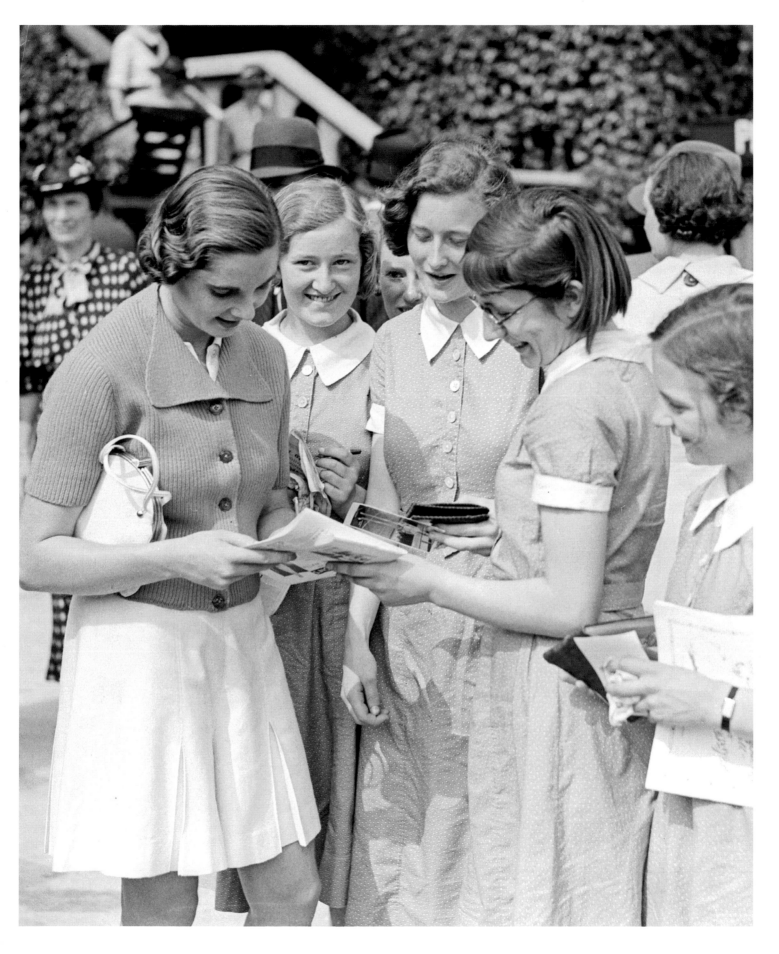

This page: *British tennis player Kay Stammers signs autographs for fans at Wimbledon, 1936.* Opposite: *Wimbledon spectators watch a match at the All England Lawn Tennis and Croquet Club, 1966.*

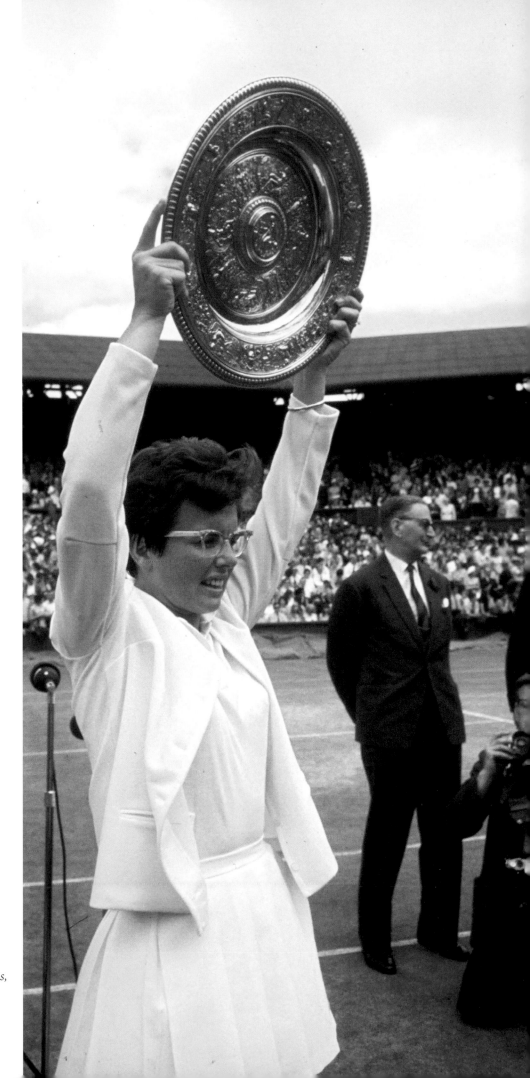

Opposite, clockwise from left: *Billie Jean King shows off her trophy at the 1966 Wimbledon Championships; a traditional Wimbledon sign hangs on an ivy-covered wall; British tennis star Fred Perry reaches to return a shot during a Wimbledon semi-finals match.* Following pages, from left: *Members of the Palm Springs Tennis Club relax around the pool, circa 1970; fashionable players socialize in the Bahamas, circa 1957.*

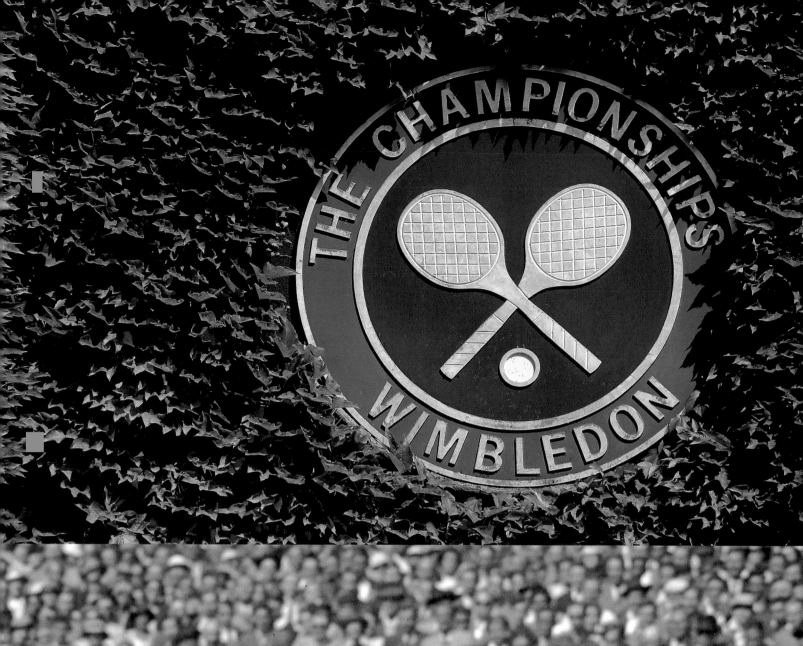

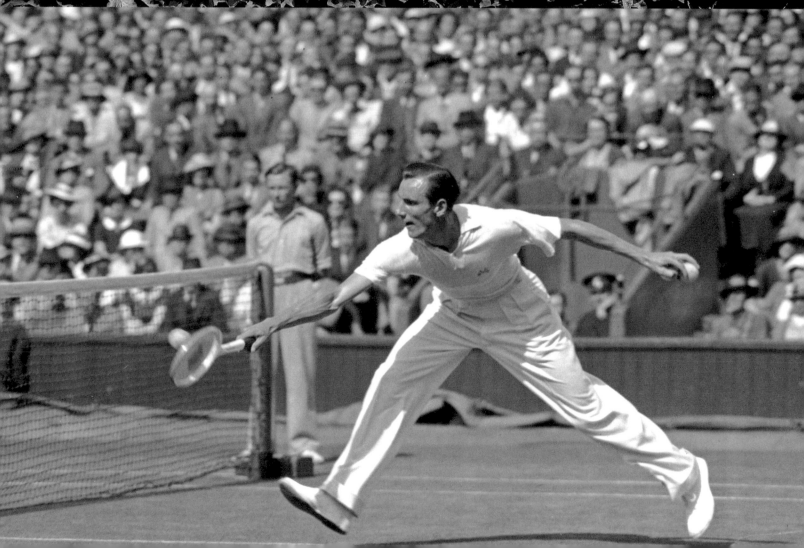

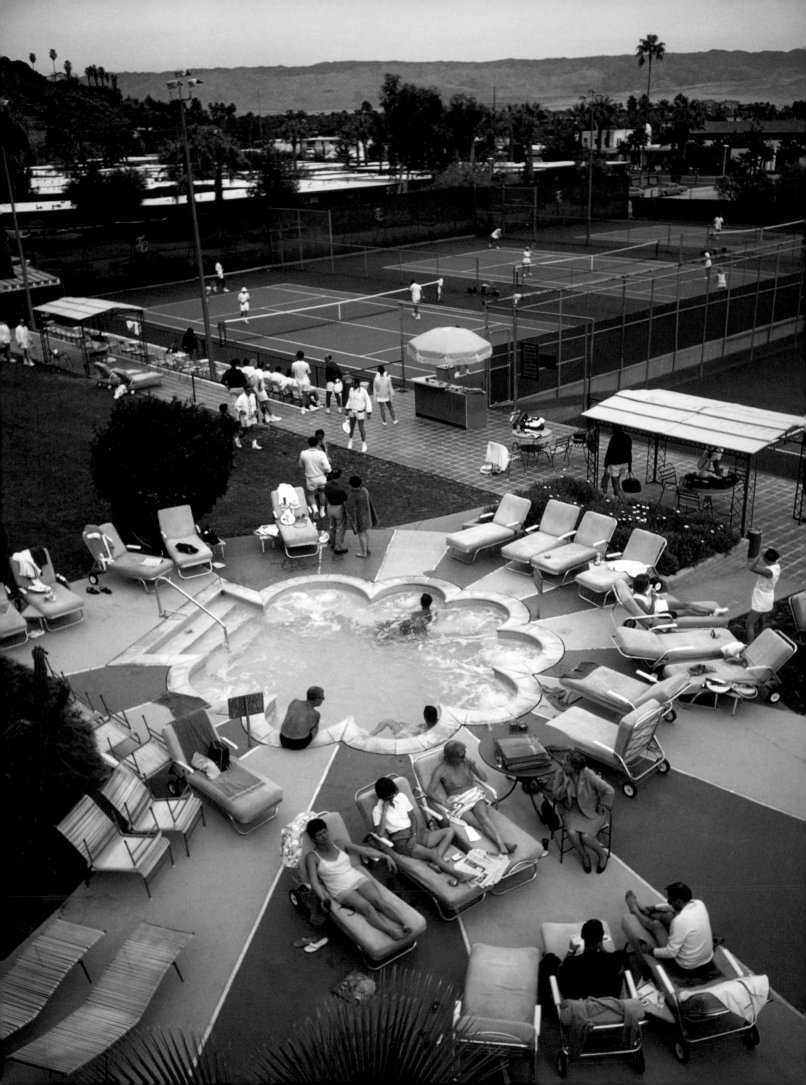

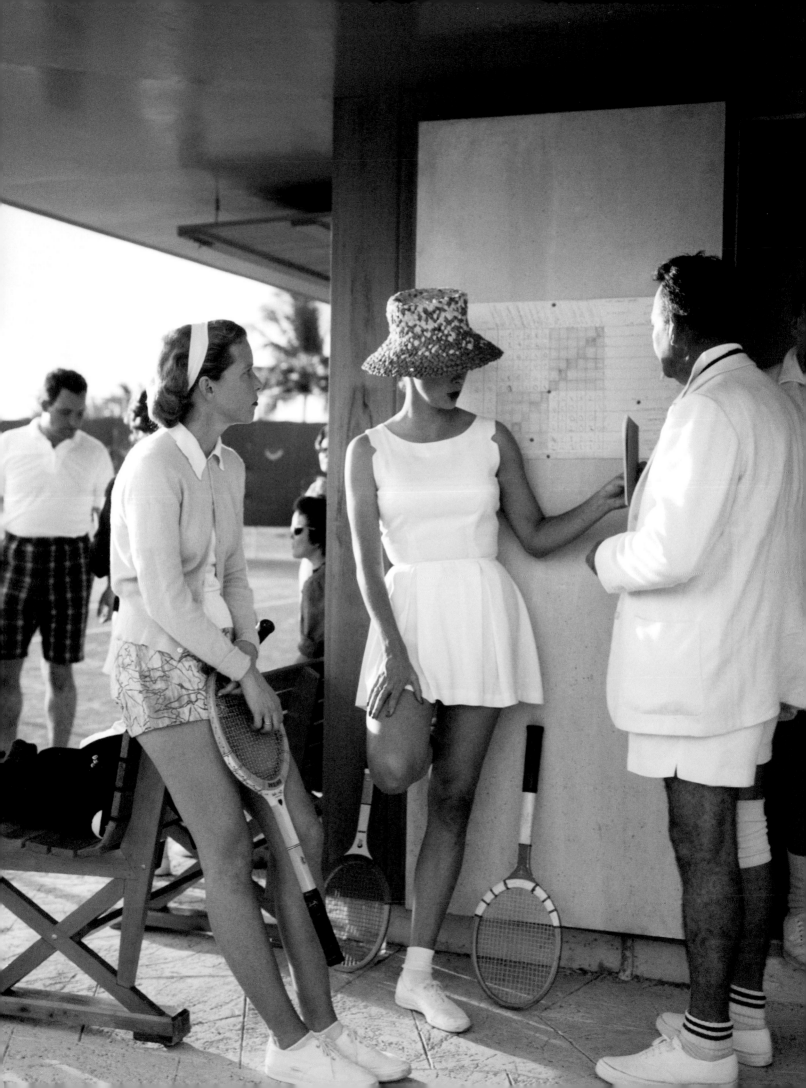

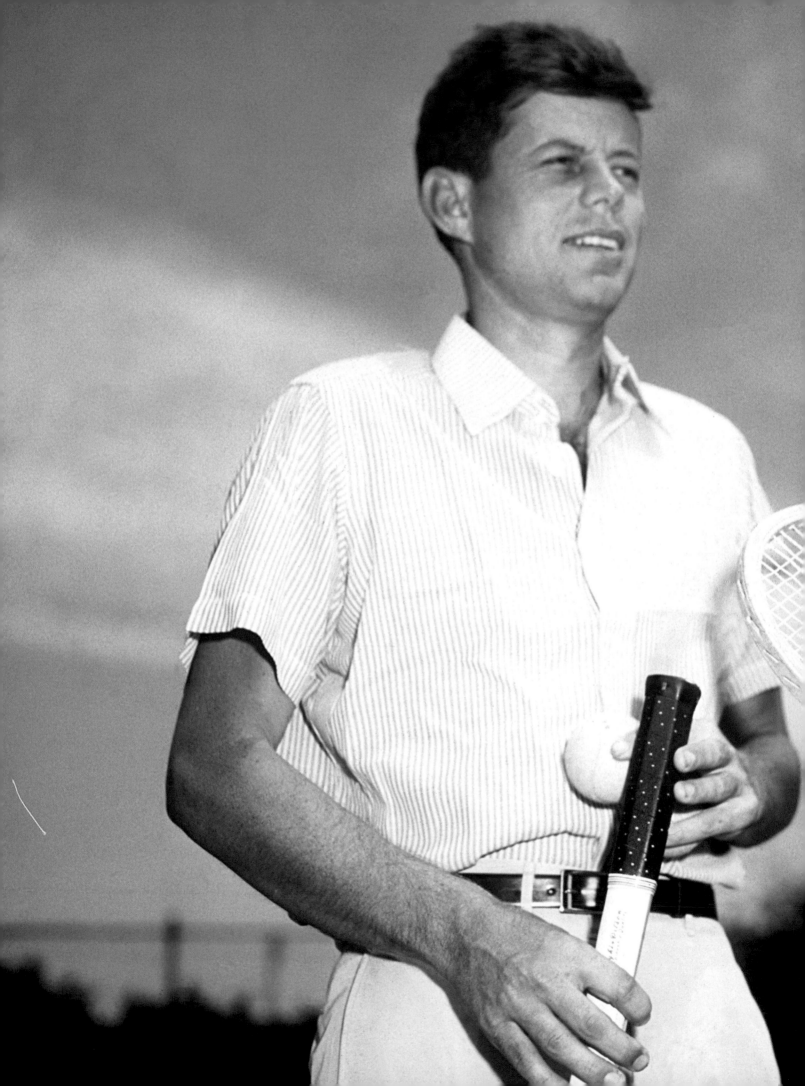

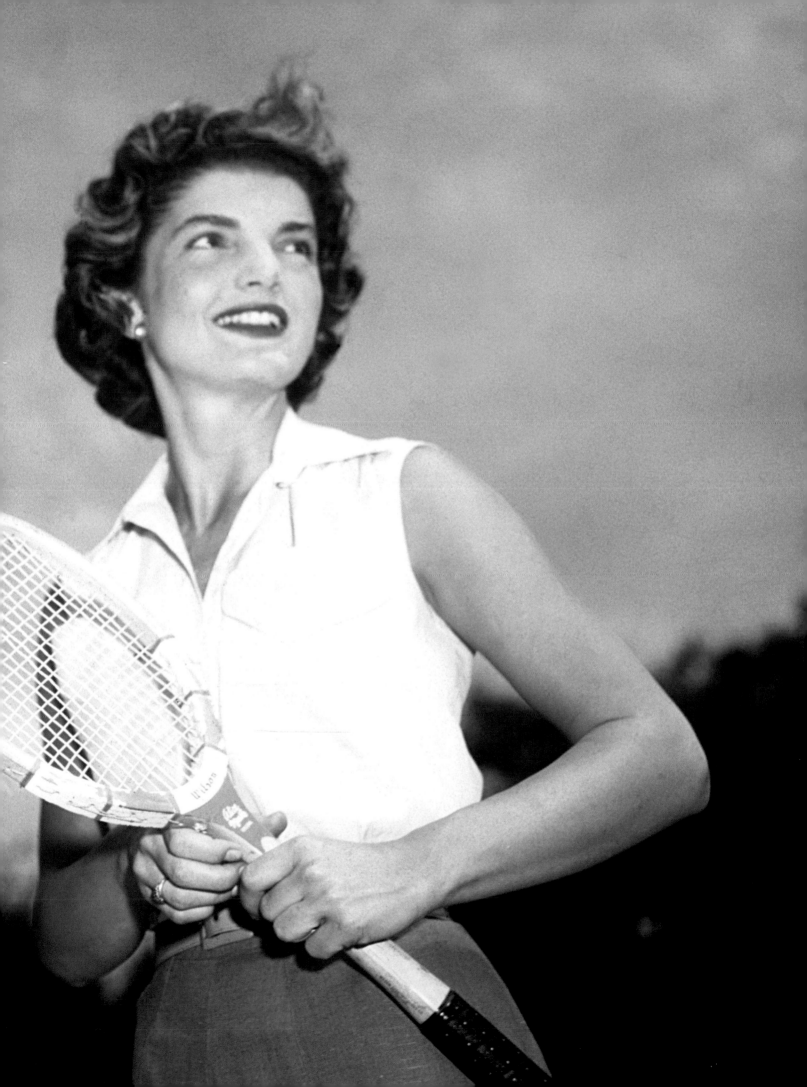

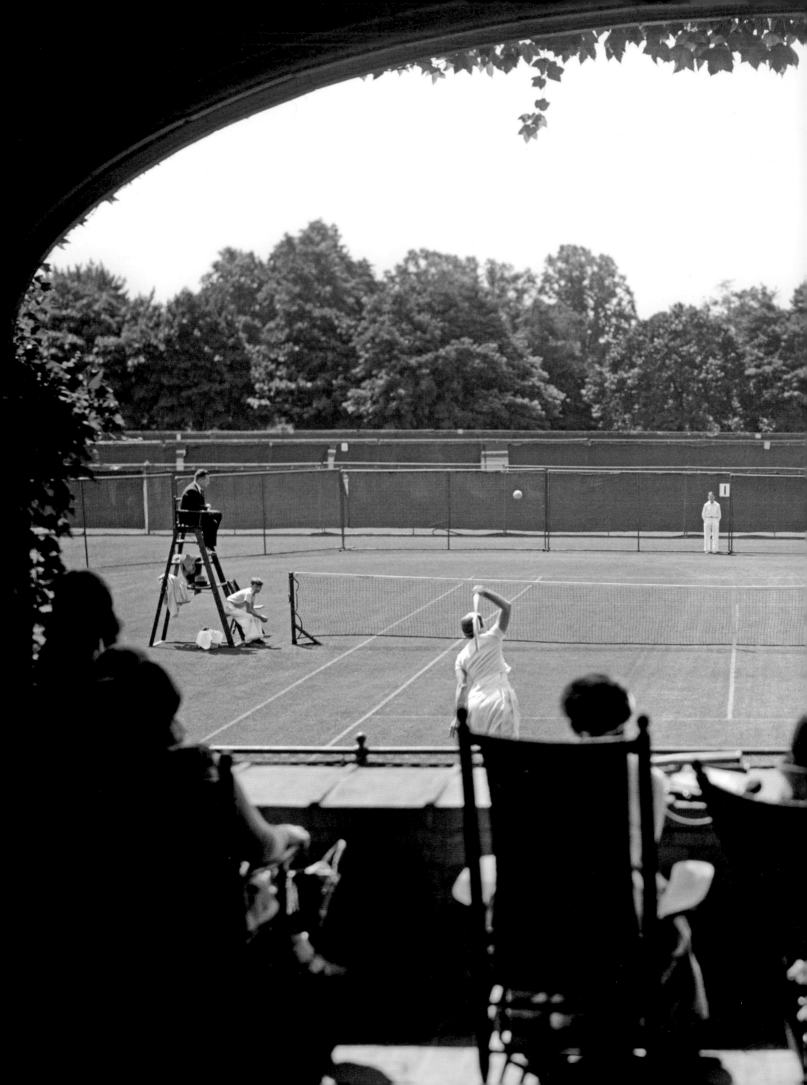

Previous pages: *John F. Kennedy and his fiancée, Jacqueline Bouvier, play tennis, 1953.* Opposite: *Onlookers watch a tennis match at a posh 1930s-era country club.*

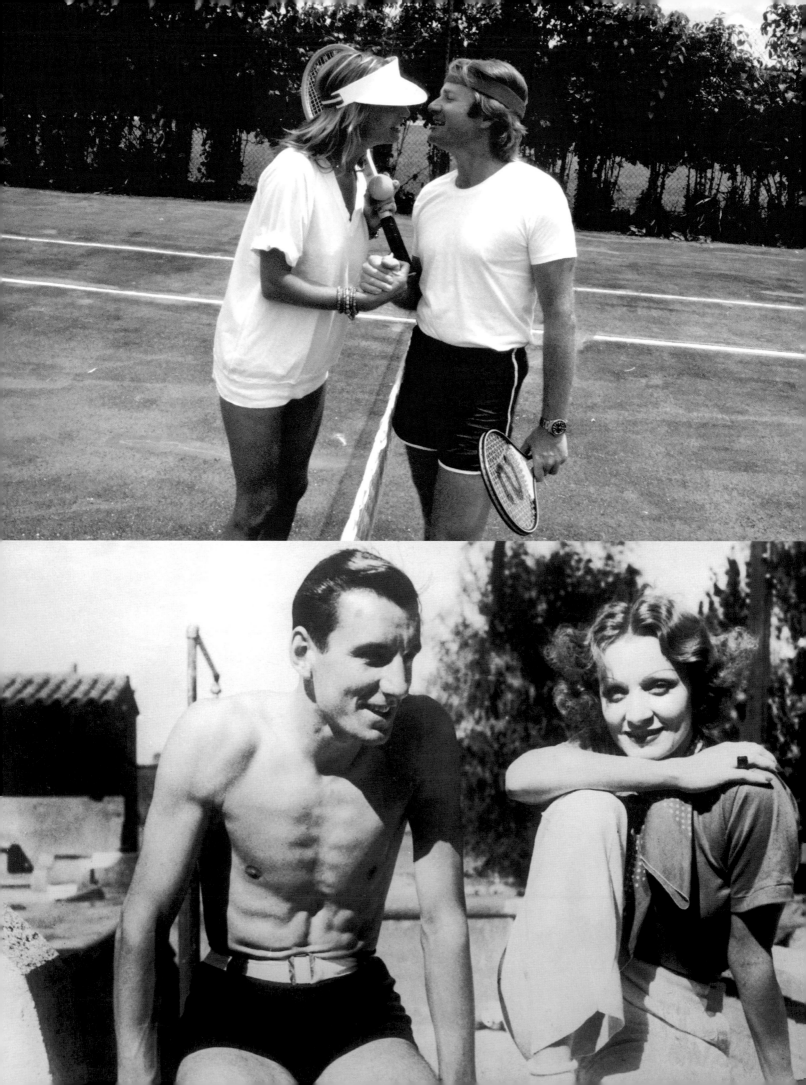

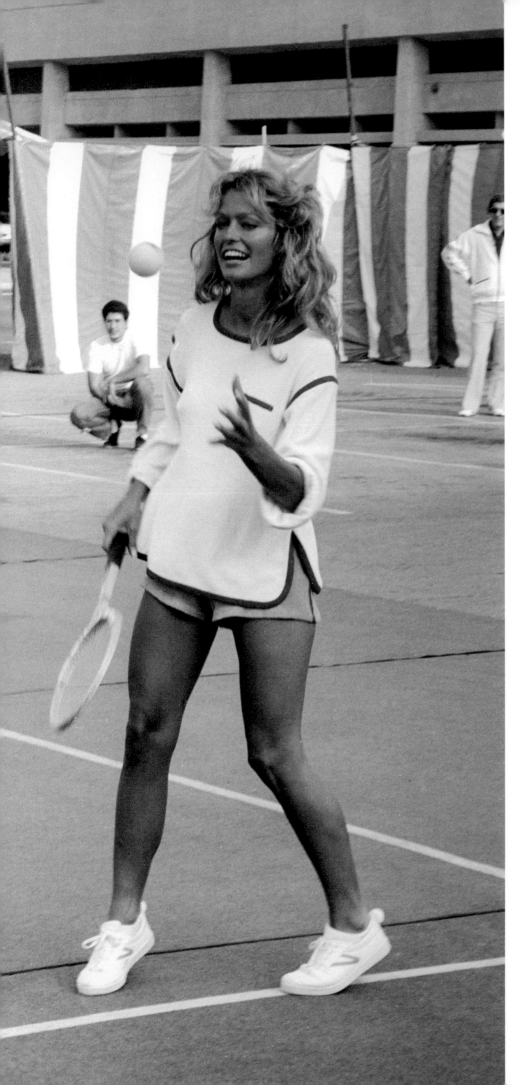

Opposite, clockwise from top left: *German actor Fritz Wepper and Angela, Princess of Hohenzollern, enjoy a game of tennis while on vacation in Barbados, 1978; Farrah Fawcett on the court at a 1976 charity tournament in Hollywood; Marlene Dietrich and Fred Perry in Palm Springs, 1934.* Following pages: *Groomed courts at the Saddlebrook Resort in Tampa, Florida.*

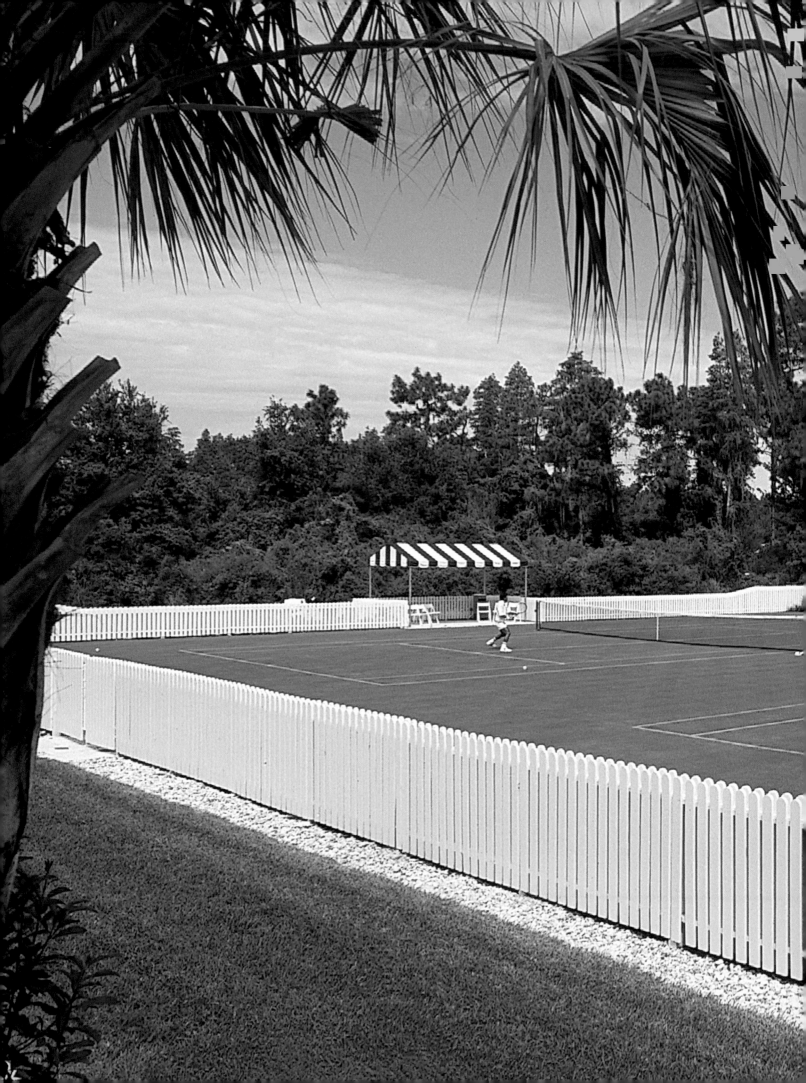

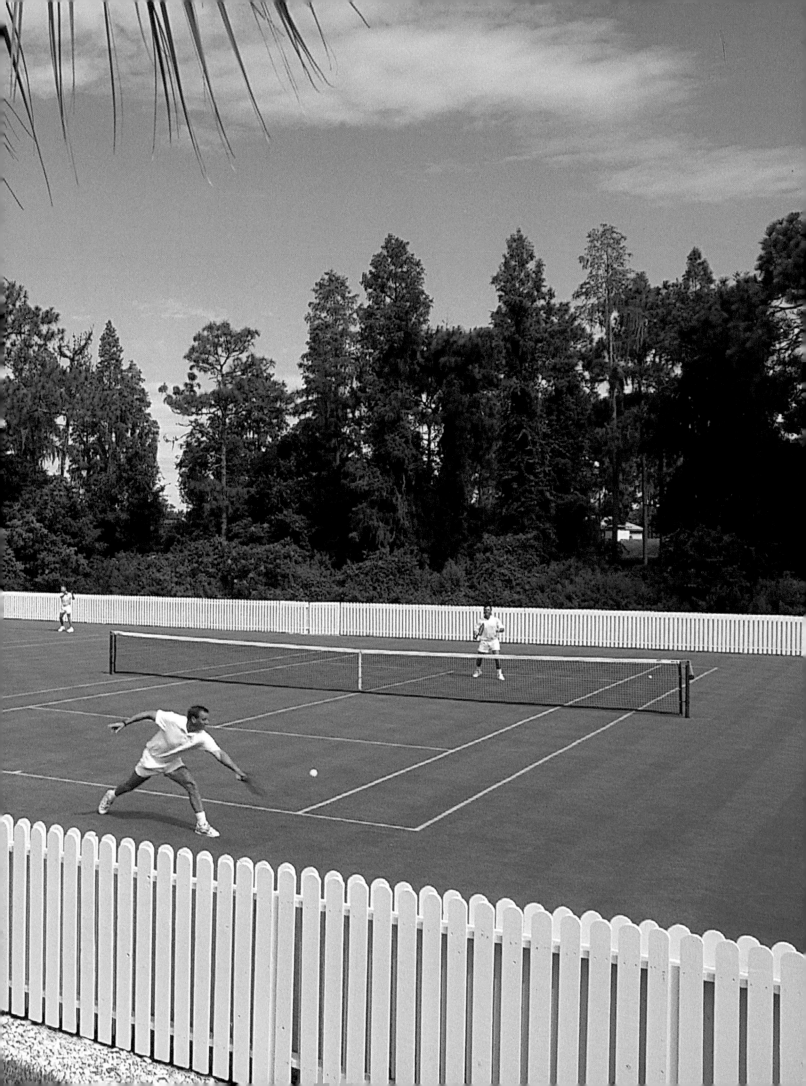

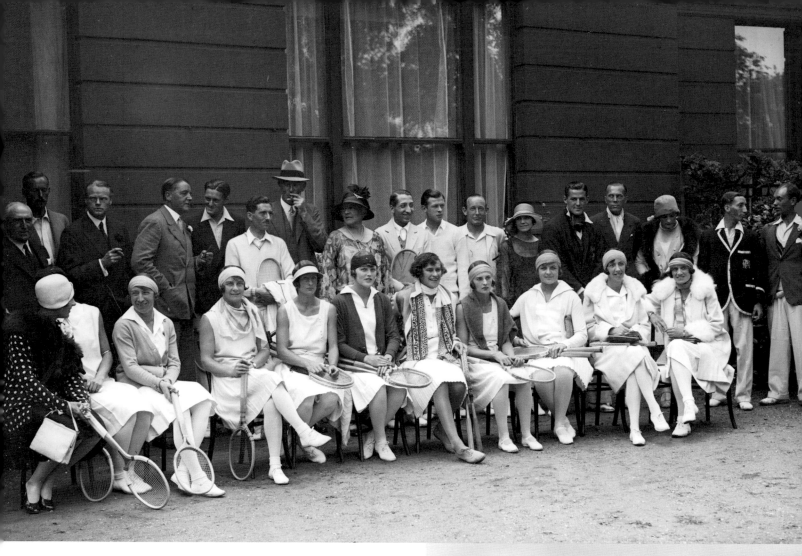

Clockwise from top left: *Wimbledon tennis stars at a garden party, 1928; English tennis players Virginia Wade and Lorna Greville-Collins with France's Marlys Burel wear sleeveless dresses, 1967; a stylish teenager takes in the Wimbledon tennis scene, 1960.*

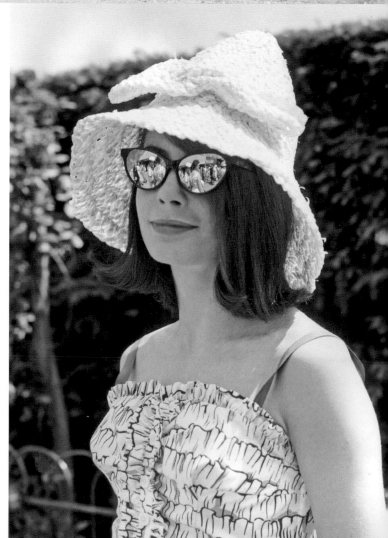

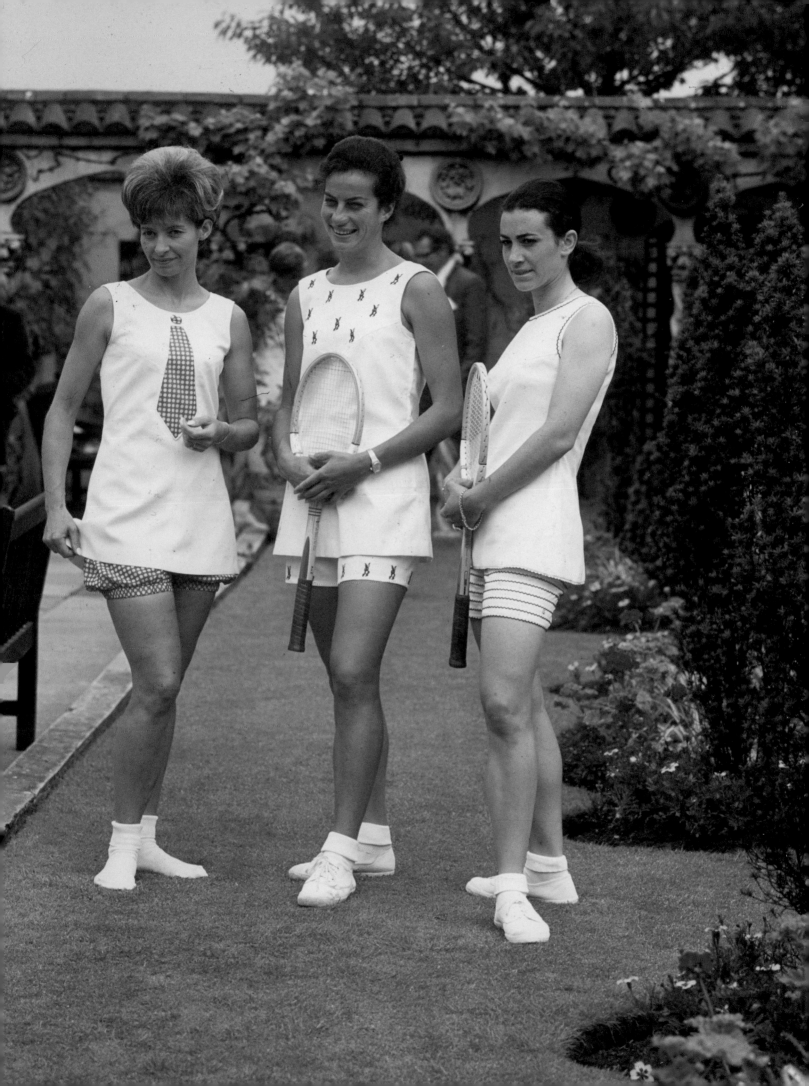

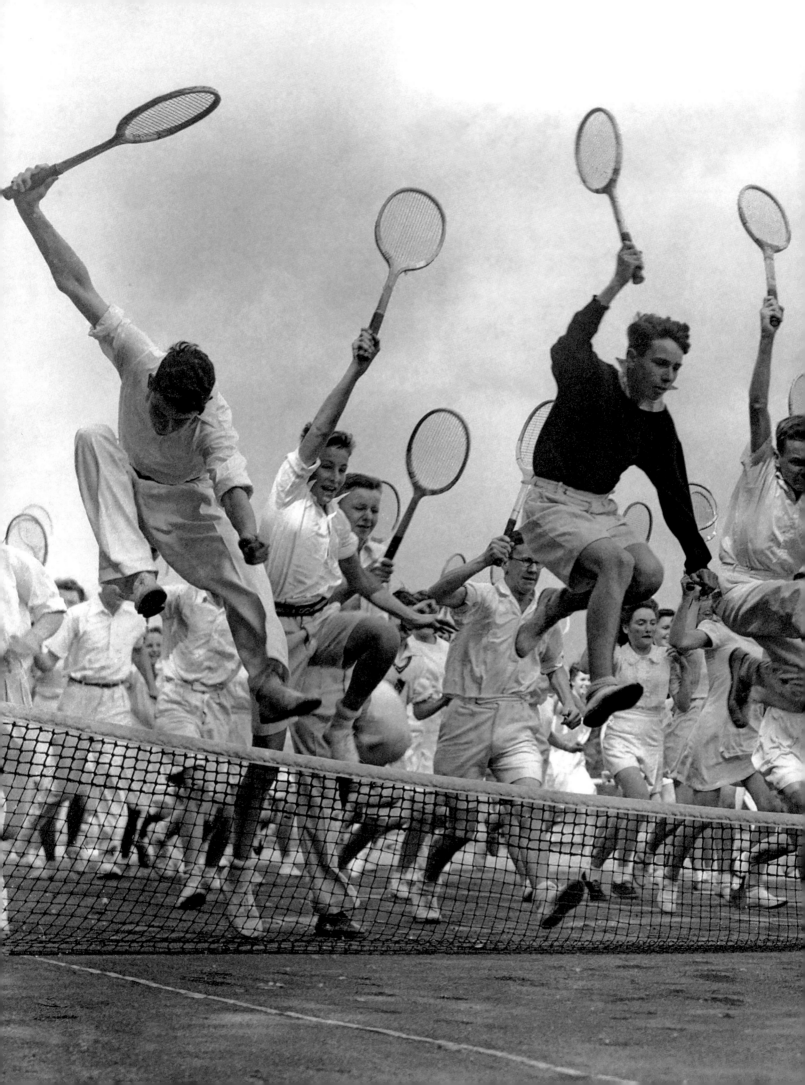

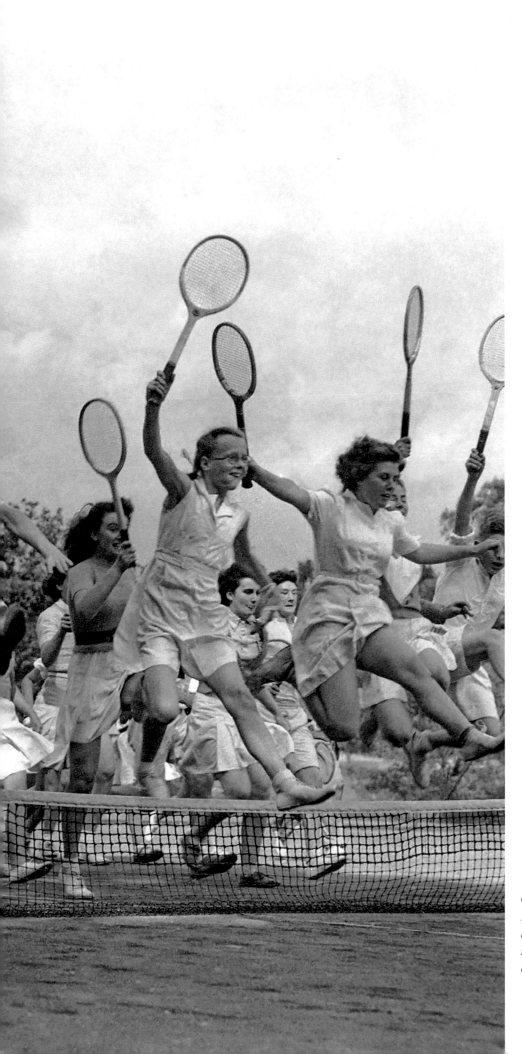

Opposite: *Young competitors at the 1945 Essex Junior Tennis Championship leap over a net.* Following pages: *The breathtaking setting at the ATP Monte Carlo Masters, held at the Monte Carlo Country Club, 2014.*

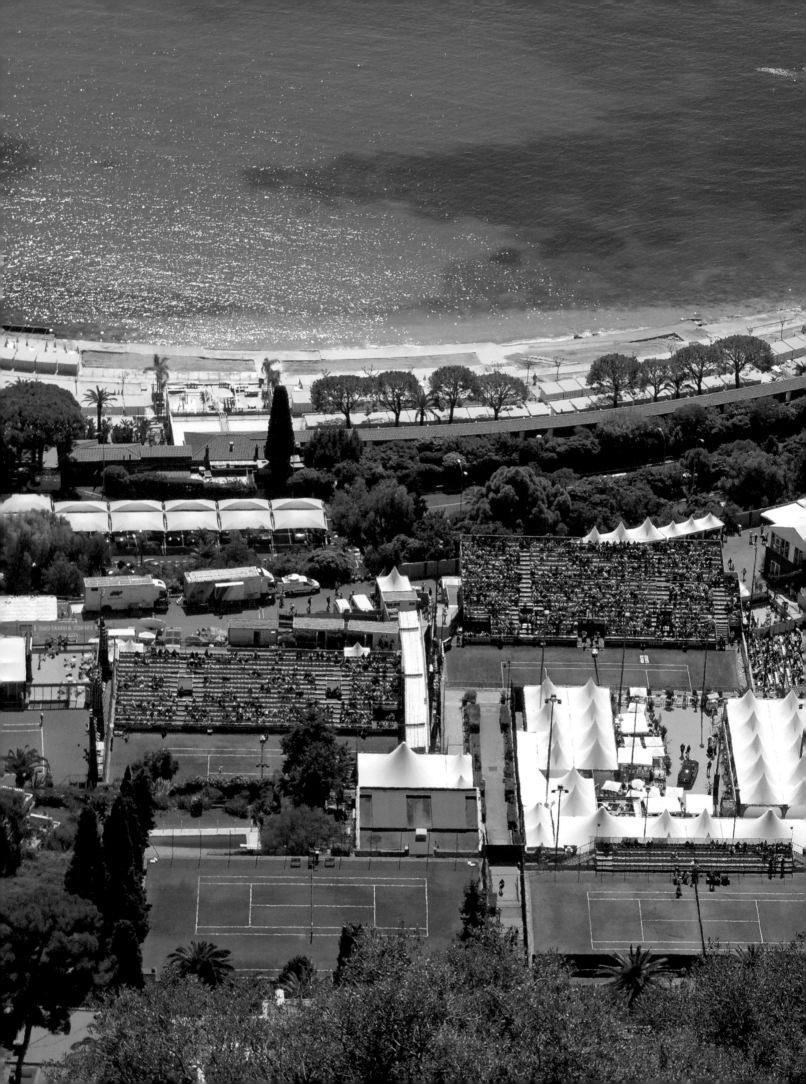

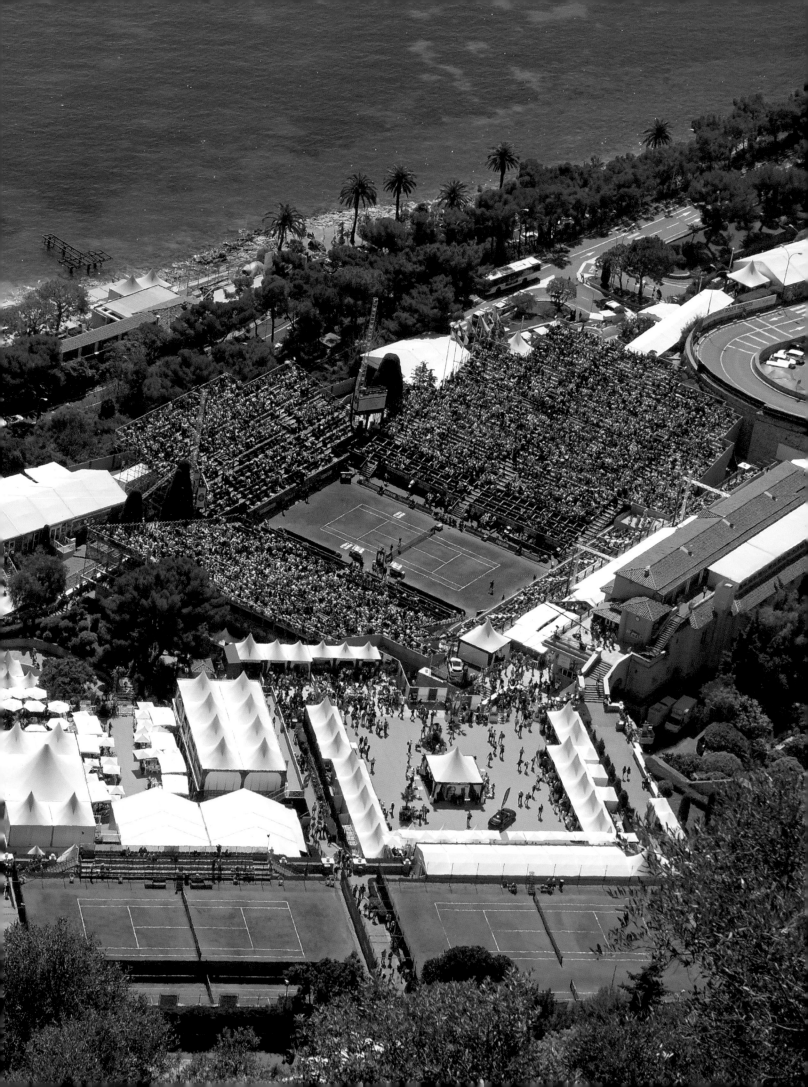

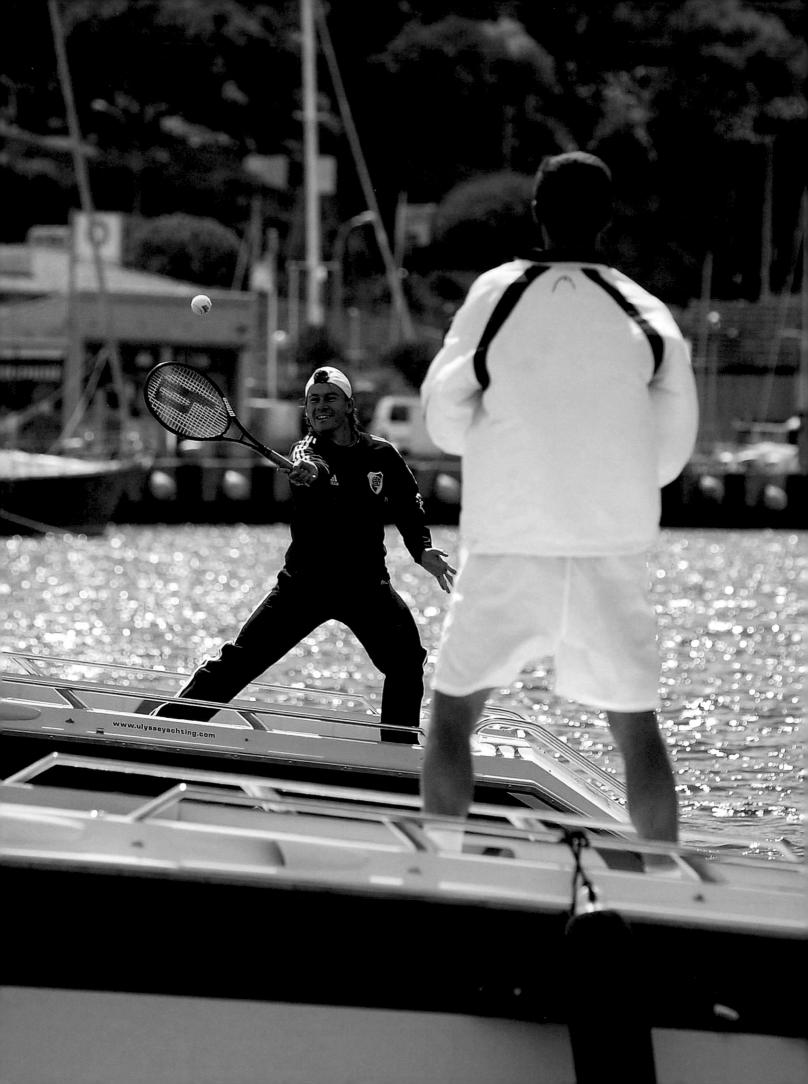

This page: *Bjorn Borg and his wife, Mariana, in Long Island, New York, 1982.* Opposite: *Argentina's Guillermo Coria and Brazil's Gustavo Kuerten play tennis between two boats in the Monaco harbor, 1994.* Following pages: *Yannick Noah poses on a fancy sportscar in Monte Carlo, 1981.*

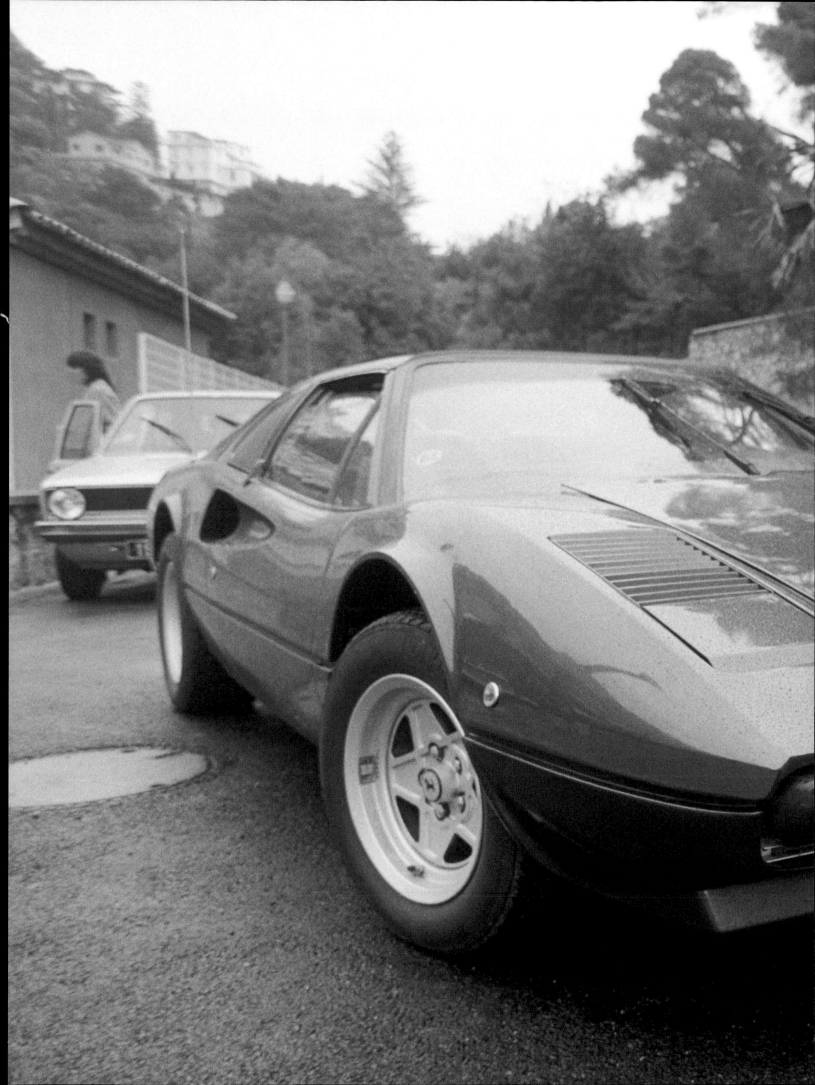

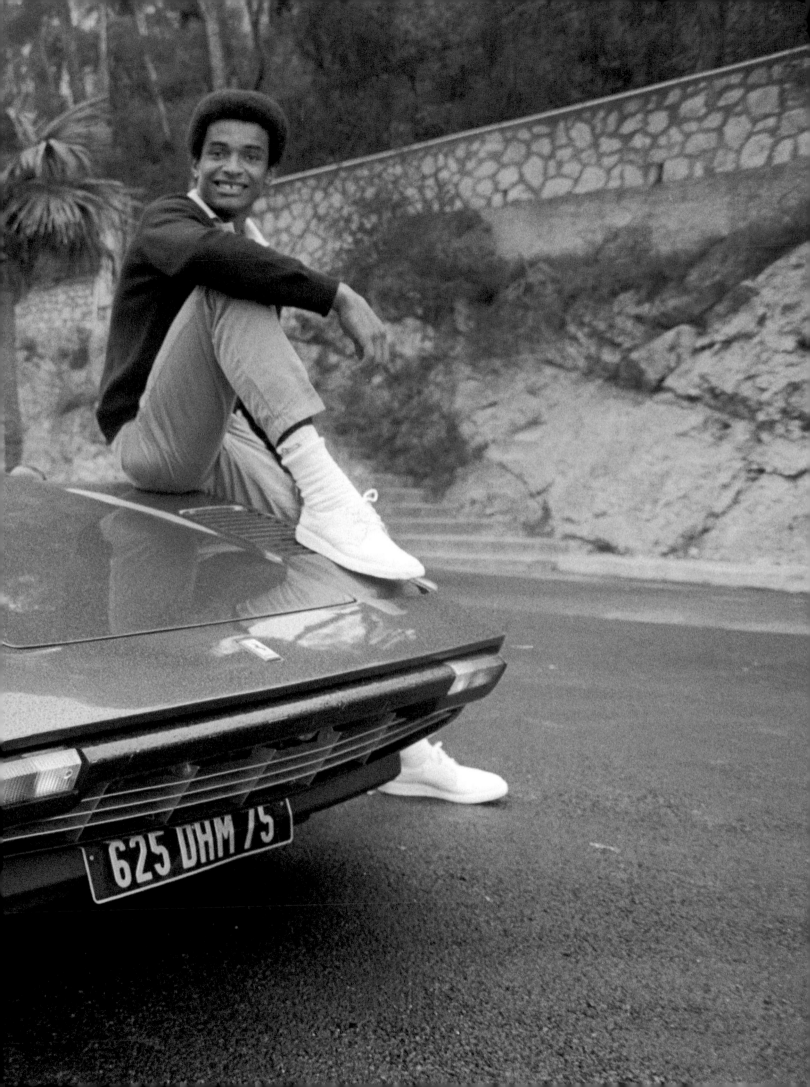

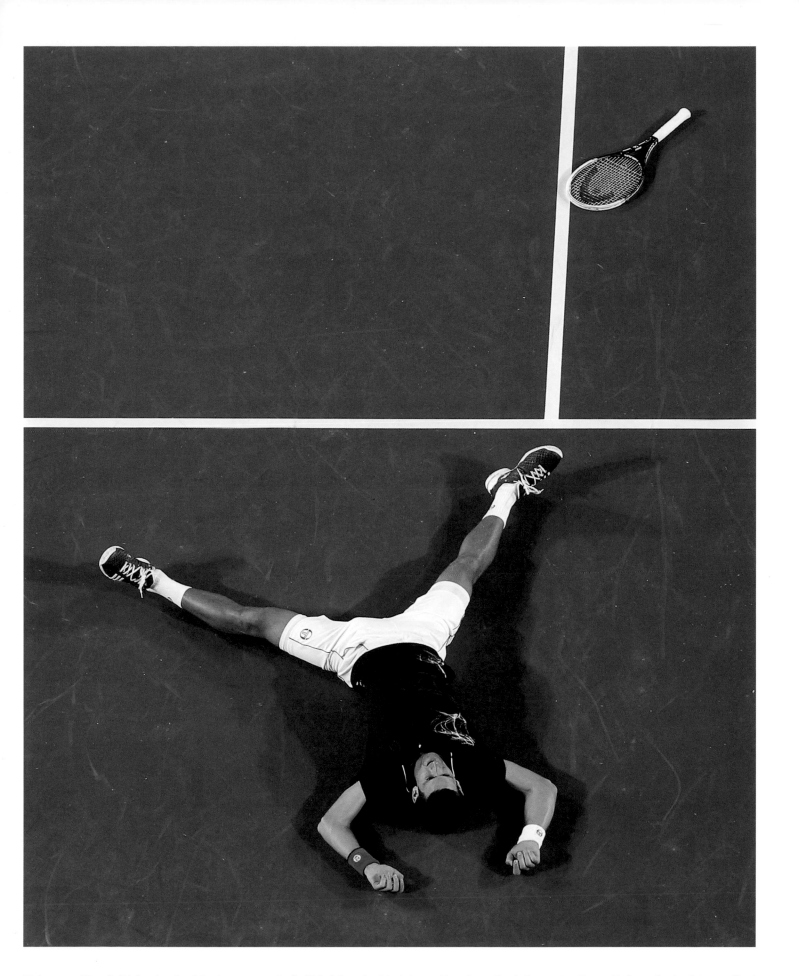

This page: *Novak Djokovic after his victory over Rafael Nadal at the 2012 Australian Open final.* Opposite: *Roger Federer during his semifinal match against Rafael Nadal at the 2012 Australian Open.*

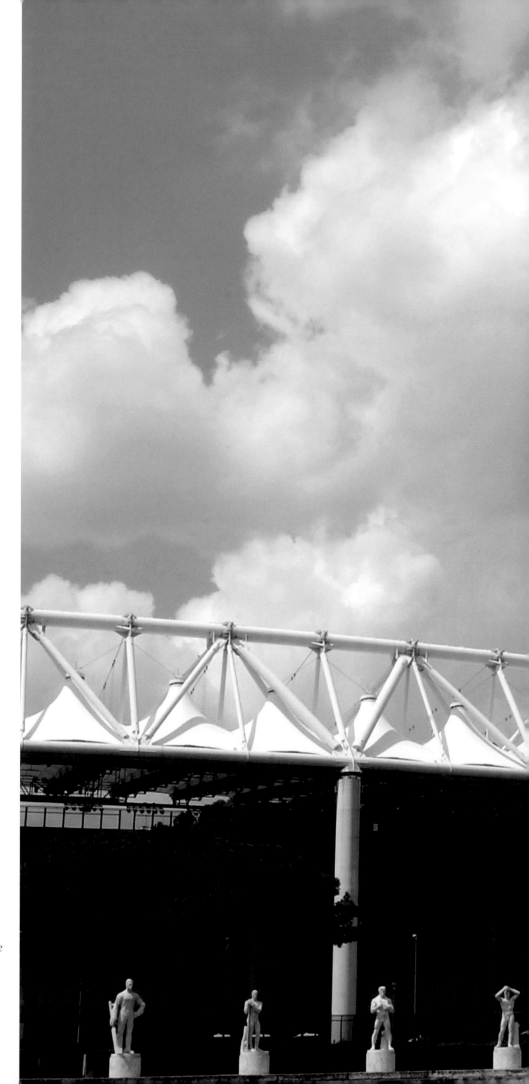

Opposite: *Rome's Foro Italico features impressive marble statues of tennis players.* Following pages, from left: *Indian Wells, California, provides a scenic backdrop for the 2014 BNP Paribas Open; Sloane Stephens of the U.S. returns to Italy's Flavia Pennetta during the 2014 BNP Paribas Open.*

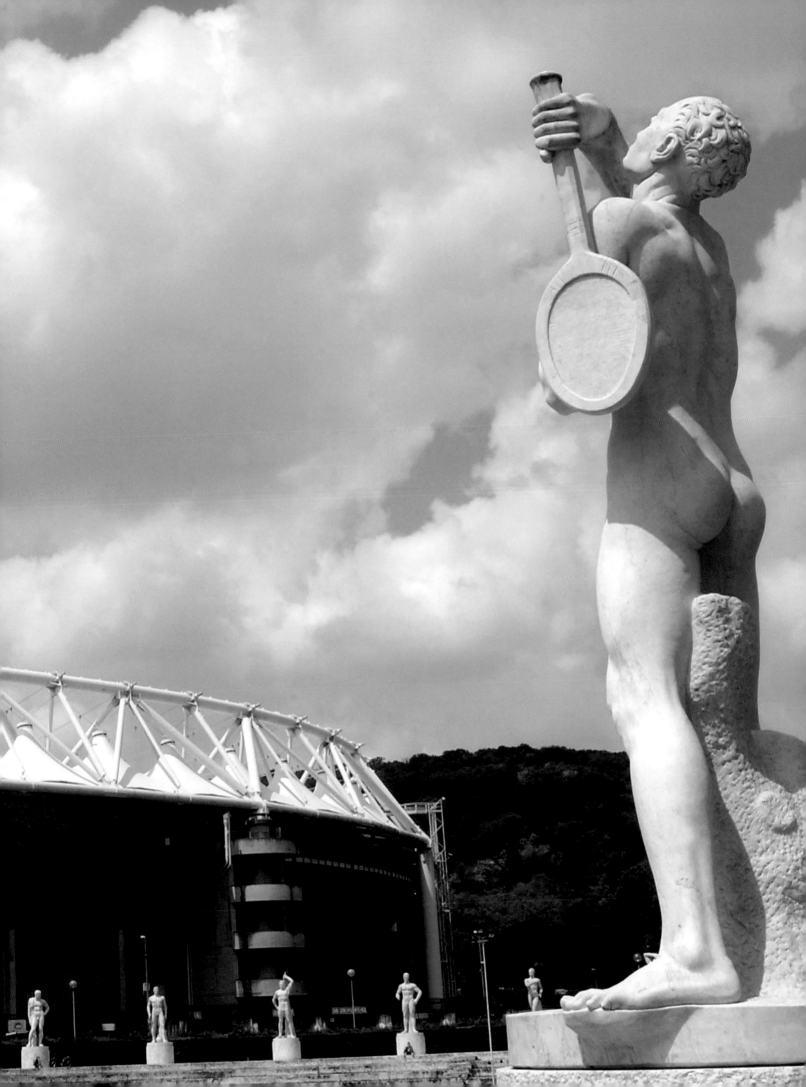

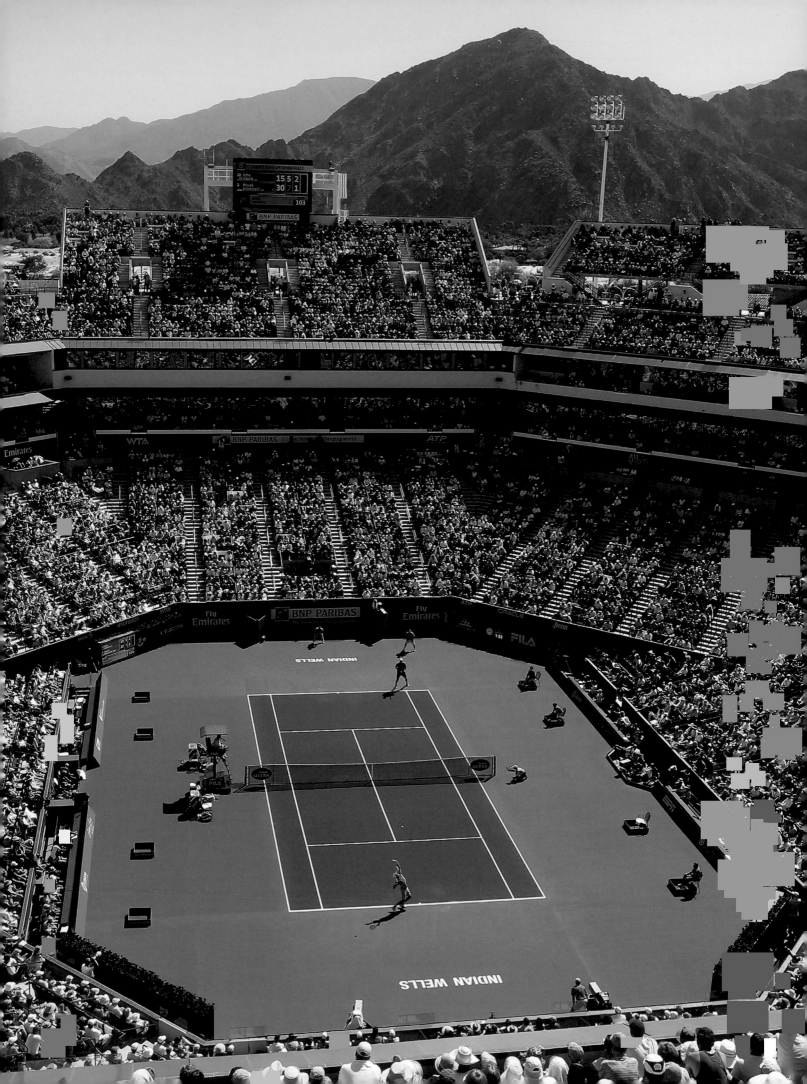

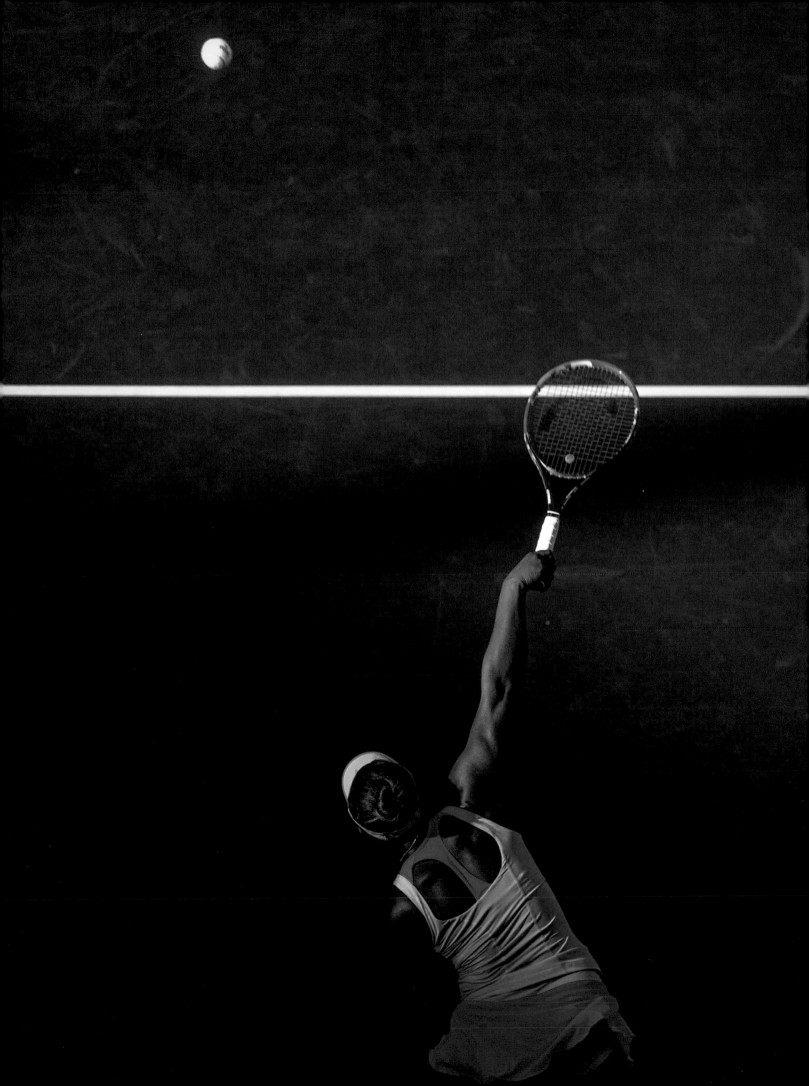

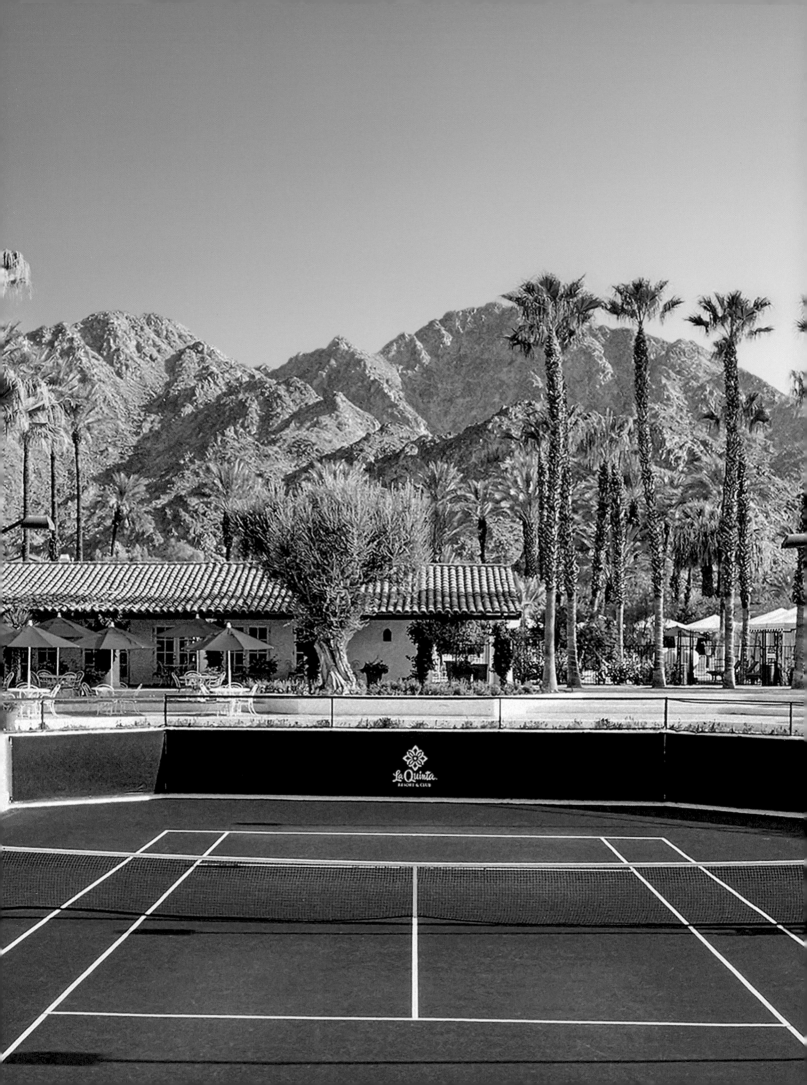

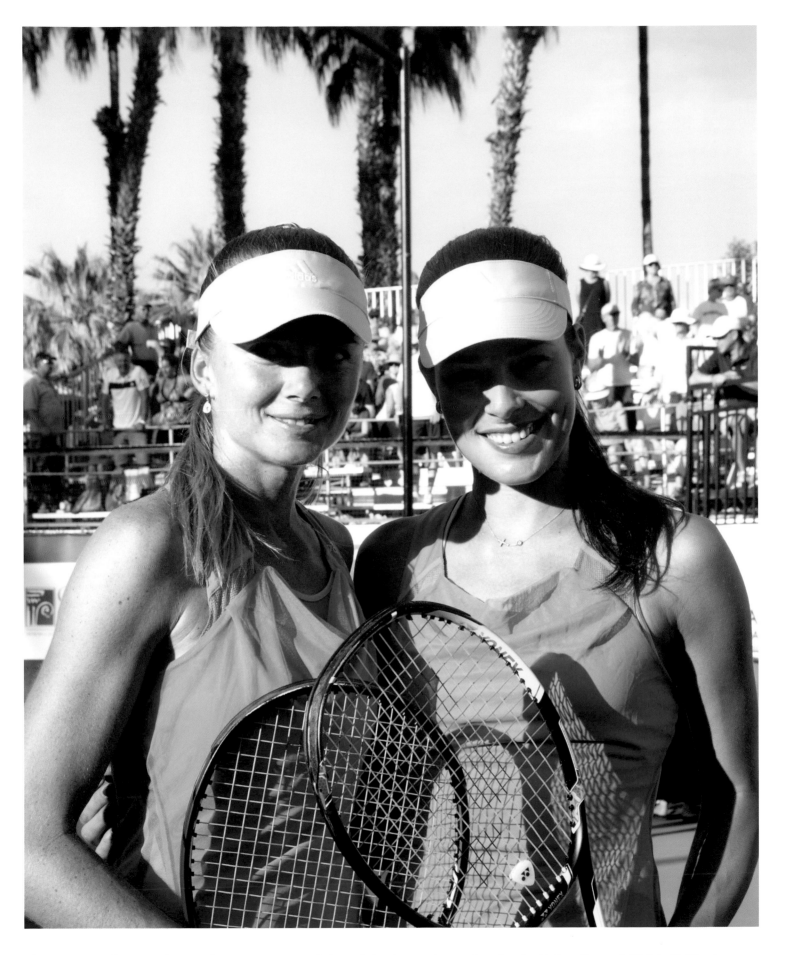

This page: *Dianela Hantuchova and Ana Ivanovic attend the 10th Anniversary Desert Smash at La Quinta Resort & Club in California.*
Opposite: *La Quinta Resort & Club's tennis courts.*

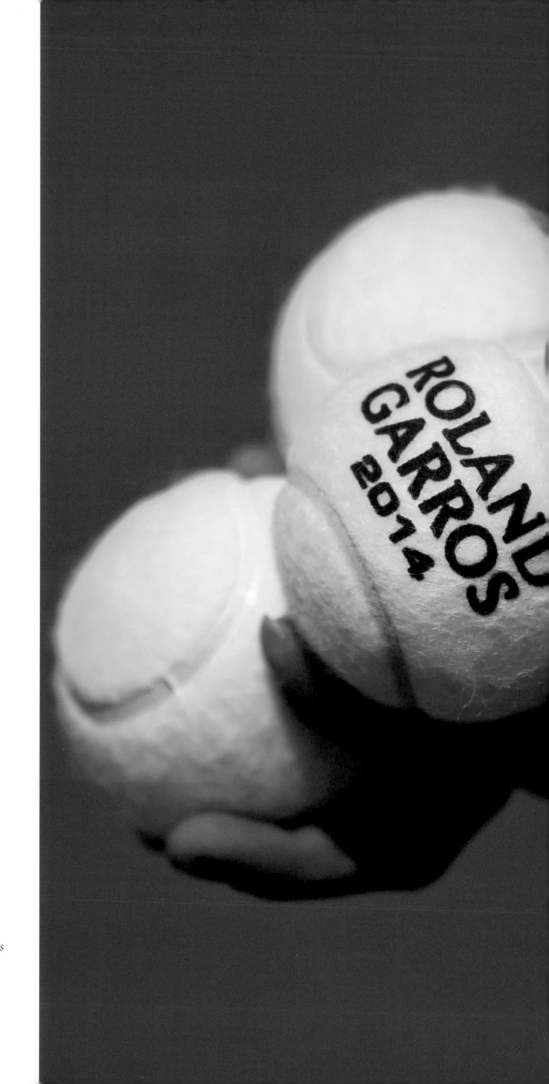

Opposite: *A ballboy holds Roland Garros 2014 tennis balls.* Following pages: *An American flag unfurled at Arthur Ashe Stadium during the 2013 U.S. Open.*

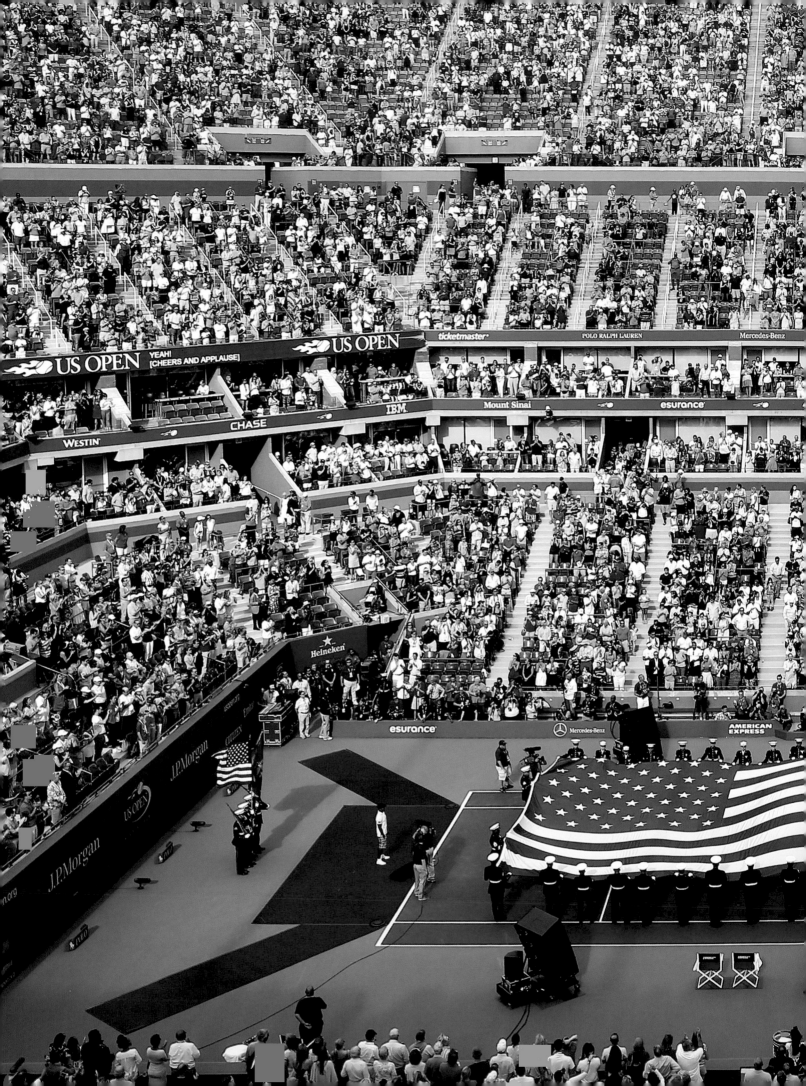

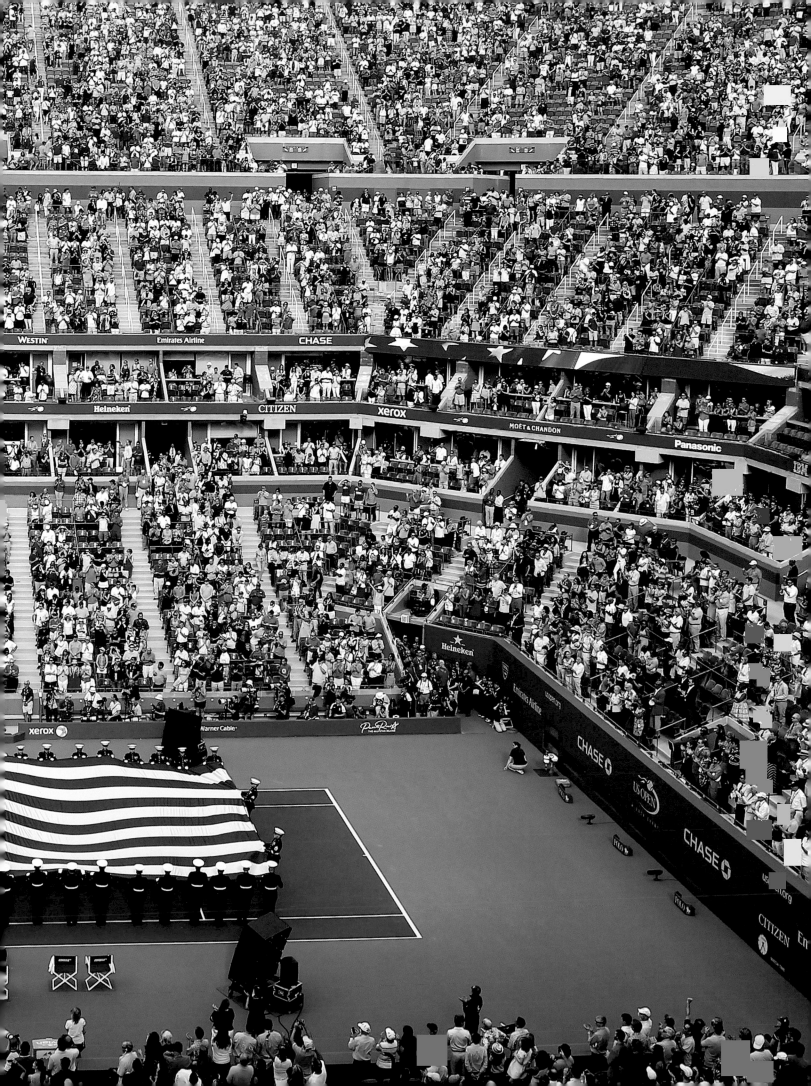

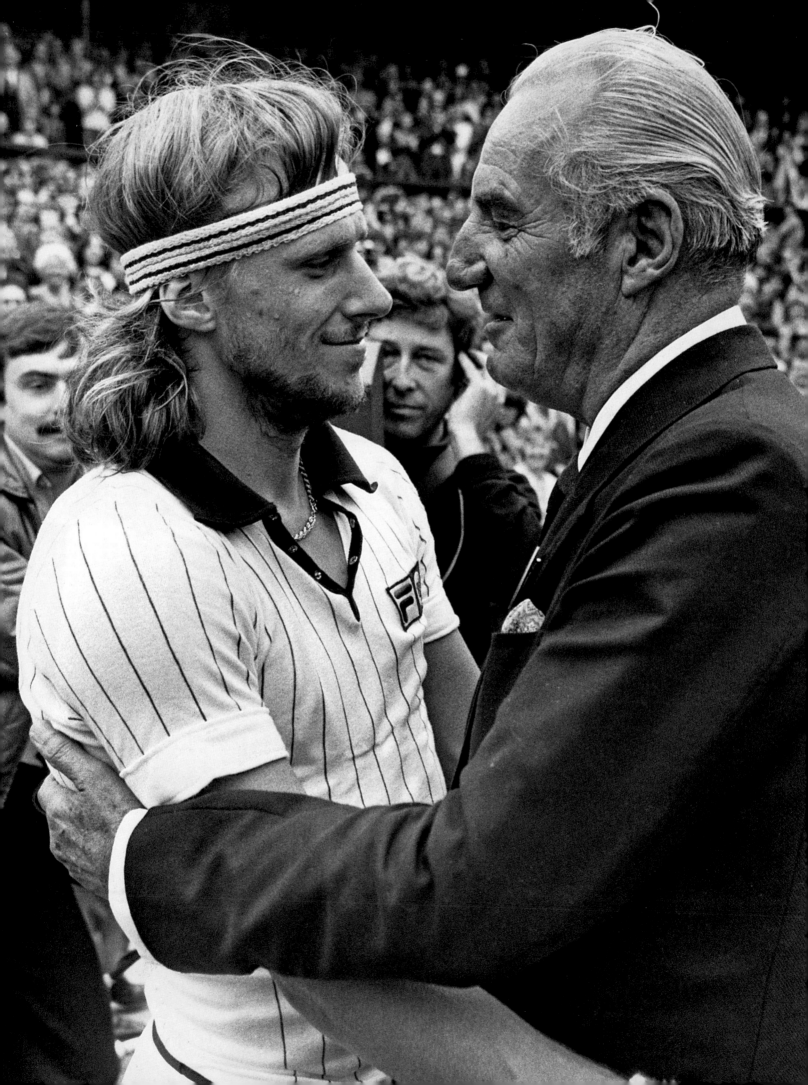

PEOPLE

LEGENDS AND CHARACTERS

Pioneers

The forces of progress and social change that swept through the 1960s and 1970s were personified by the unlikely vessels of two American players: Billie Jean King and Arthur Ashe. On top of winning tennis matches—King won twelve Grand Slam titles, Ashe won three—they championed equality for men and women across all races (one of King's best known achievements was beating Bobby Riggs in the "Battle of the Sexes" match in 1973). For their efforts on and off the court, the two are now honored at the U.S. Open, which is played in Arthur Ashe Stadium at the Billie Jean King National Tennis Center.

Fire and Ice

When it comes to tennis rivalries, opposites attract fans. John McEnroe, the fiery American whose petulance earned him the nickname of "Superbrat," both repelled and endeared fans with his unfiltered, mannerless conduct, not to mention his deft volleying. Björn Borg was his opposite: an unflappably handsome Swedish blond who drew fans with his stylish baselining and steely composure. Evenly matched, each won seven of their fourteen meetings. Their most famous encounters came in the finals of the U.S. Open and Wimbledon in 1980 and 1981, with Borg winning

Opposite: *Fred Perry congratulates Björn Borg at Wimbledon in 1978.*

their first Grand Slam final but McEnroe claiming the next three before Borg's premature retirement.

Love Match

"Love" means "nothing" in tennis lingo, but two of the most iconic figures in the sport during the 1990s were able to find their perfect matches. Steffi Graf, the businesslike German juggernaut who won an Open Era–best twenty-two Grand Slam titles (including all four in 1988), would have seemed an unlikely pairing for Andre Agassi, a wild-haired, neon-wearing American. But as Agassi matured into a philanthropist and elder statesman of the game, he won "Fraulein Forehand" over. The two, both winners of all four Grand Slam events, married in 2001, and have since had two children.

Teen Phenoms

Tennis is a sport for all ages, and even at the elite levels there is often room for old and young alike. Boris Becker, a lanky German teen with a shock of reddish-blond hair, became the youngest Wimbledon champion ever at just seventeen years old, igniting a career that would last for over a decade. As Becker's light was fading, a new young star emerged. With beguiling creativity and finesse, Swiss teen Martina Hingis made history on the women's side, winning her first three Grand Slam titles and earning the No. 1 ranking when she was just sixteen years old.

Sister Act

It's not often that the second-best player in a family is also second-best in the entire world. Forging an improbable path from the public courts of Compton, California, Venus and Serena Williams broke the mold, overpowering their competition with a one-two punch of power tennis—which took them to No. 1 and No. 2 in the world. They also turned Grand Slam finals into family affairs, meeting in eight different major finals. As good as they are apart, they're even more intimidating together, having won thirteen Grand Slam titles and three Olympic gold medals in doubles.

Modern Legends

With a constellation of stars atop the sport shining more brightly than ever before, many consider this modern day a "Golden Era" of tennis. Roger Federer, the effortlessly elegant Swiss maestro, has won seventeen Grand Slam titles, more than any other man. Spain's Rafael Nadal, his frequent nemesis, is without equal on clay courts, having won a staggering nine Roland Garros titles. Novak Djokovic fought valiantly to emerge from the shadows of these two titans, putting his native Serbia atop the game. On the women's side, Russian Maria Sharapova sustains the success she first achieved as a teen, becoming one of the game's most successful crossover stars.

Fans

Tennis fans can be found atop nearly any field of achievement and love nothing more than to see (and be seen) at the court. The Centre Court of Wimbledon features the Royal Box, in which royalty including Prince William and Princess Kate watch the action alongside various dignitaries. *Vogue* editor Anna Wintour is a fixture at the U.S. Open in New York, often sitting with Roger Federer's team (actors like Kevin Spacey and Alec Baldwin are also often spotted courtside). Away from the Grand Slams, Prince Albert of Monaco and Michelle Obama take in the tennis in their respective hometowns of Monte Carlo and Washington D.C.

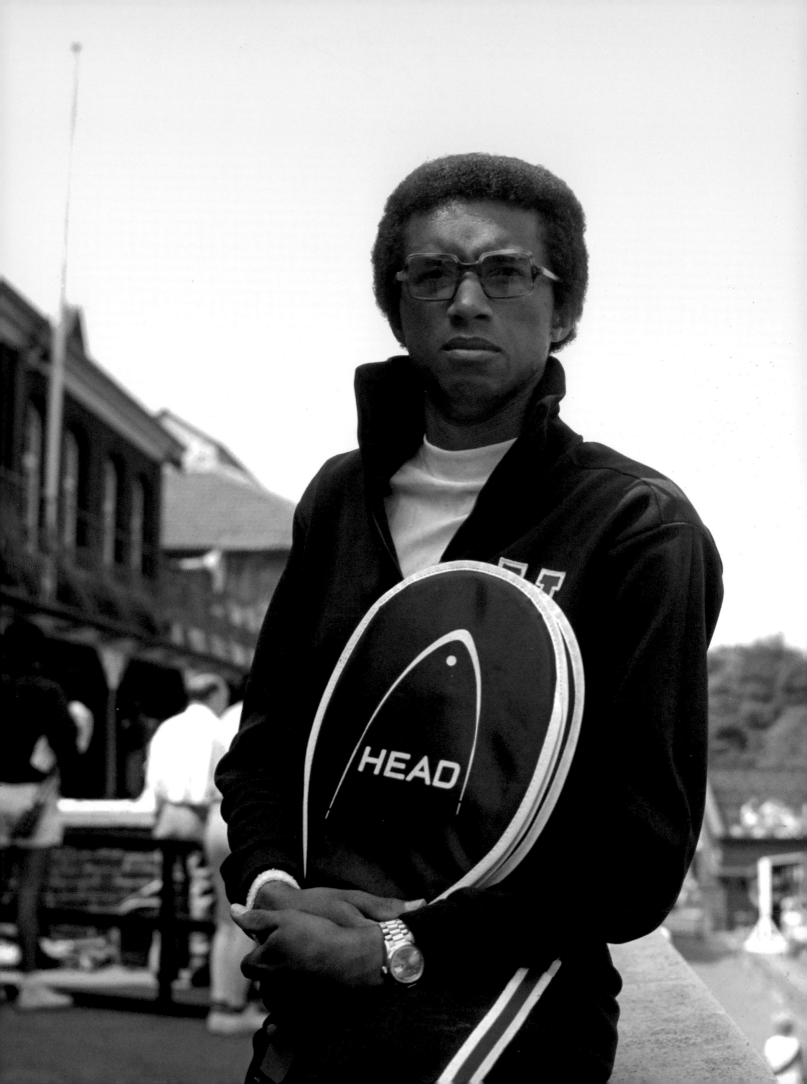

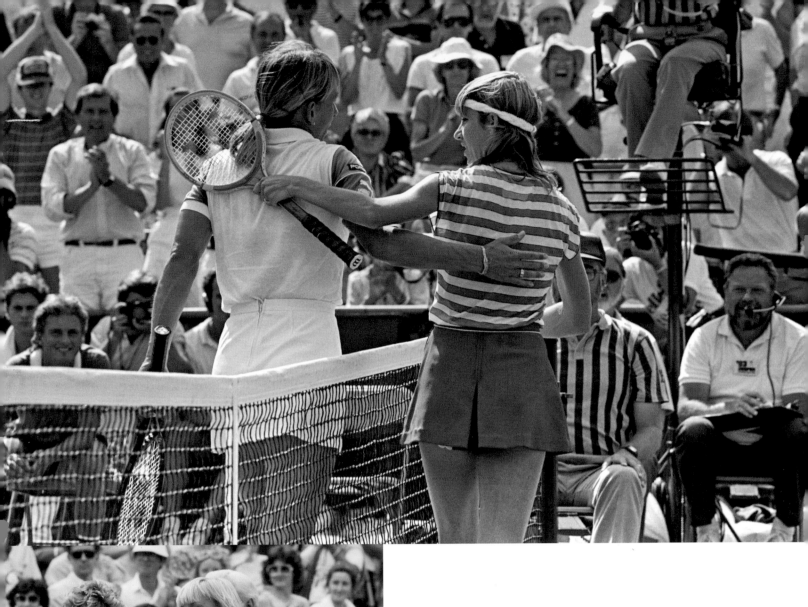

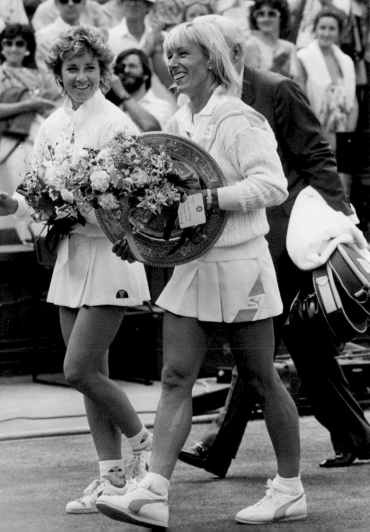

Opposite, clockwise from left: *Arthur Ashe at the Queen's Club in London, 1970; Chris Evert (right) congratulates rival Martina Navratilova after her first U.S. Open championship, 1983; Chris Evert and Martina Navratilova after the 1985 Wimbledon final. Following pages: Björn Borg and John McEnroe before fiercly facing off at the 1981 Wimbledon Championships—McEnroe won the match.*

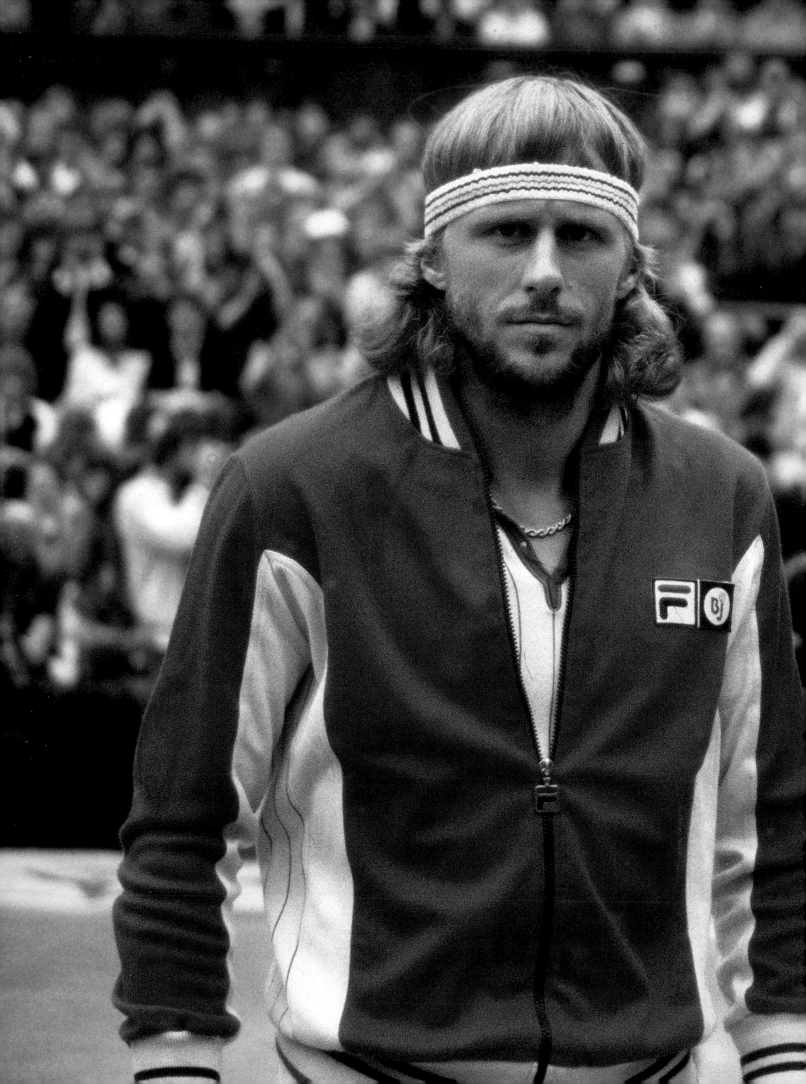

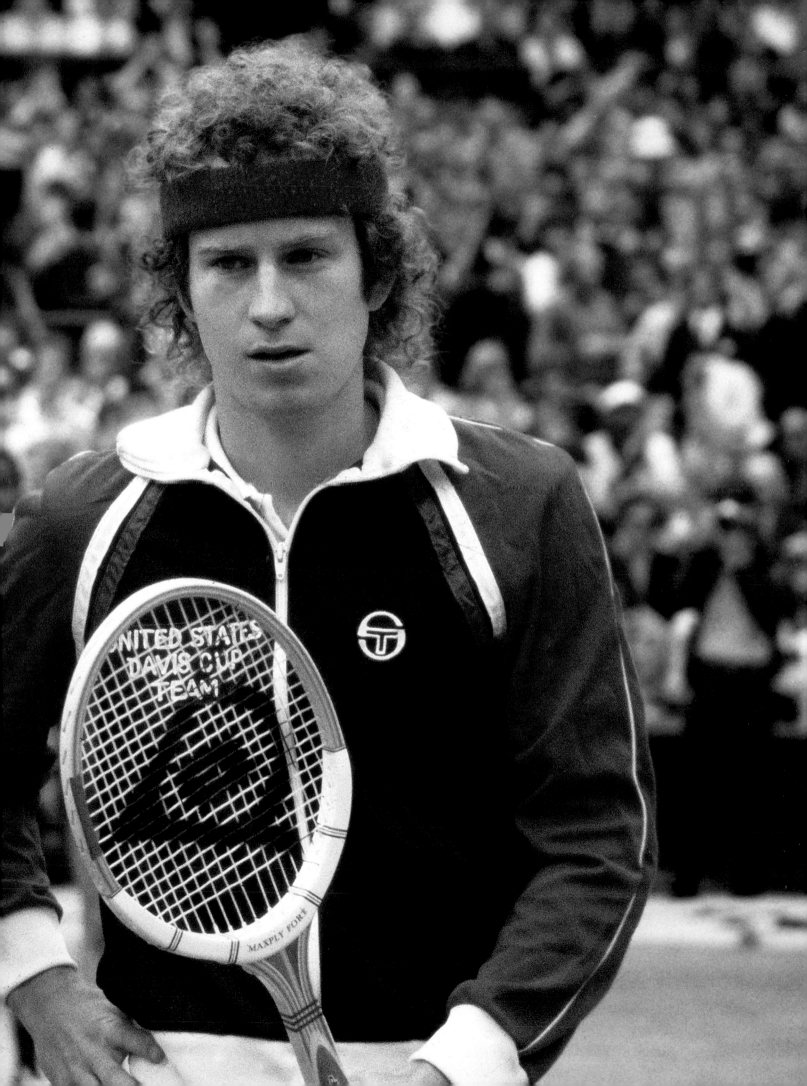

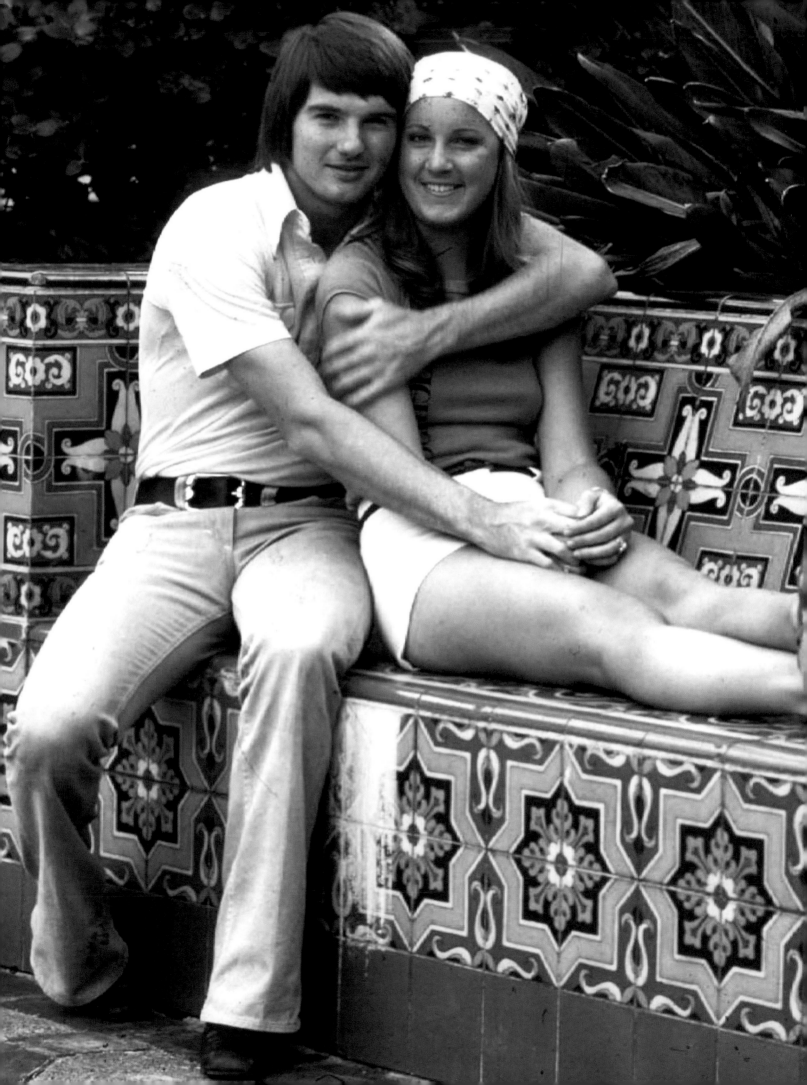

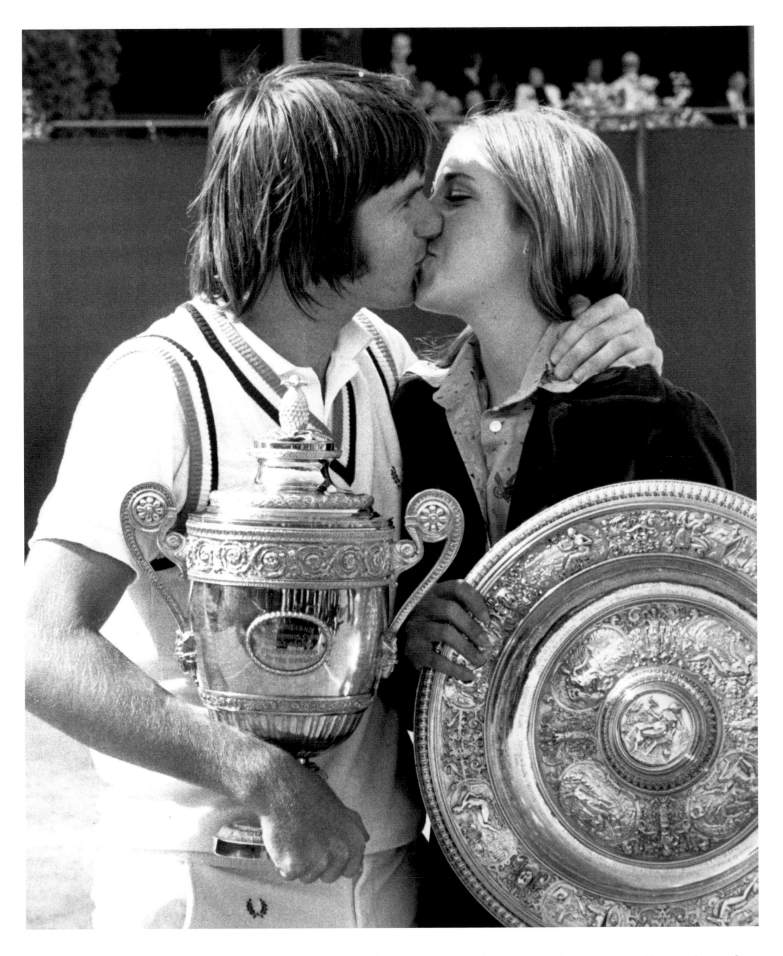

This page: *Jimmy Connors kisses his fiancée, Chris Evert, following their victories at Wimbledon, 1974.* Opposite: *The golden couple seated on a bench at the Boca Raton Resort in Florida, 1973.*

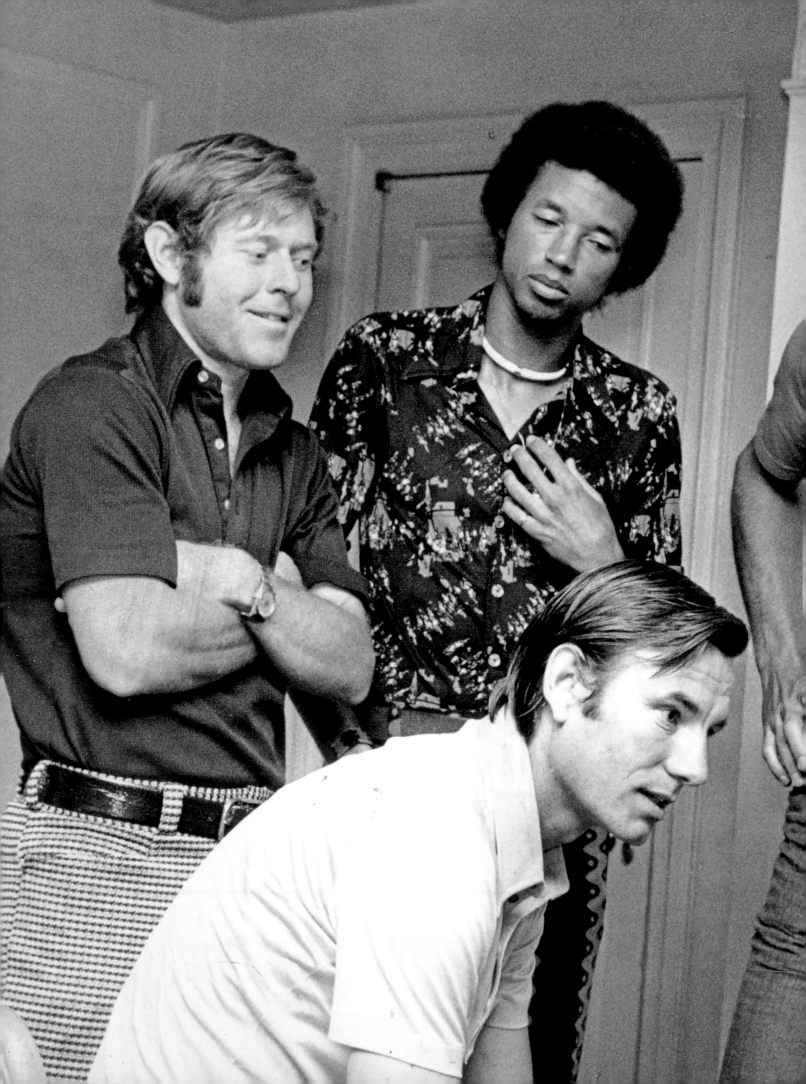

Opposite: *Cliff Richey (left), Arthur Ashe (middle), and Stan Smith (back) with Niki Pilić and Jack Kramer (front) discuss boycotting Wimbledon based on Pilić's suspension for refusing to play for Yugoslavia in the Davis Cup, 1973.*

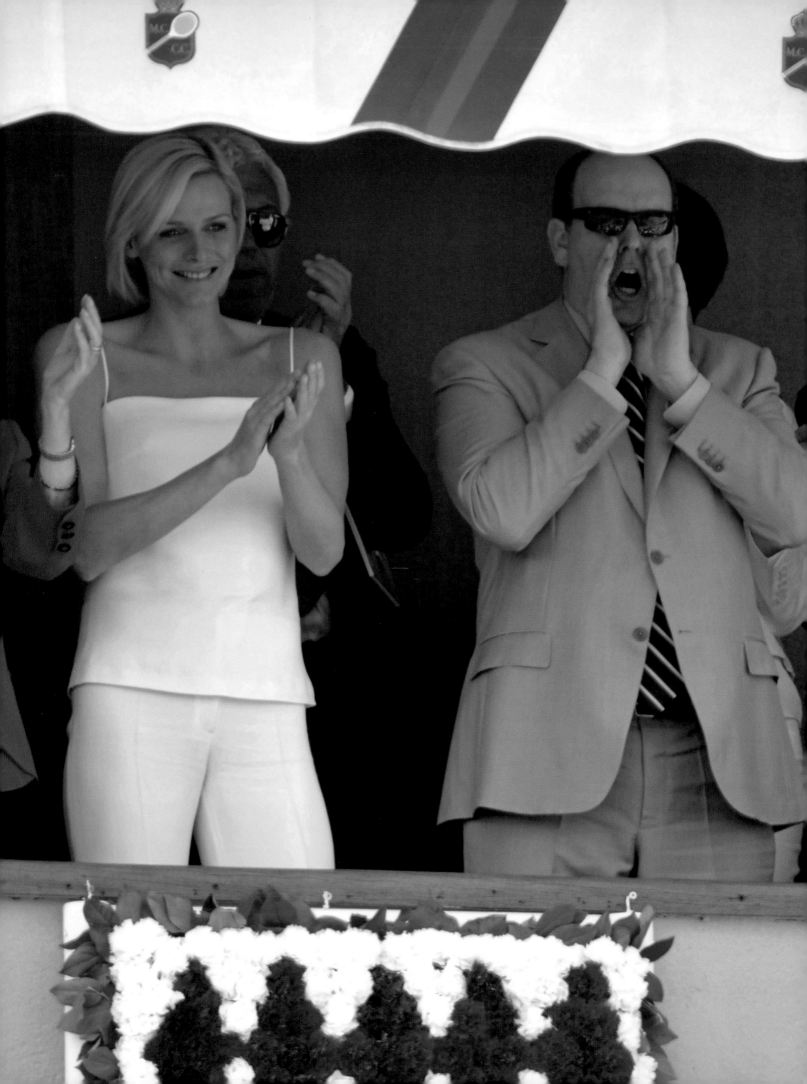

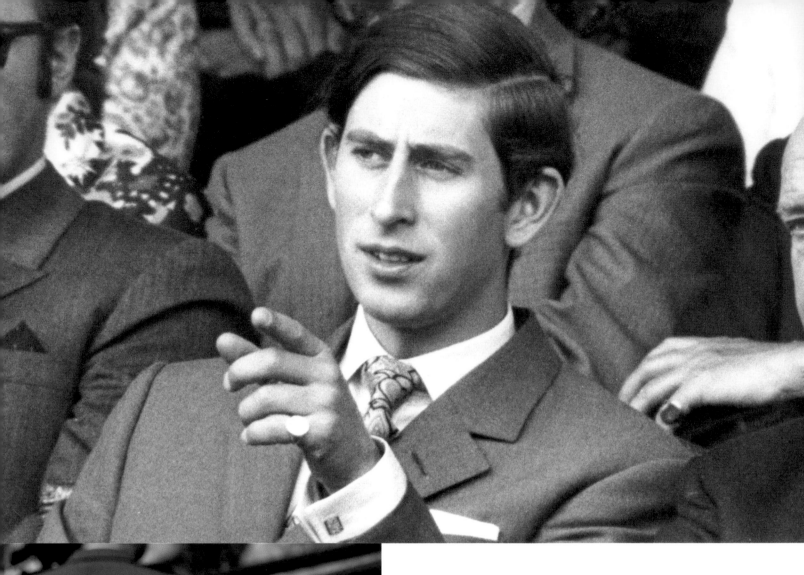

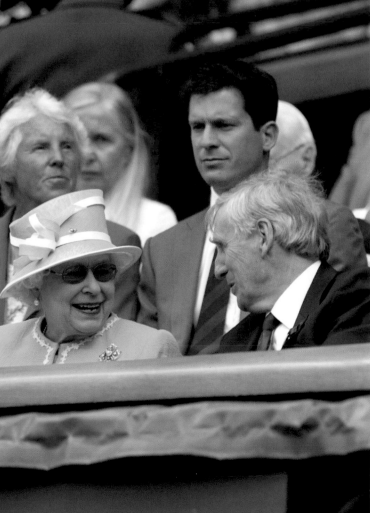

Clockwise from left: *Prince Albert II and Charlene Wittstock of Monaco clap during a match between Rafael Nadal and Roger Federer at the Monte Carlo Masters Series 2008; Prince Charles enjoys the scene at Wimbledon, 1970; Britain's Queen Elizabeth in the Royal Box at Wimbledon's Centre Court, 2010.*

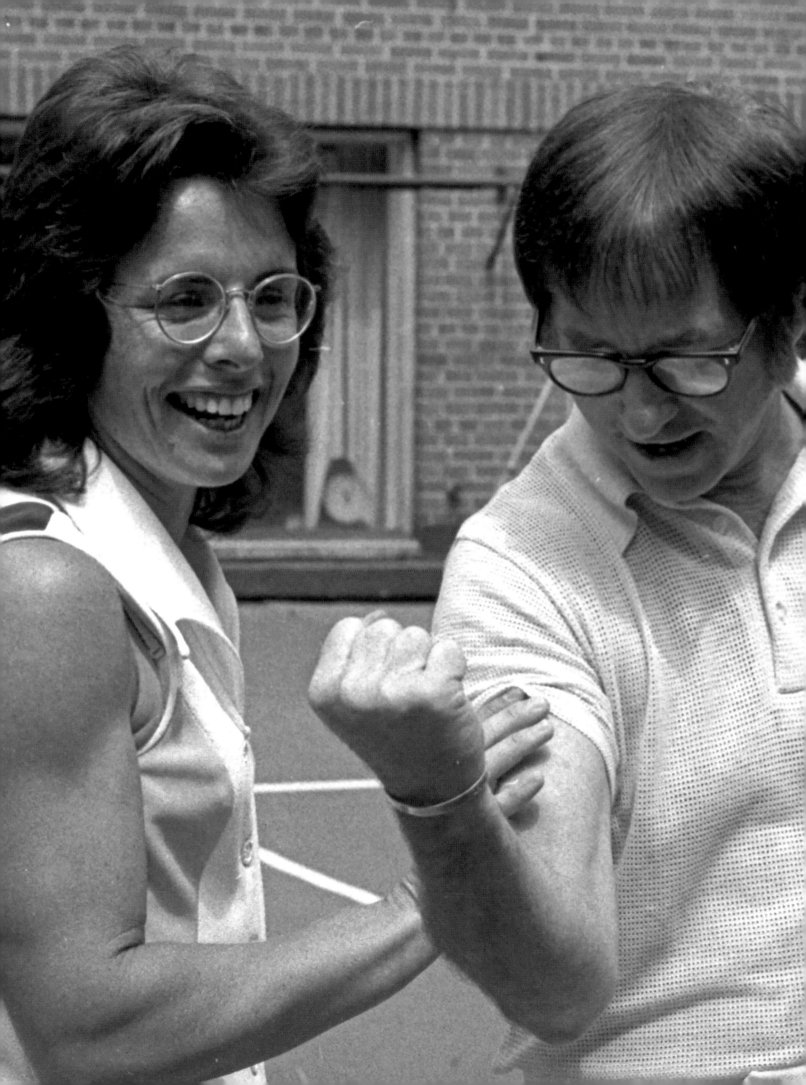

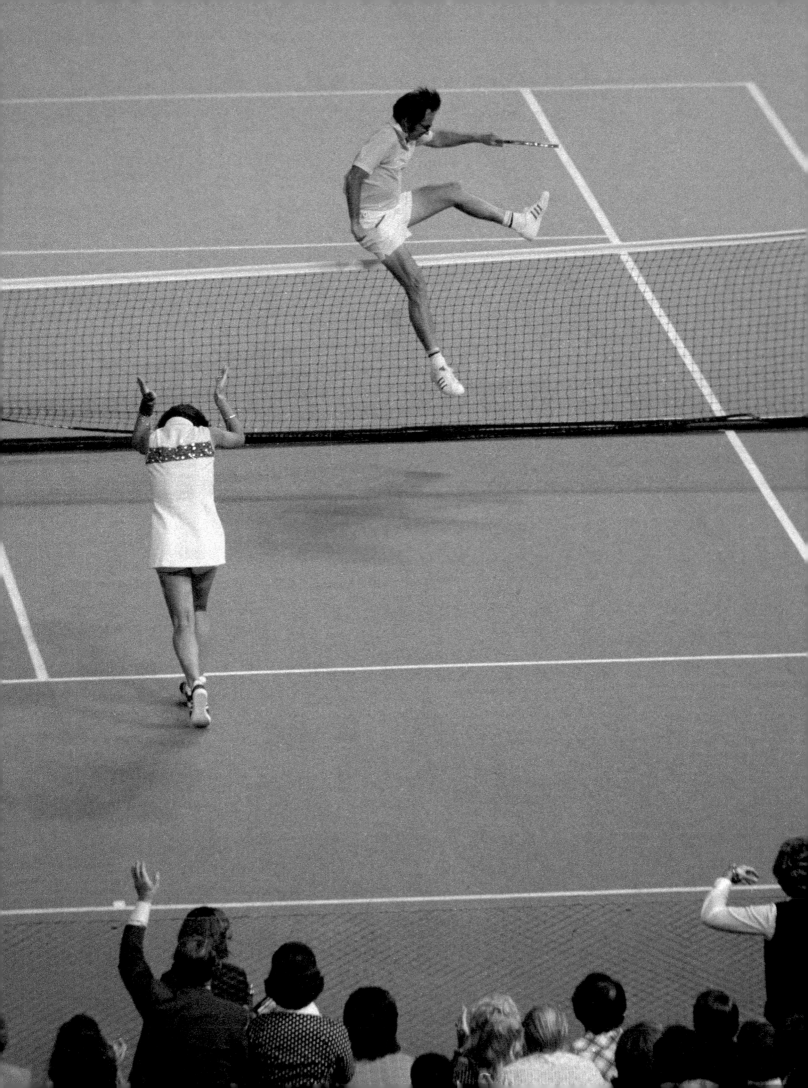

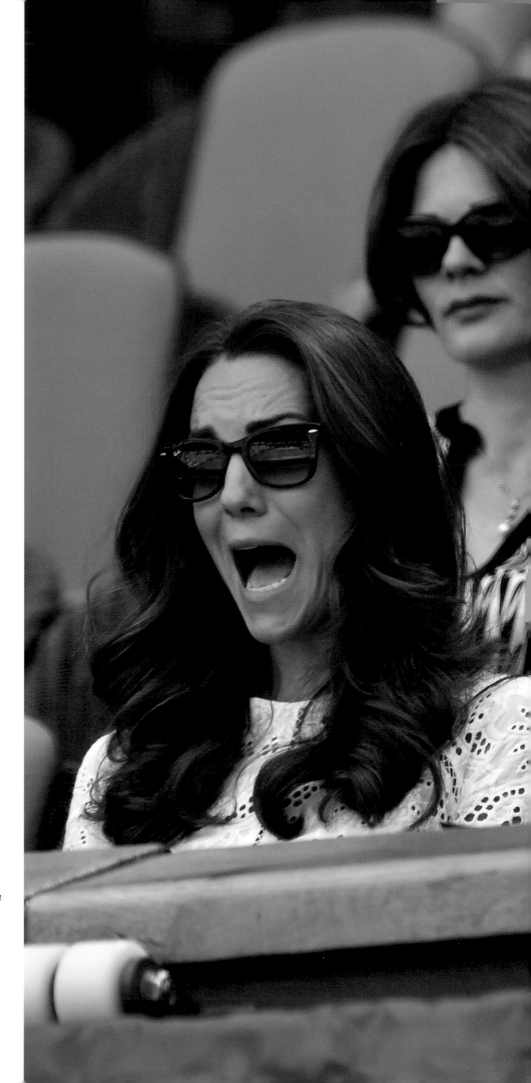

Previous pages, from left: *Billie Jean King and Bobby Riggs prepare for their infamous "Battle of the Sexes" match, 1973; Billie Jean King claps as Bobby Riggs jumps the net to congratulate her on her victory in a $100,000 winner-take-all match.* Opposite: *Kate Middleton gasps as Prince William covers his eyes during a thrilling match at the 2014 Wimbledon Championships.*

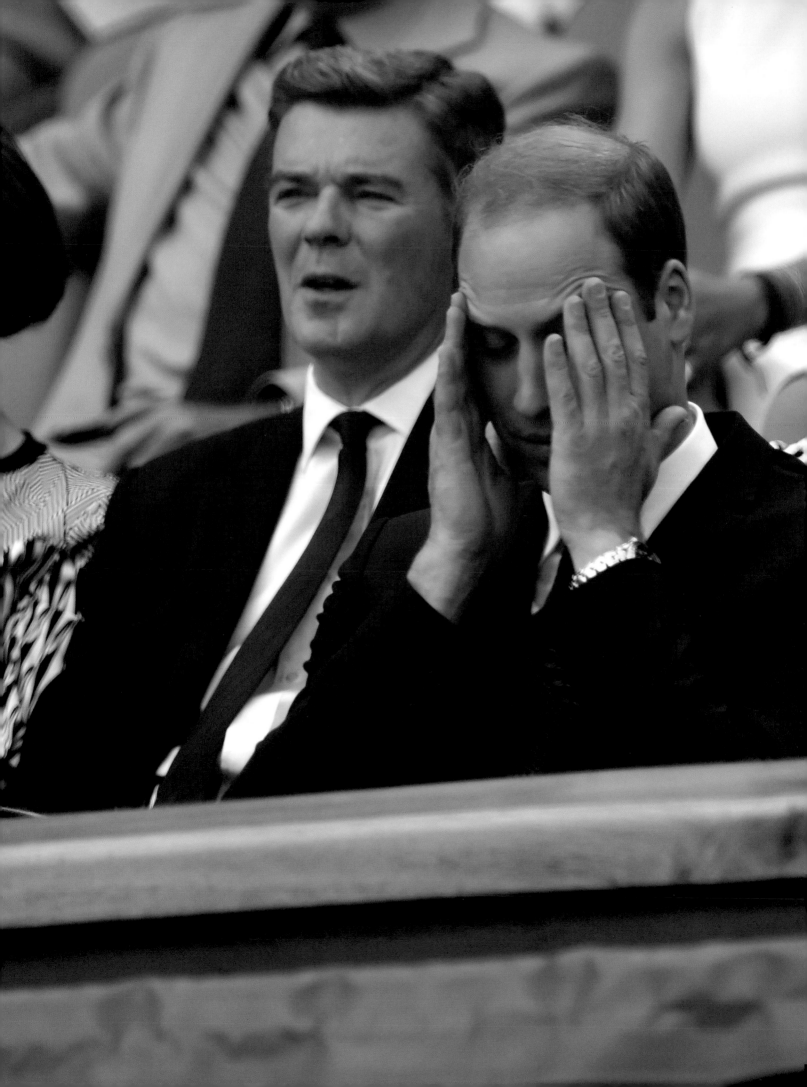

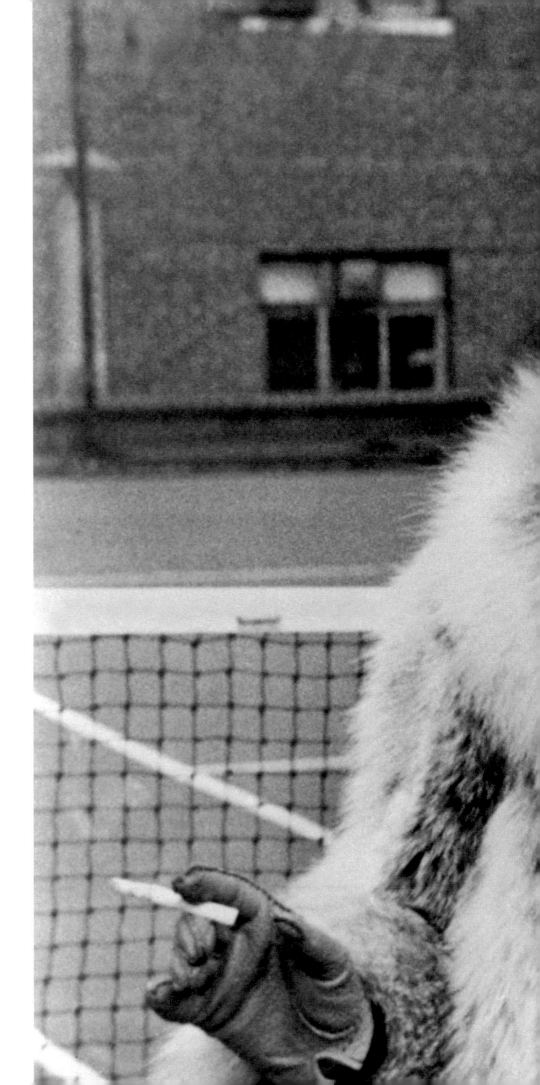

Opposite: *Swedish actress Ann Margret sports a stylish fur coat and scarf while smoking on a tennis court.*

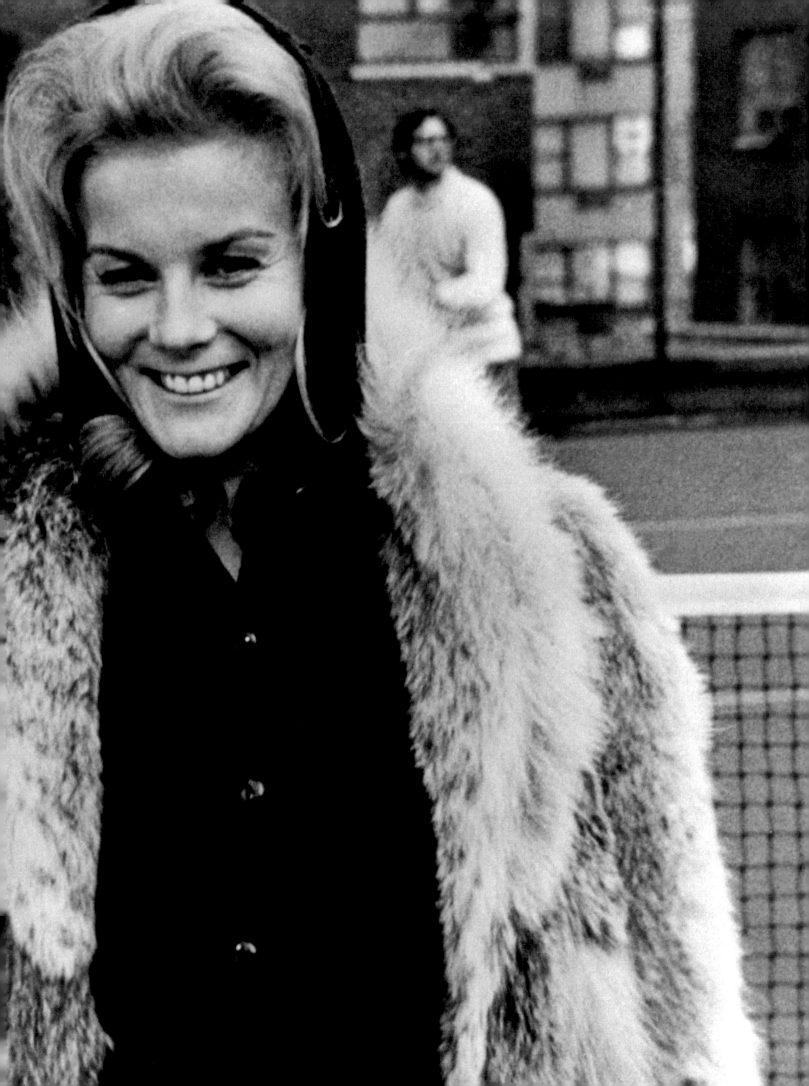

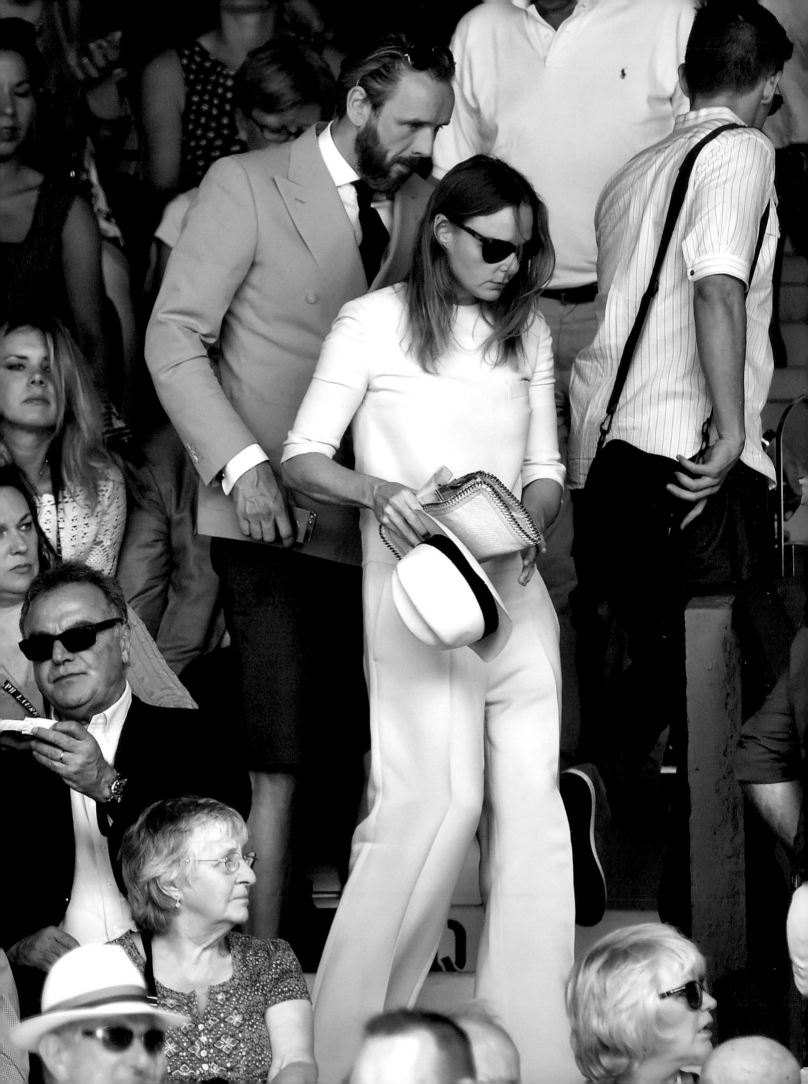

This page: *British model and actress Suki Waterhouse in the stands at Wimbledon, 2014.* Opposite: *Stella McCartney and Alasdhair Willis attend a match at the 2014 Wimbledon Championships.*

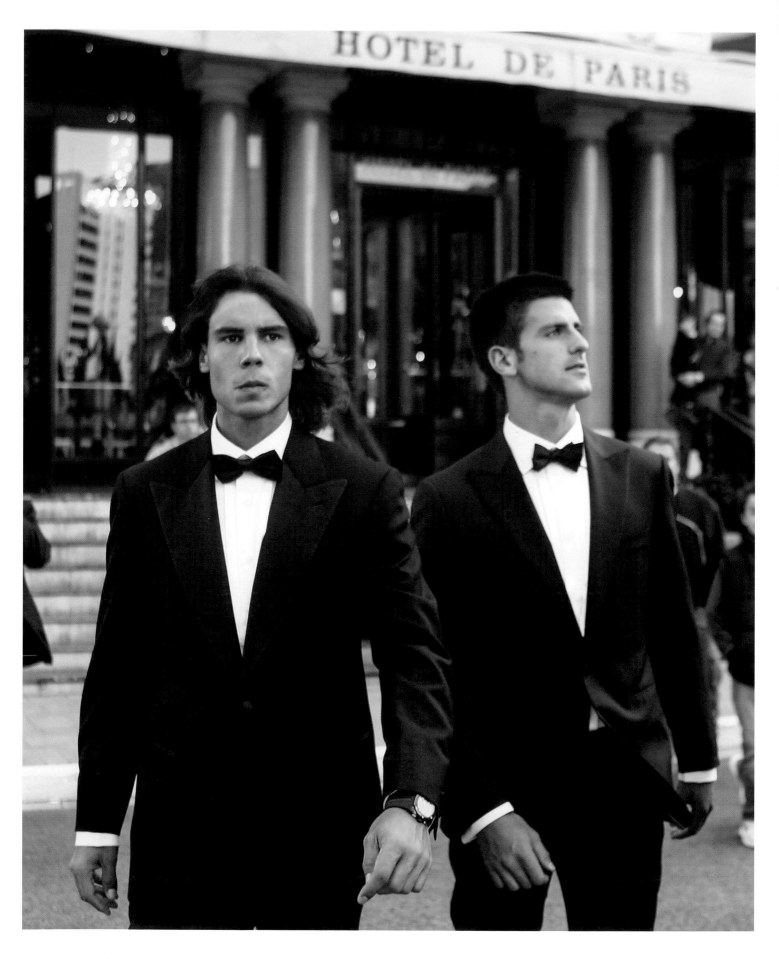

This page: *Novak Djokovic (right) and Rafael Nadal on their way to the Monte Carlo Casino in Monaco, 2008.* Opposite: *Anna Wintour and Roger Federer at the 270th Anniversary celebration for Moët & Chandon champagne on August 20, 2013.*

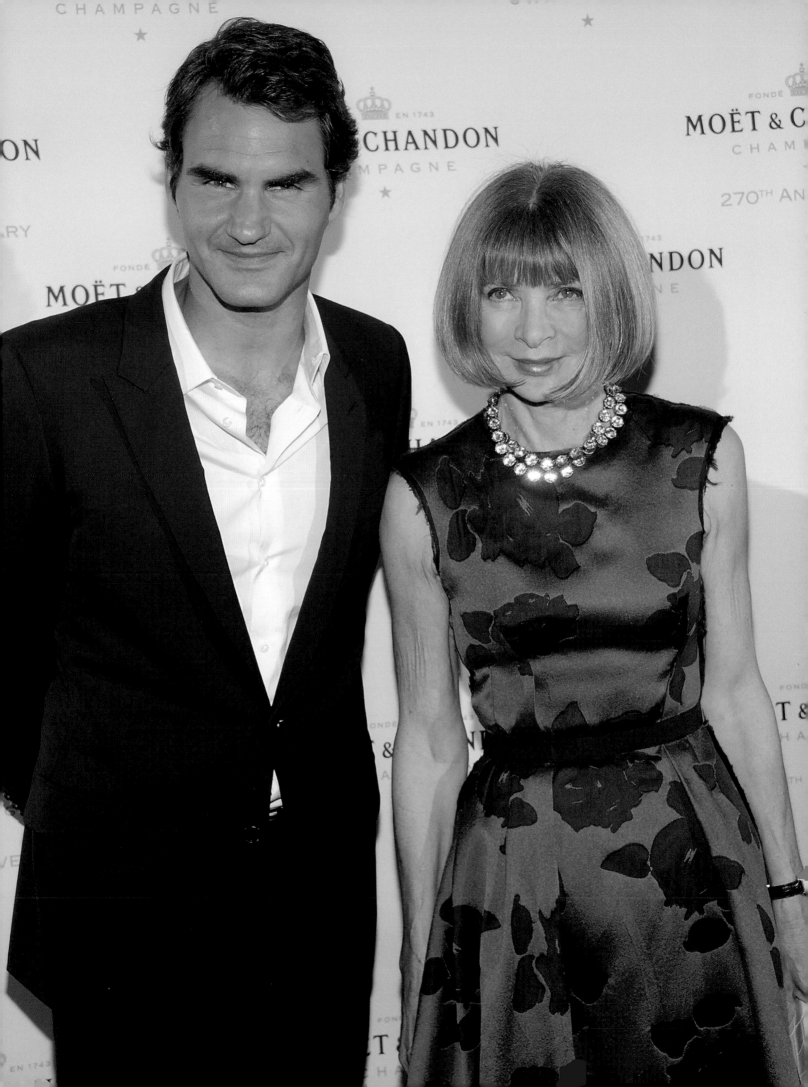

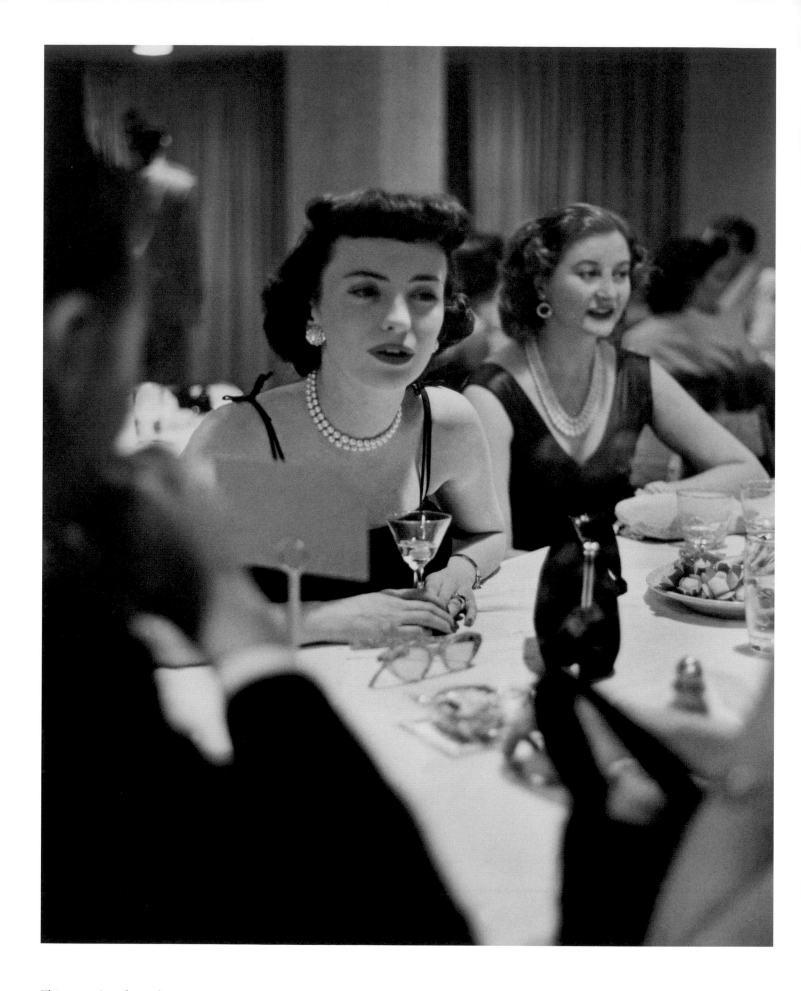

This page: *Socialites schmooze at a tennis club party, 1954.* Opposite: *Björn Borg and Mariana Simionescu on the dance floor, circa 1980.*

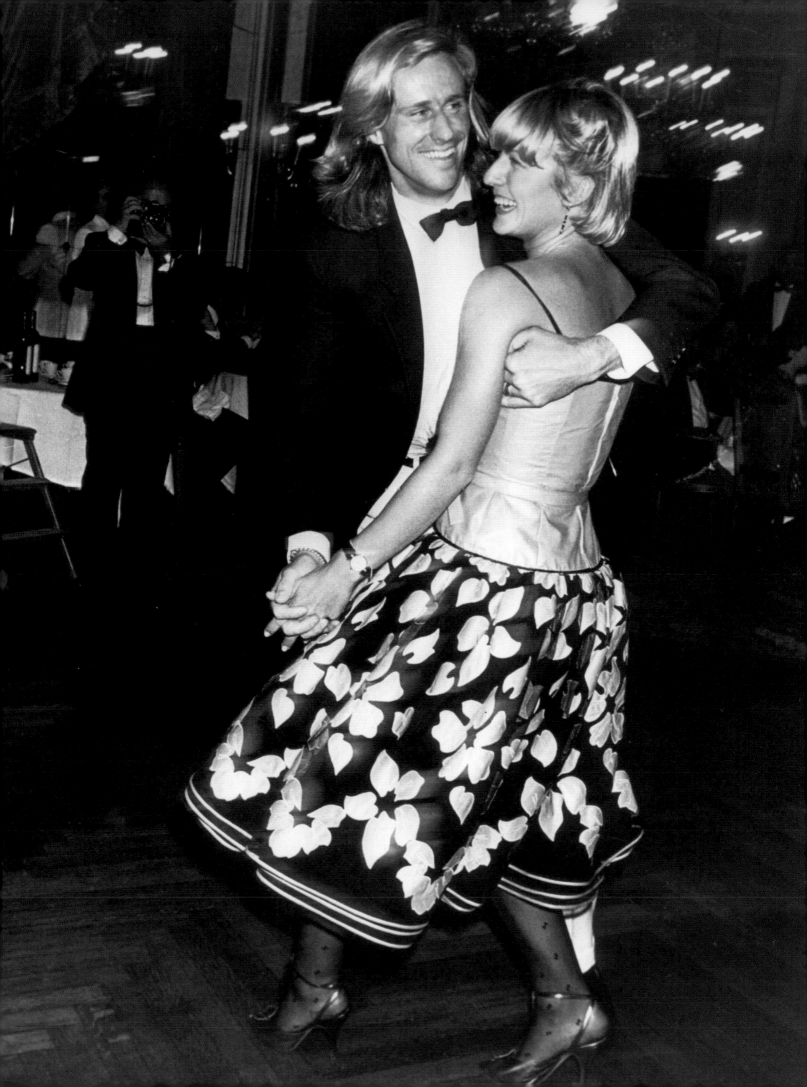

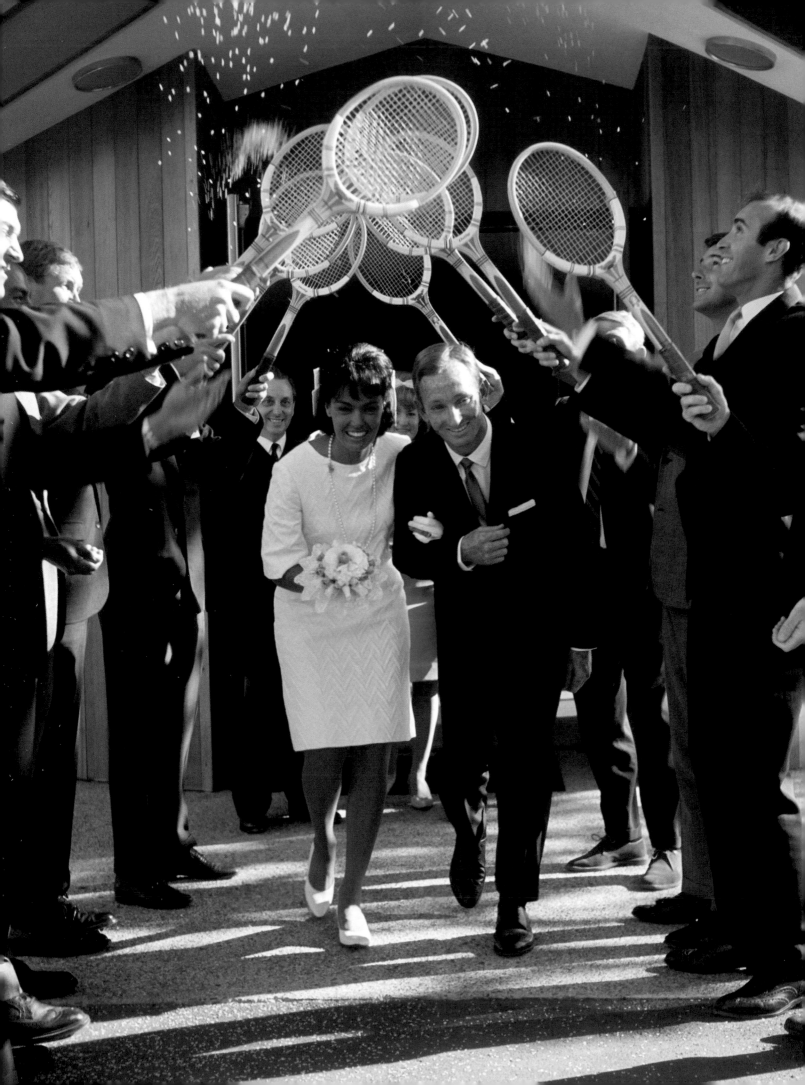

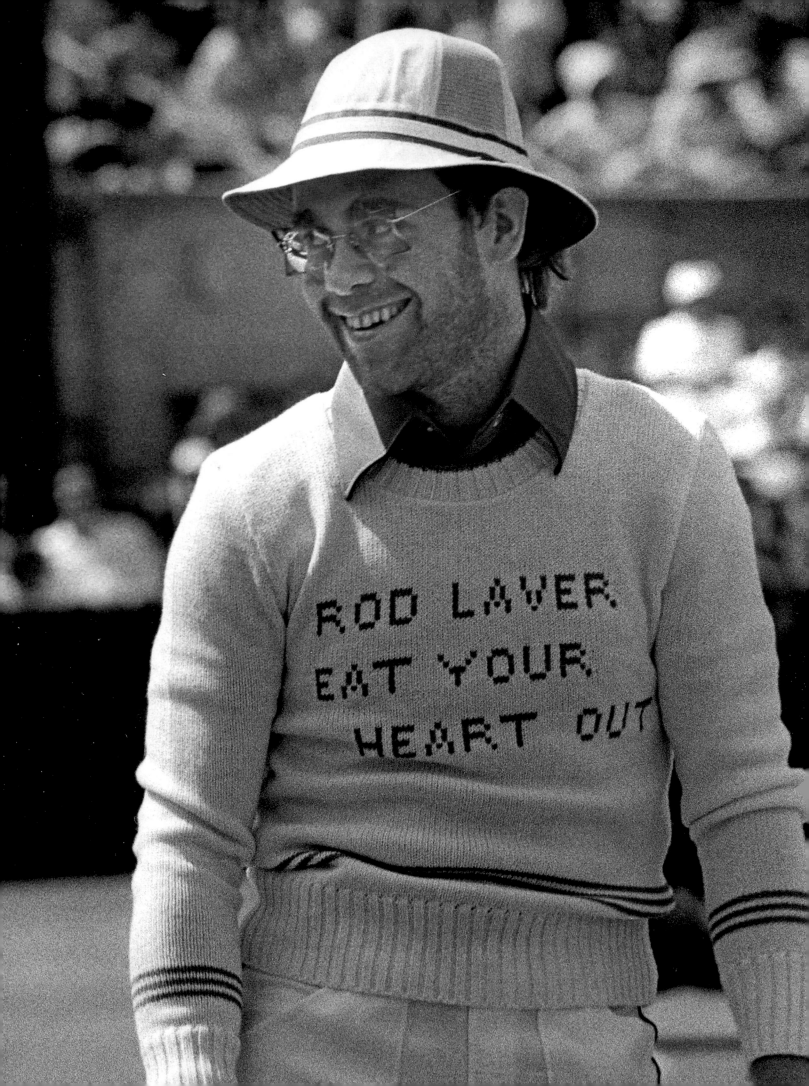

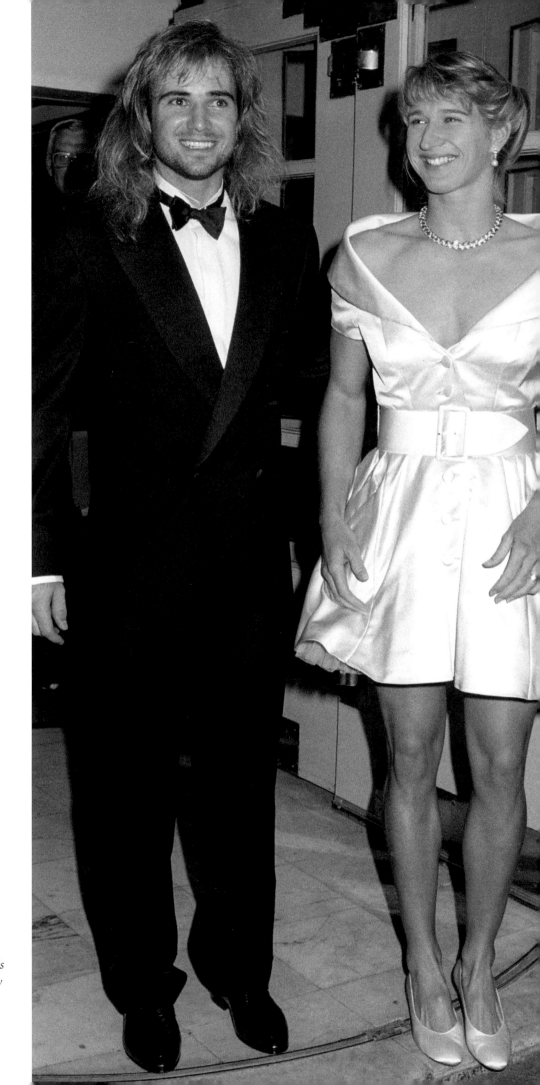

Previous pages, from left: *Rod Laver walks under an arch of tennis rackets on his wedding day, 1966; Elton John in a Rod Laver sweater at a celebrity tennis tournament, 1975.* Opposite, clockwise from left: *Andre Agassi and Steffi Graf step out for the Wimbledon Winners Ball at the Savoy Hotel, 1991; John McEnroe with his wax likeness at Madame Tussauds in London, 1981; the Williams sisters early in their careers, 1998.*

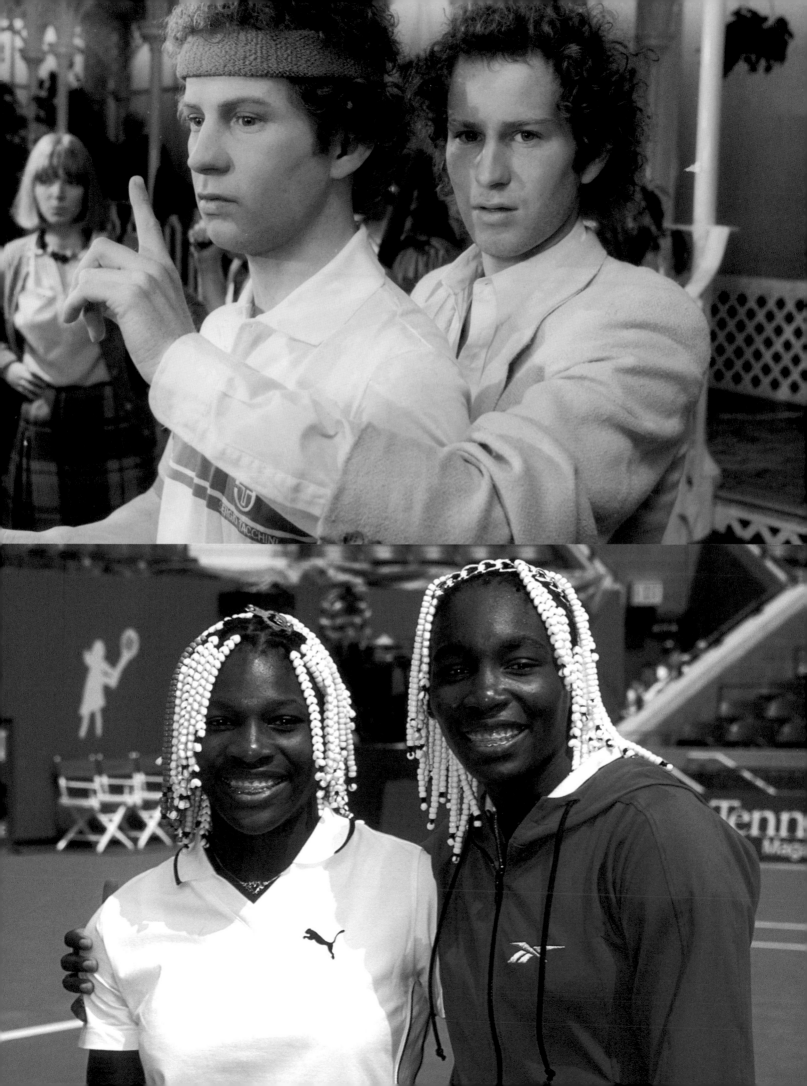

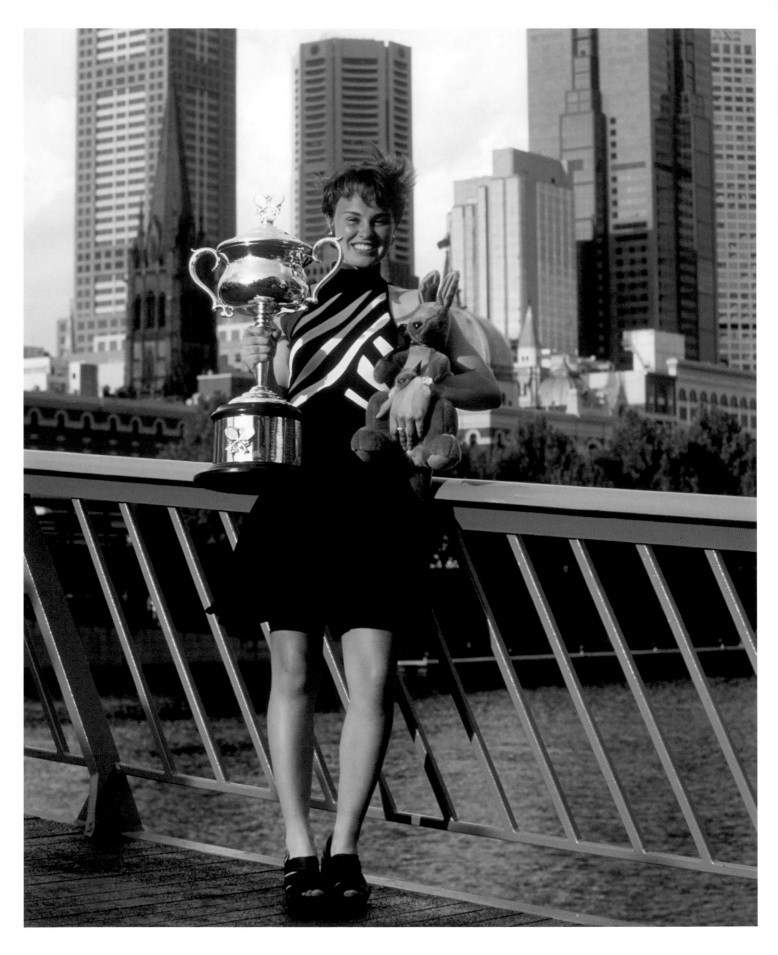

This page: *Martina Hingis shows off a trophy after winning her first Grand Slam title, 1997.* Opposite: *A youthful Boris Becker holds a trophy high over his head, 1987.*

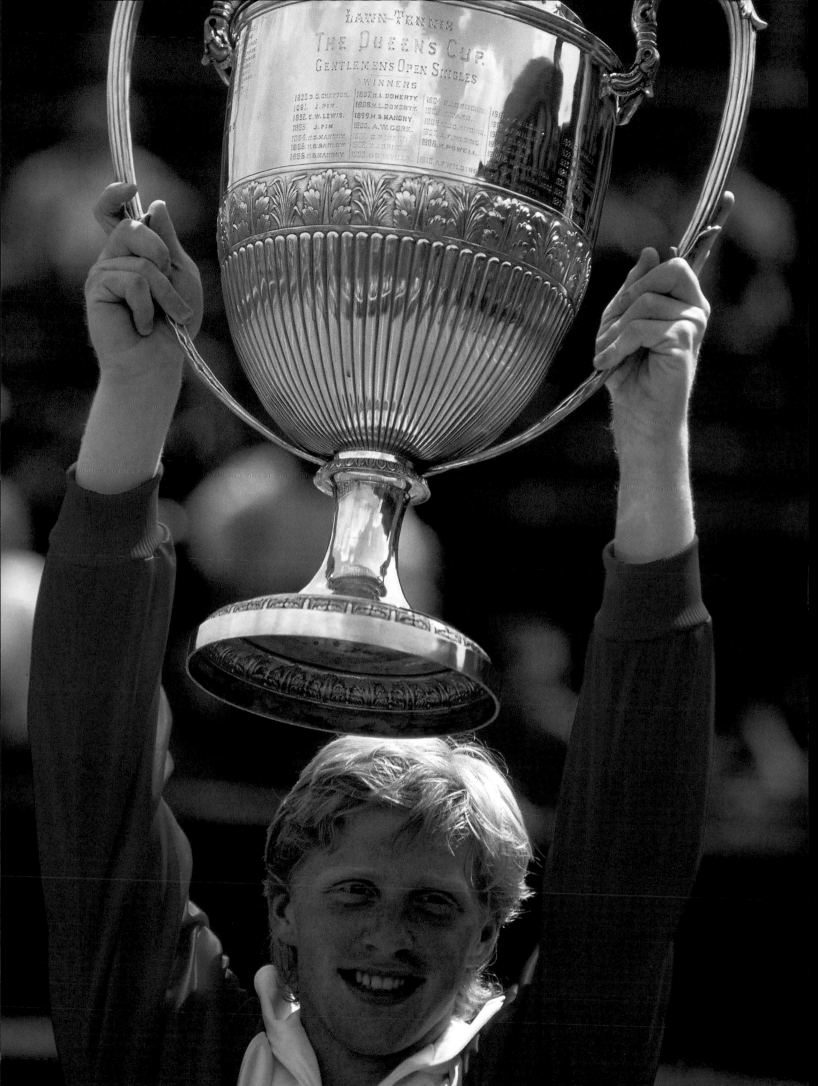

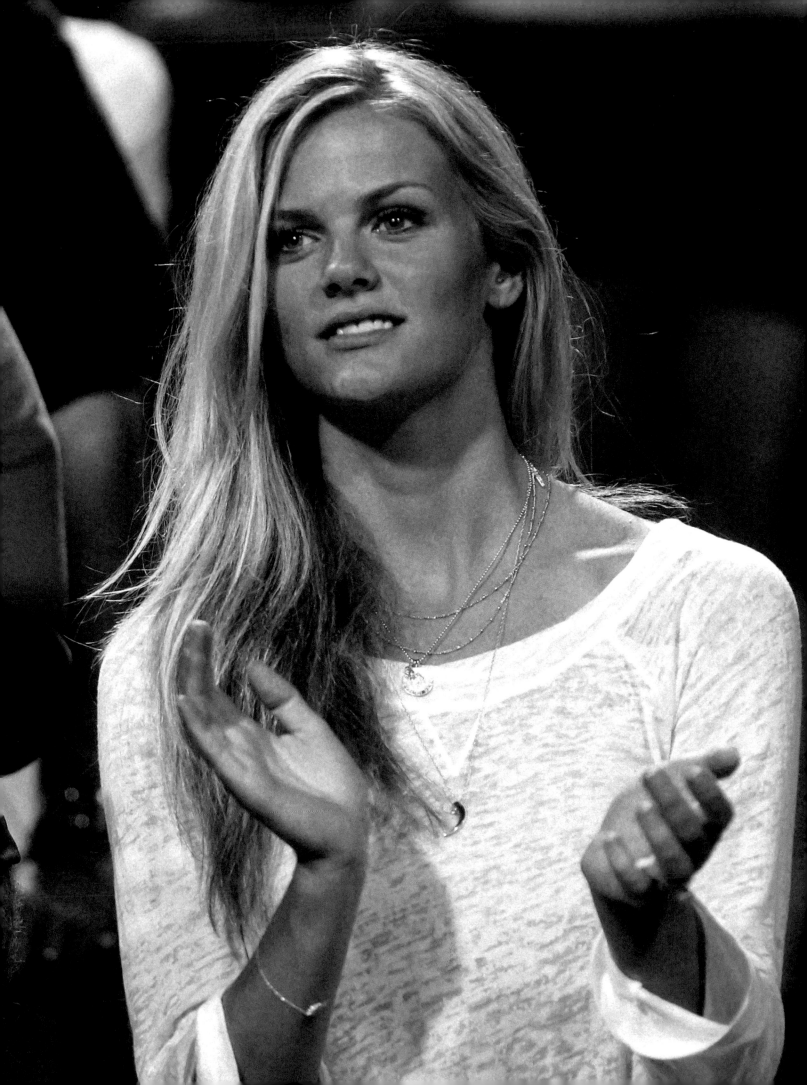

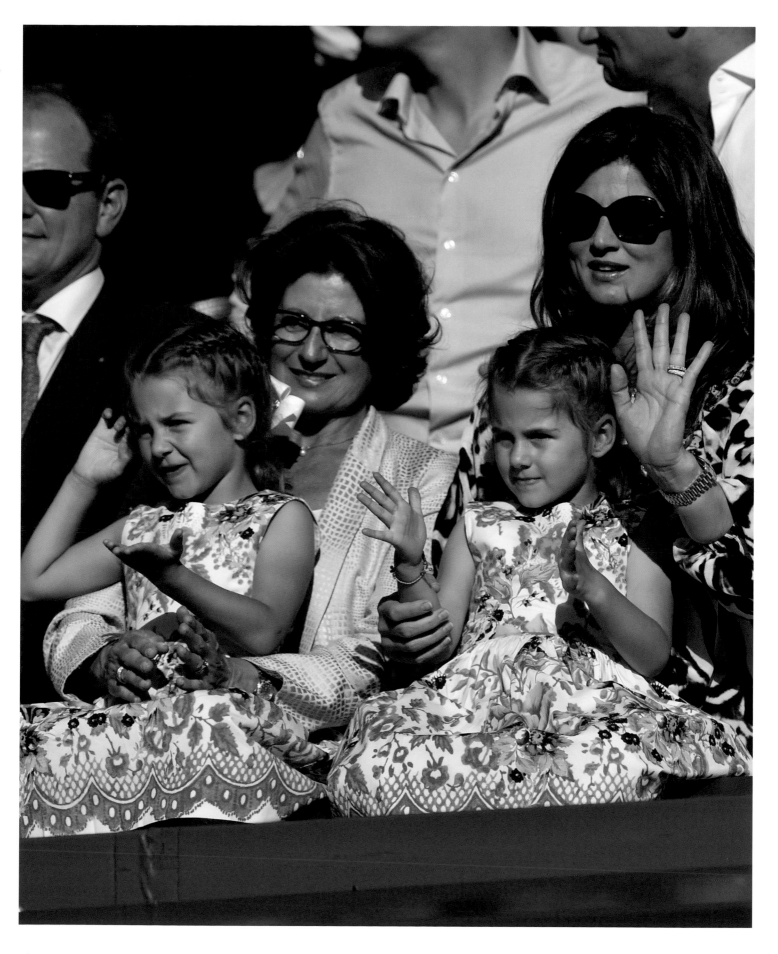

This page: *Roger Federer's family watching him play at the Wimbledon men's singles final, 2014.* Opposite: *Model Brooklyn Decker claps for her husband, Andy Rodick, during a 2009 match.*

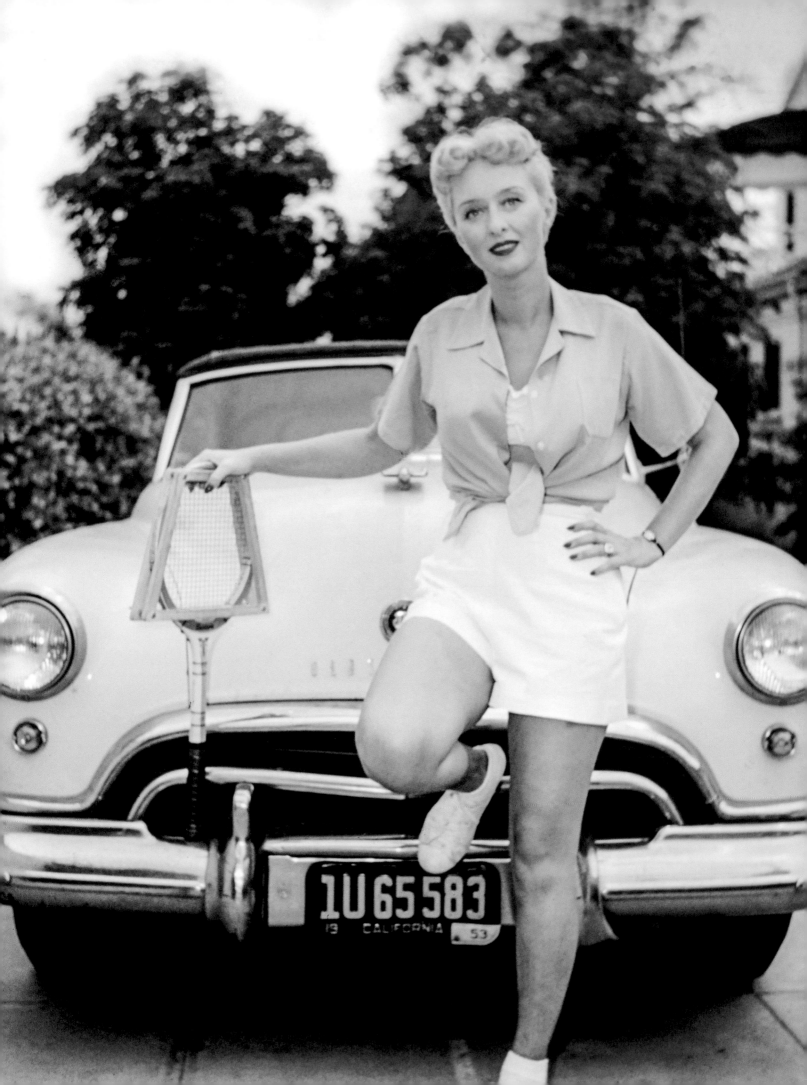

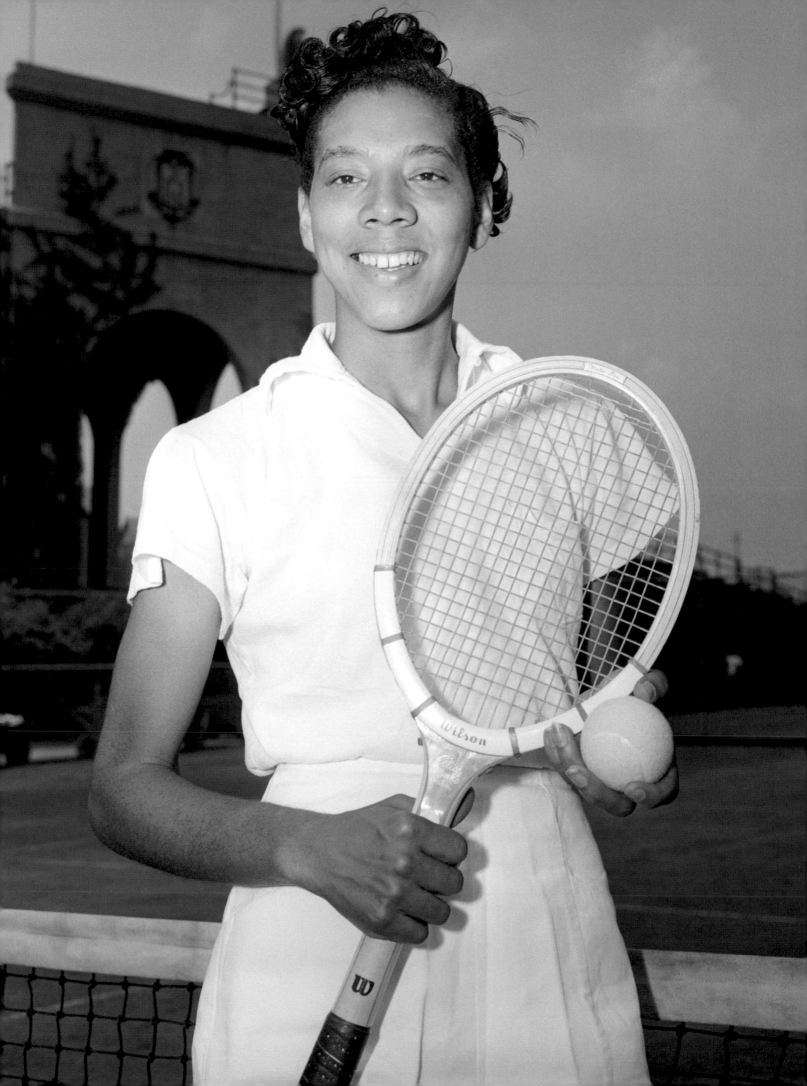

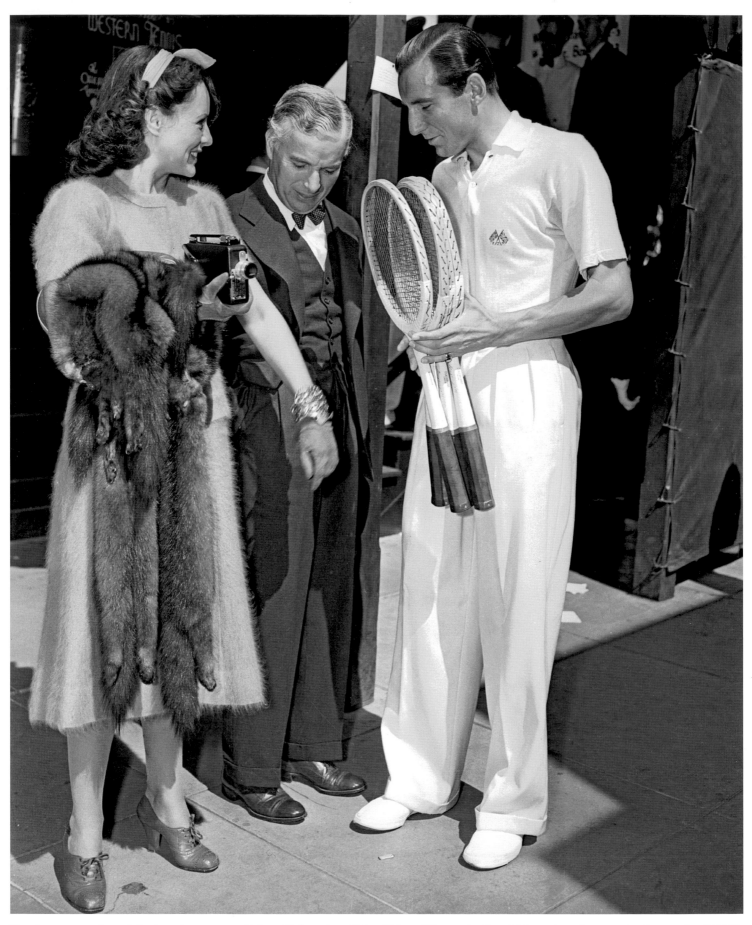

Previous pages, from left: *American actress Celeste Holm, circa 1950; Althea Gibson, the first African-American to play in a major USLTA competition, poses at the West Side Tennis Club in Forest Hills, New York, 1950.* This page: *Actress Paulette Godard, Charlie Chaplin (middle), and Fred Perry, circa 1935.* Opposite: *Ava Gardner embodies tennis chic, 1948.*

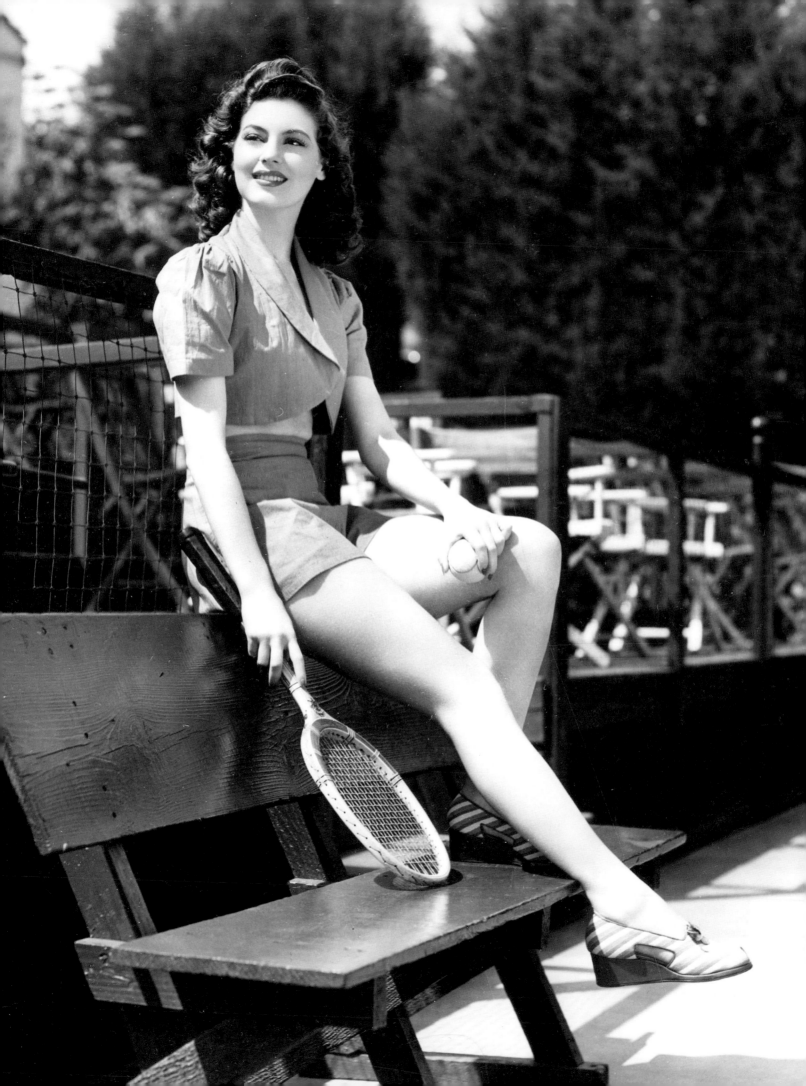

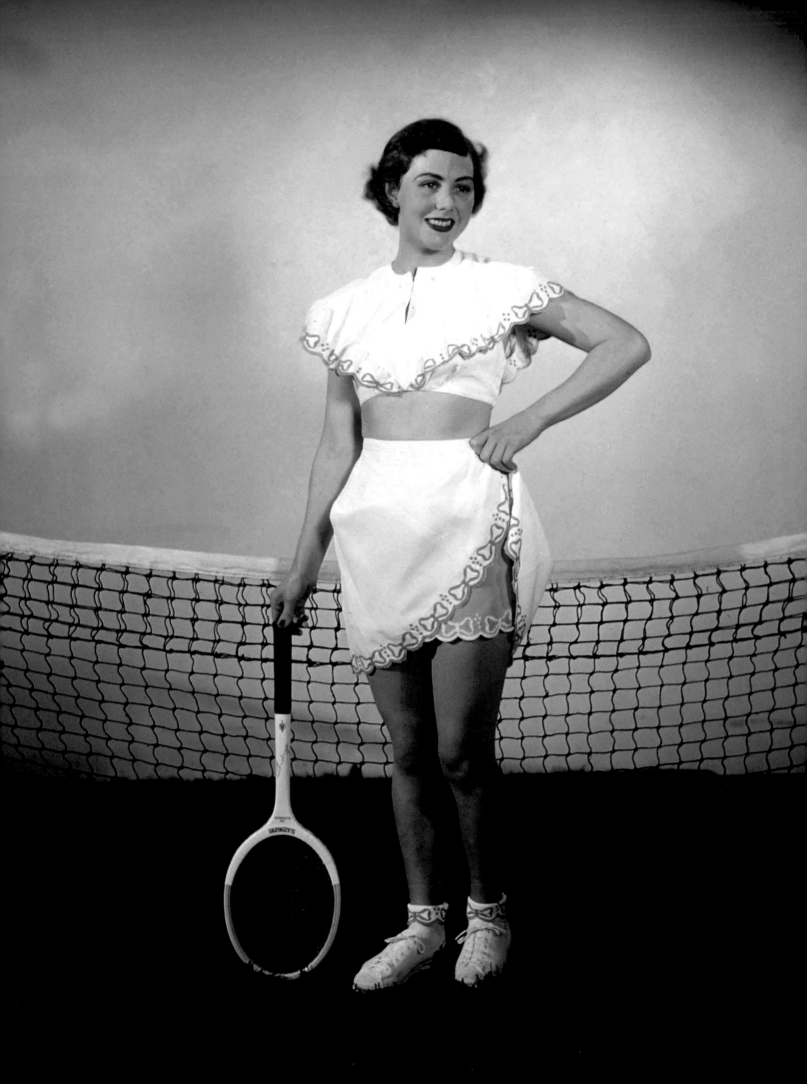

FASHION

THE DRESS CODE

When tennis first became popular in Victorian England, the clothing worn for playing matched the regular dress of the day. Collars were high, sleeves reached the wrist, and neckties were sometimes worn during play. Women wore long, sweeping skirts and men donned full-length flannel trousers. Ankles and wrists were never to be seen. Players boldly broke from tradition and changed the clothing to fit the sport's needs. And in so doing, they changed fashion and sportswear forever.

No tennis player was more instrumental in moving fashion forward than the French champion René Lacoste, one of the "Four Musketeers" who ruled during the heyday of French tennis. Unhappy with the cumbersome outfits that he and his fellow players wore in the 1920s, Lacoste pioneered a lightweight, short-sleeved shirt made of breathable cotton.

Lacoste's nickname, "The Crocodile," became his company's logo (he had the animal embroidered on his clothing even before launching the brand) and the crocodile was one of the first logos to be featured on the exterior of clothing. In 1933, Lacoste began mass-producing the shirts (also known as polo shirts). They quickly became iconic and crossed over into mainstream fashion as a menswear staple, casual but dignified, sporty but sharp.

Opposite: *A frilly tennis frock from the 1950s.*

Fred Perry—who for seventy-seven years stood as the last British man to win Wimbledon—followed in Lacoste's footsteps. After his retirement, Perry launched his own line of enduring sportswear in the 1950s that remains popular today, especially in Britain.

Lacoste was not the only player of his era to make an impact on fashion beyond the confines of tennis. His occasional doubles partner, Suzanne Lenglen—one of the most dominant yet enigmatic champions of all time—became an icon of women's fashion outside the realm of sportswear. Lenglen stunned crowds at Wimbledon in 1921 when she took to the court wearing a sleeveless cardigan, a skirt that went only slightly past her knee, and an orange headband.

Each of these innovations crossed over into popular women's fashion, as women in the 1920s flocked to mimic Lenglen's look during the flapper era. Lenglen's bold sartorial choices matched her personality; she played tennis with an emotional investment and flair that few women had ever dared to show before, and was notorious for sipping brandy during changeovers.

Still others found their own ways to use tennis as a springboard to influencing popular fashion and culture. Bill Tilden, a towering American player nicknamed "Big Bill," was a tall, handsome champion of the 1920s whose elegance on court led to work as an actor on stage and screen. Whether they played tennis or not, men copied Tilden's clothing choices, most commonly his white V-necked sweaters over collared shirts, paired with white trousers. Tilden became one of the first examples of how tennis wear became used by those with no connection to the sport as a wearable embrace of its style and sophistication.

Tennis also had a profound impact on athletic and casual footwear. Some of the top sneaker manufacturers, including Converse, first branched out into athletic shoes for use in tennis. Tennis champions have often been used to market tennis shoes, including the Stan Smith model of Adidas shoes that still remains popular decades after Smith's career ended.

Today, tennis clothing is seamlessly integrated into popular fashion—an unmistakable representation of "preppy" polish in class. Though they have long been replaced by newer models, wooden tennis racquets are still used by designers and photographers as props, immediately connoting a lifestyle of leisure and luxury.

Aside from using tennis as a source of inspiration, some popular designers have fully plunged into modern tennis apparel. British designer Stella McCartney has her own line of uniquely ultra-feminine clothing for Adidas, which uses ruffles and a uniquely muted color palette to give a softer look to the select players who wear it, including Danish star Caroline Wozniacki.

Fashion isn't only for tennis stars. With no team uniform to abide by, every person who picks up a racquet has an opportunity to express themself through what they wear. Whether choosing classically elegant in traditional whites or donning bold colors, the court is a stage on which anyone can feel like a fashion icon in their own right.

Following pages, from left: *Tennis fashions from the early 1900s; a woman dressed in a hat and formal dress plays tennis in the South of France, 1906.*

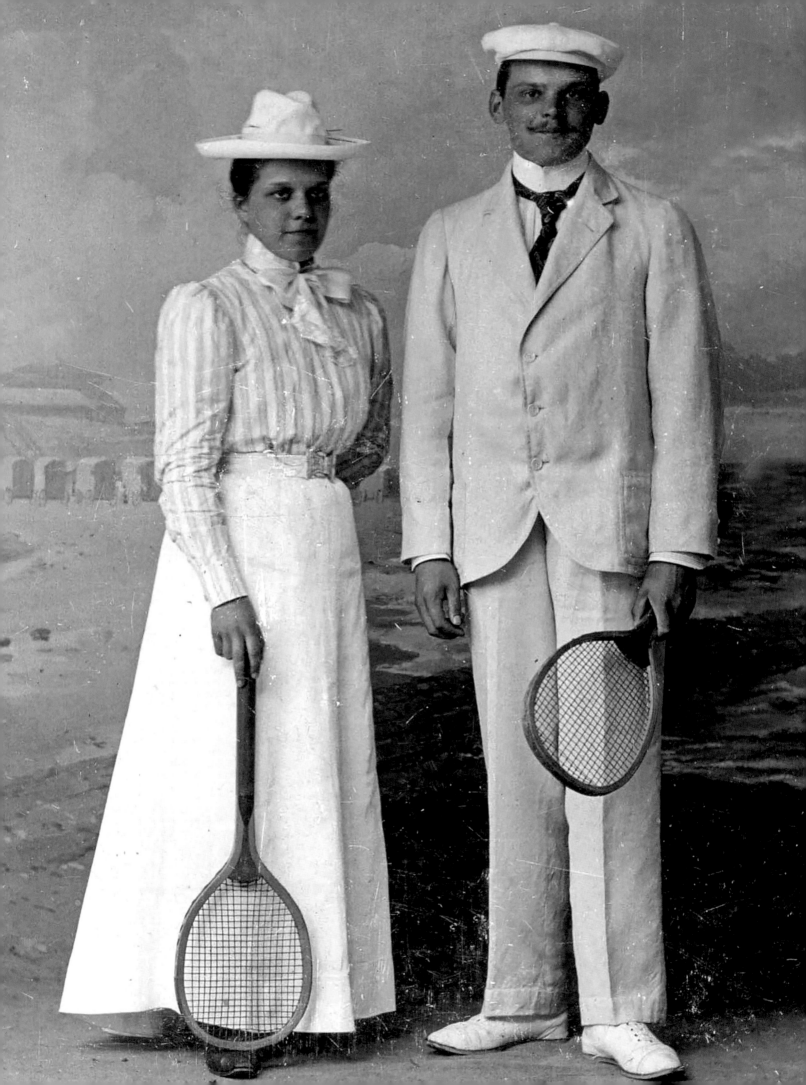

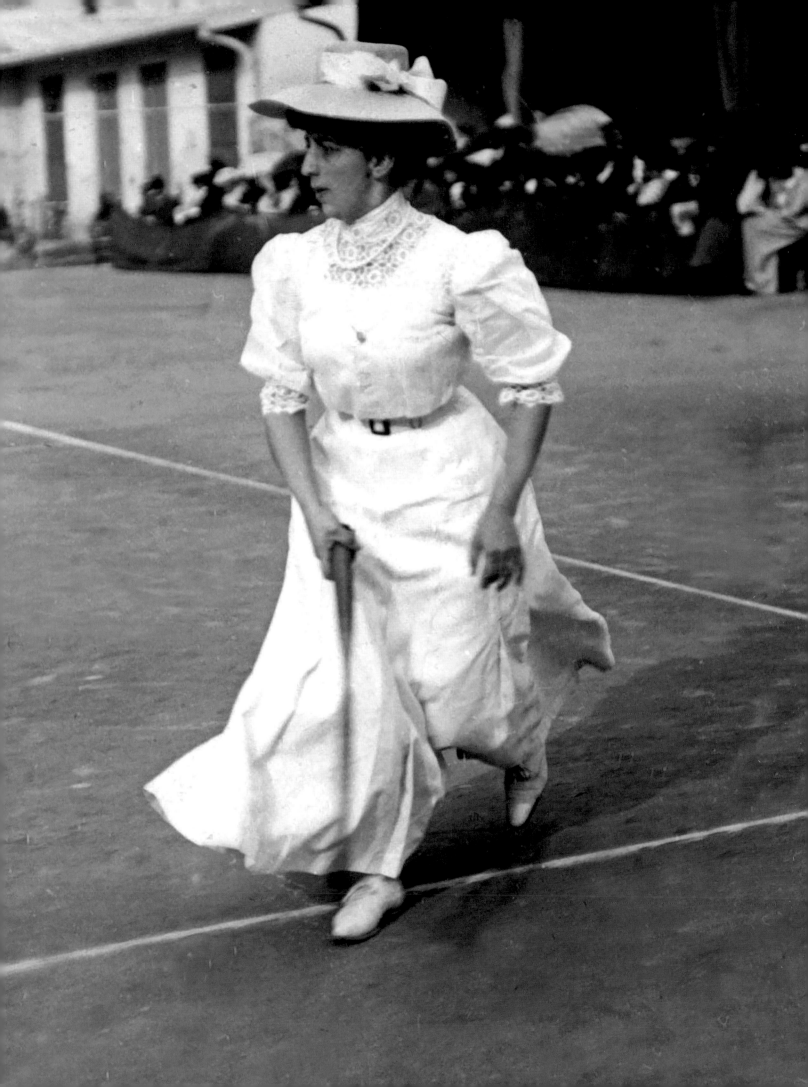

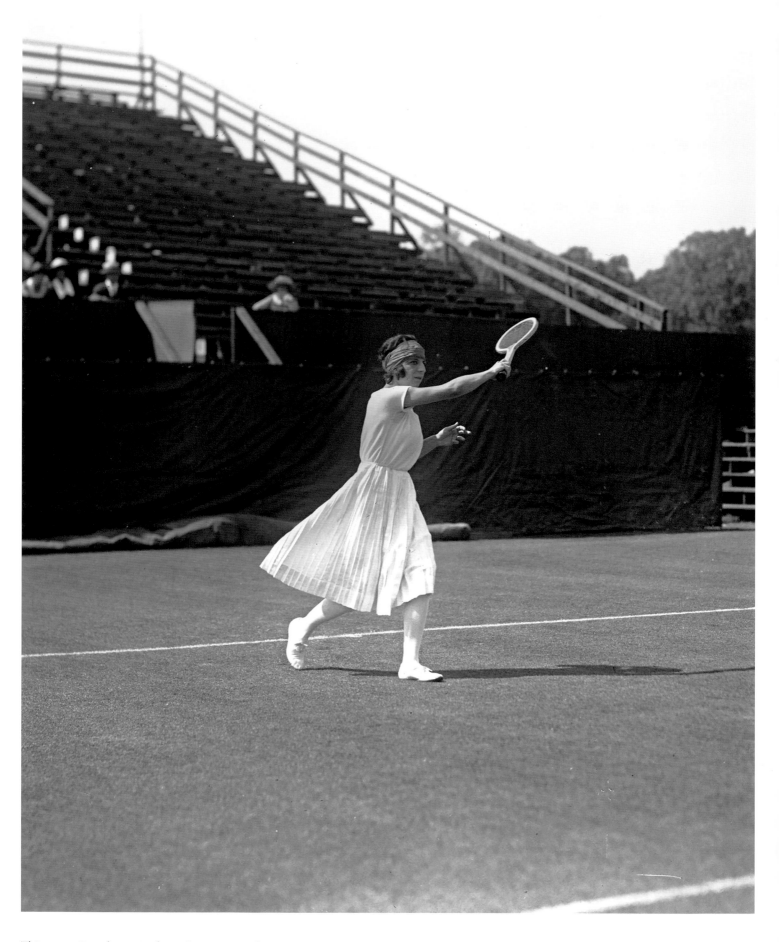

This page: *French tennis player Suzanne Lenglen in action, circa 1920.* Opposite: *Queen Mary of England bestows Lenglen with Wimbledon's Medal of Jubilee.*

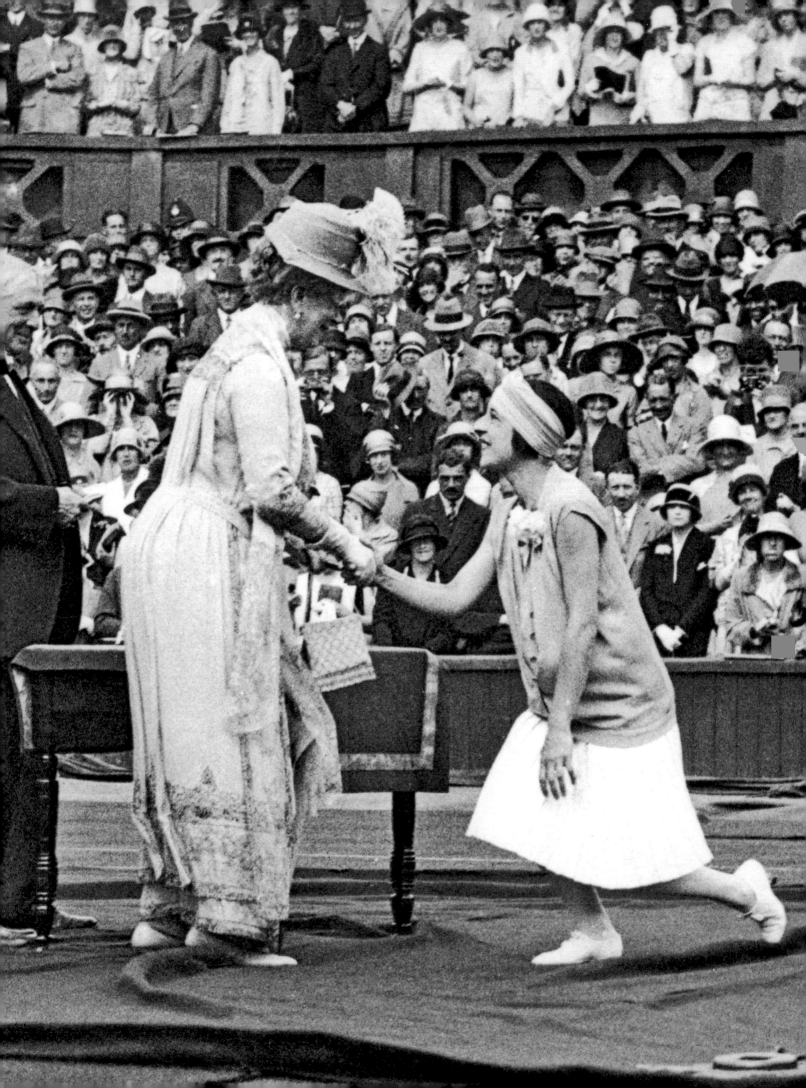

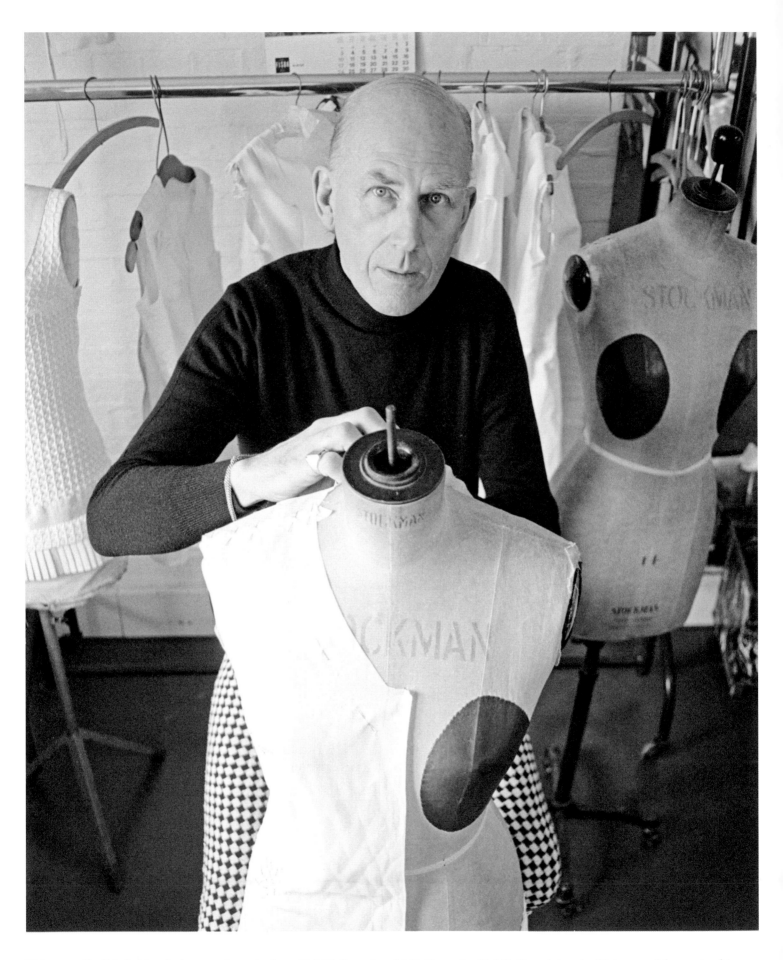

This page: *English fashion designer and tennis player Ted Tinling, circa 1963.* Opposite: *Ted Tinling pictured with two models wearing his designs, 1962.*

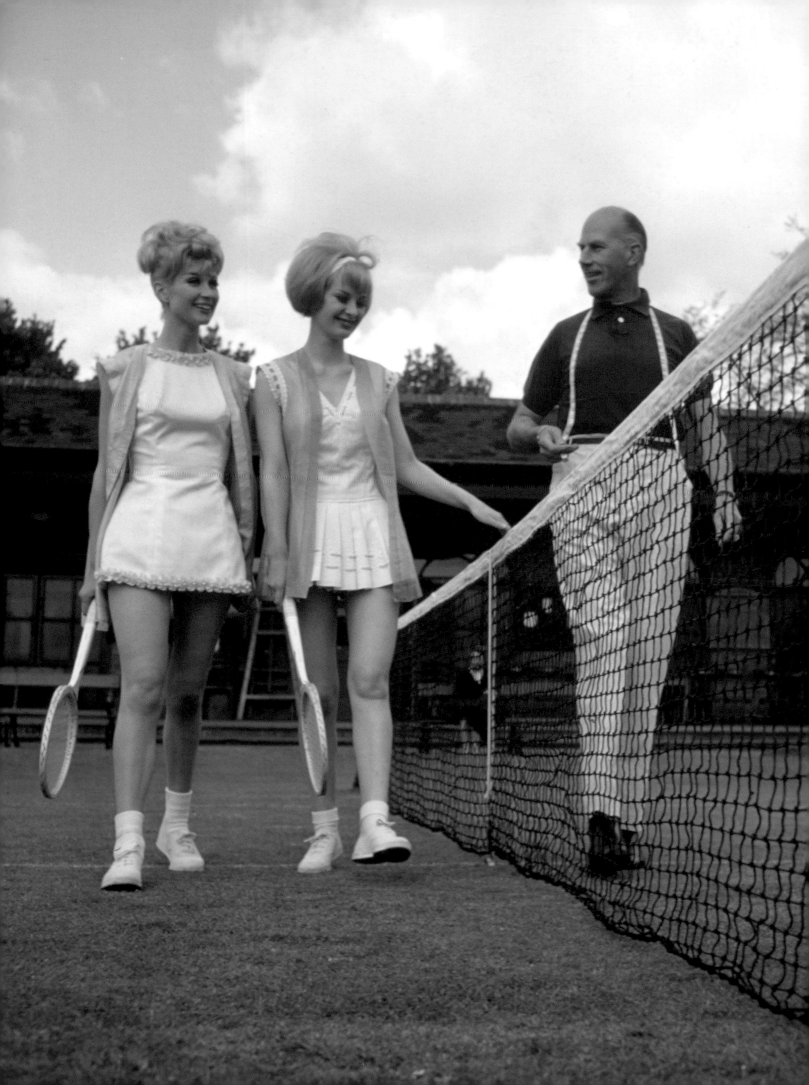

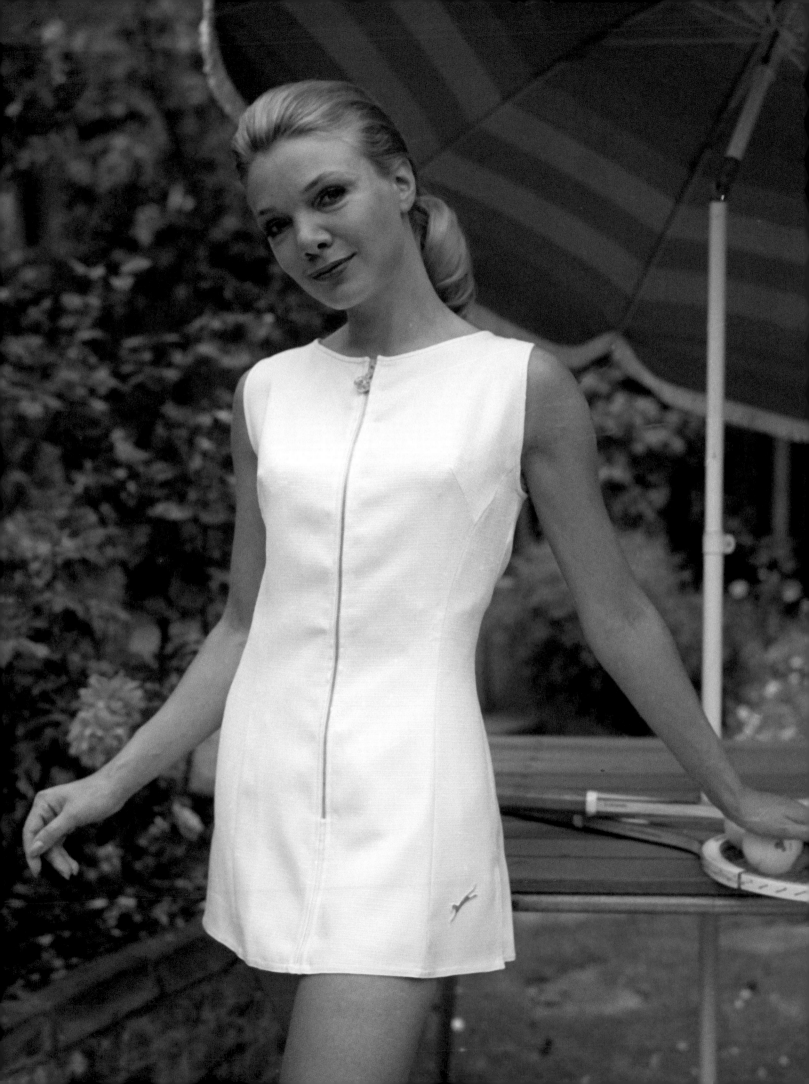

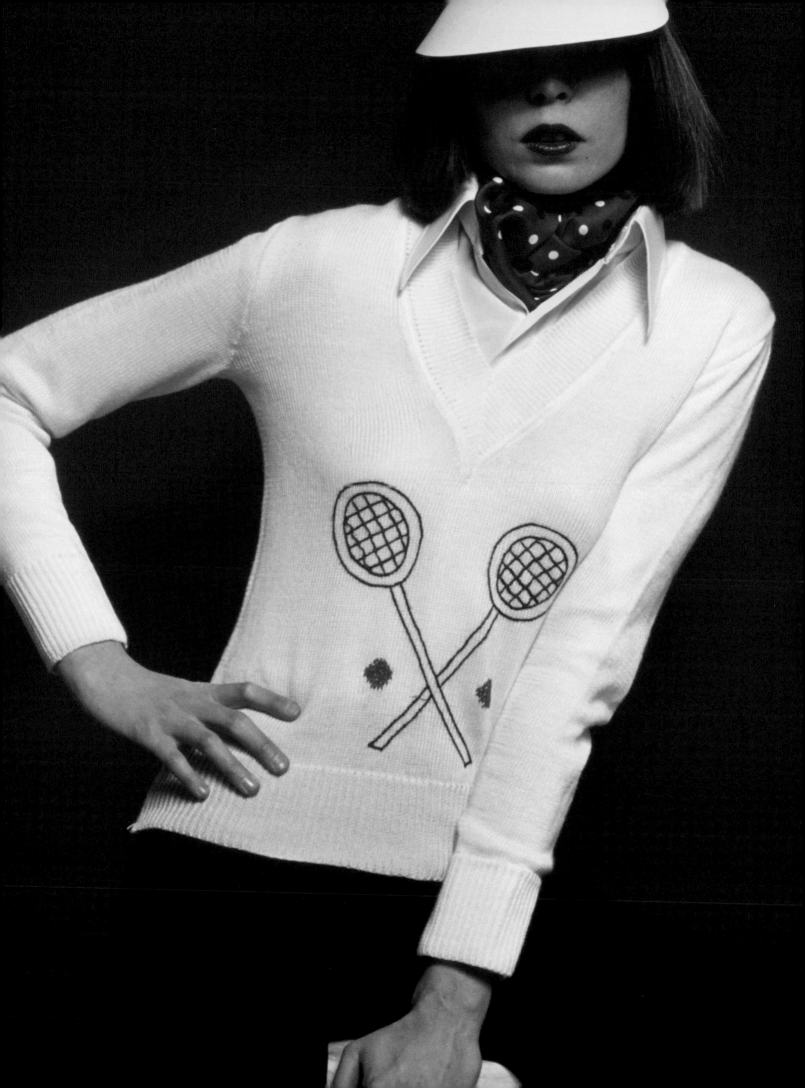

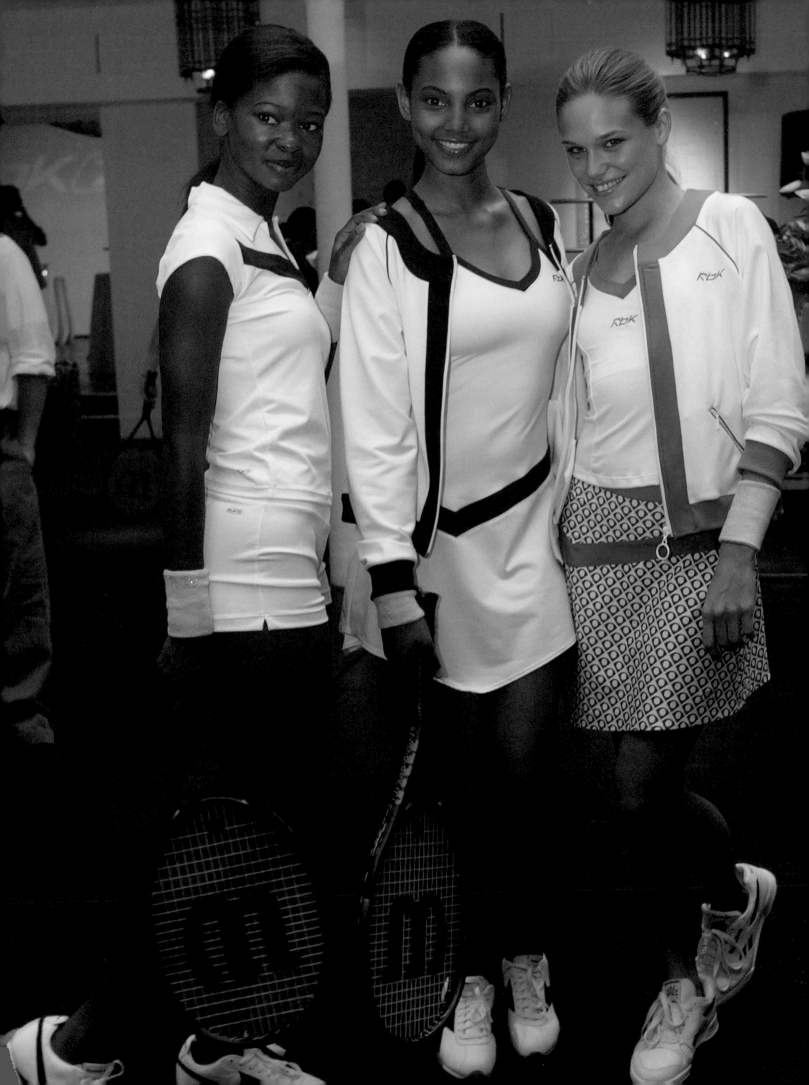

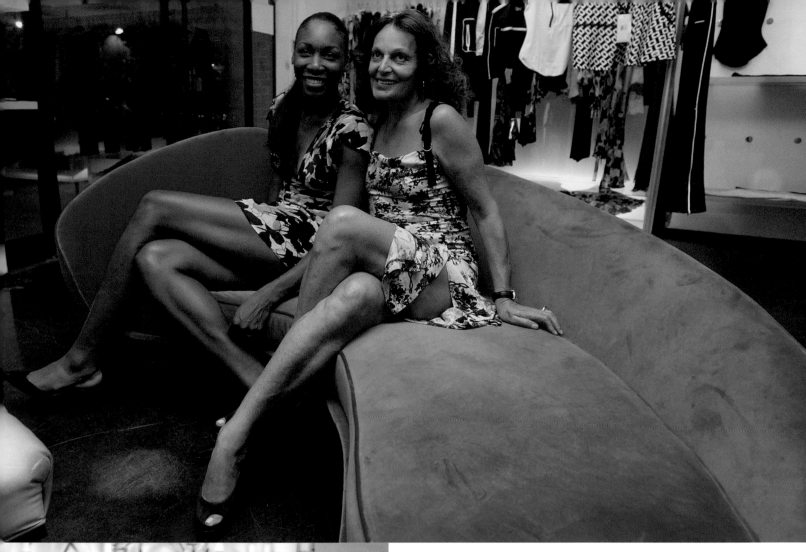

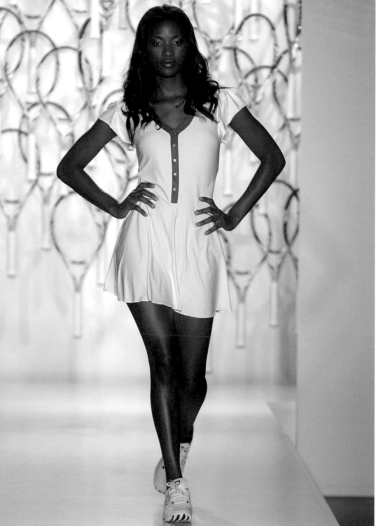

Previous pages, from left: *A model in a sleek tennis dress featuring a gold zipper front, 1966; a knitted sweater with a tennis racket motif, 1973.* Opposite, clockwise from left: *Models wear outfits from the RBK Tennis Line by Diane von Furstenberg, 2003; Venus Williams and Diane von Furstenberg at the RBK Line's launch party; a model at the Wilson Racquet Sports fashion show in New York, 2011.*

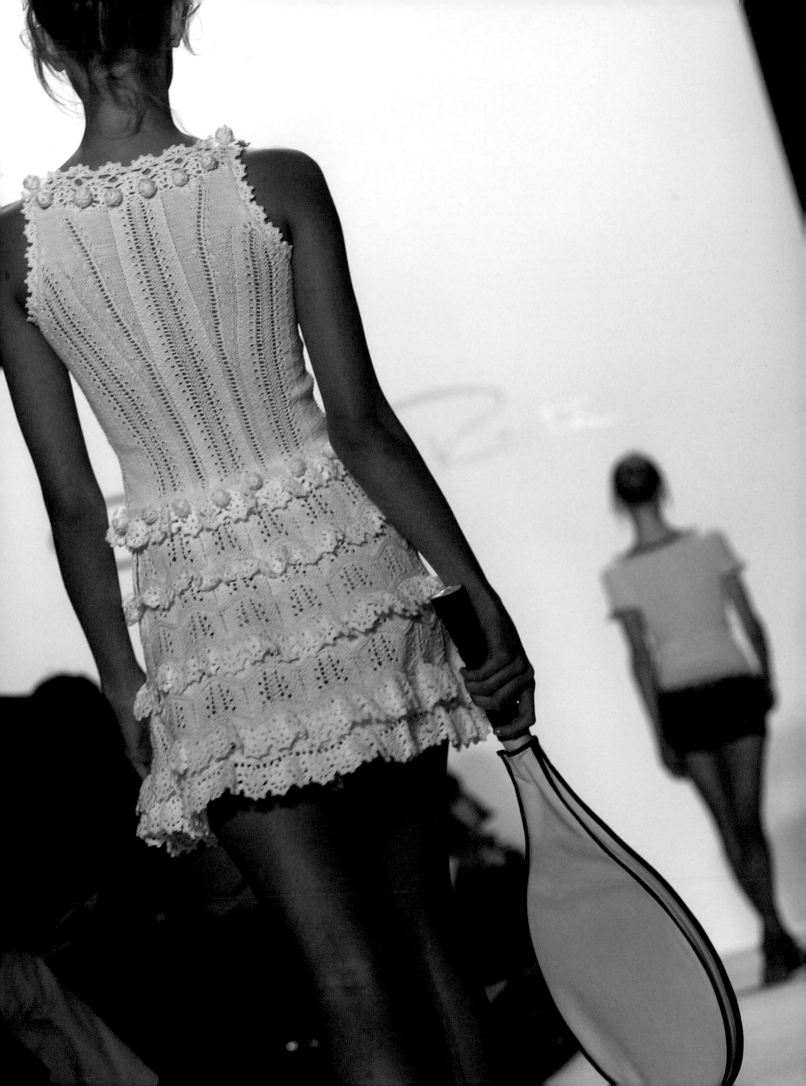

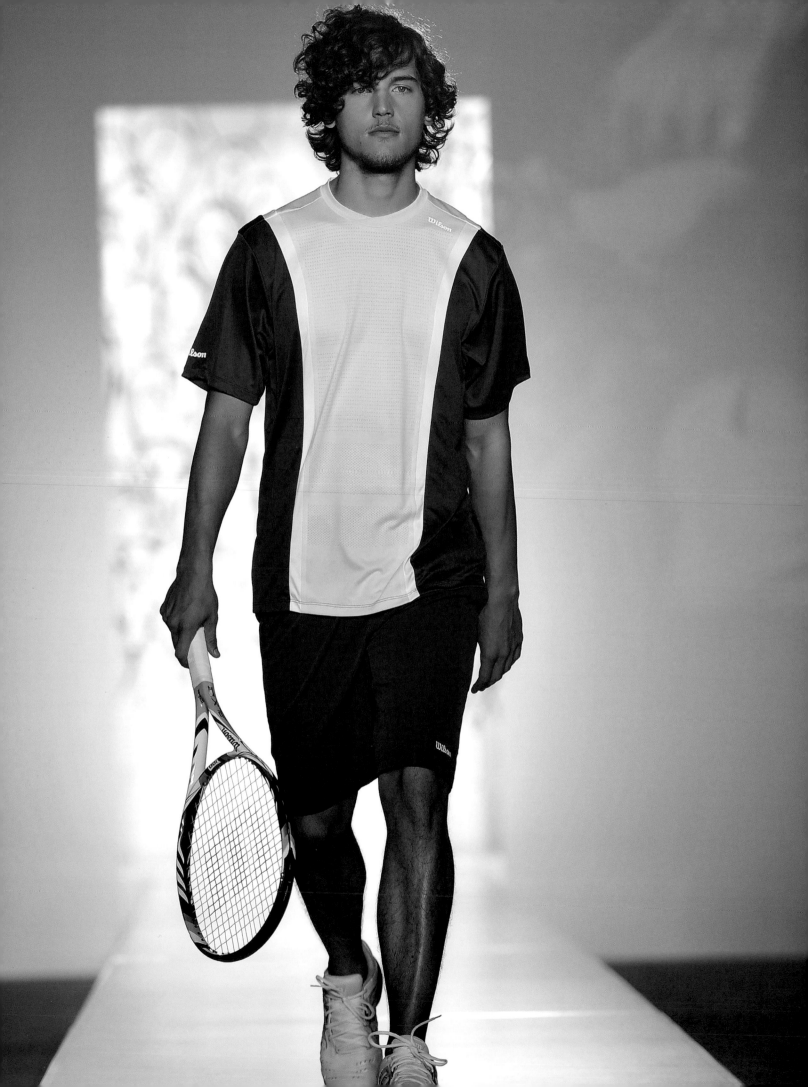

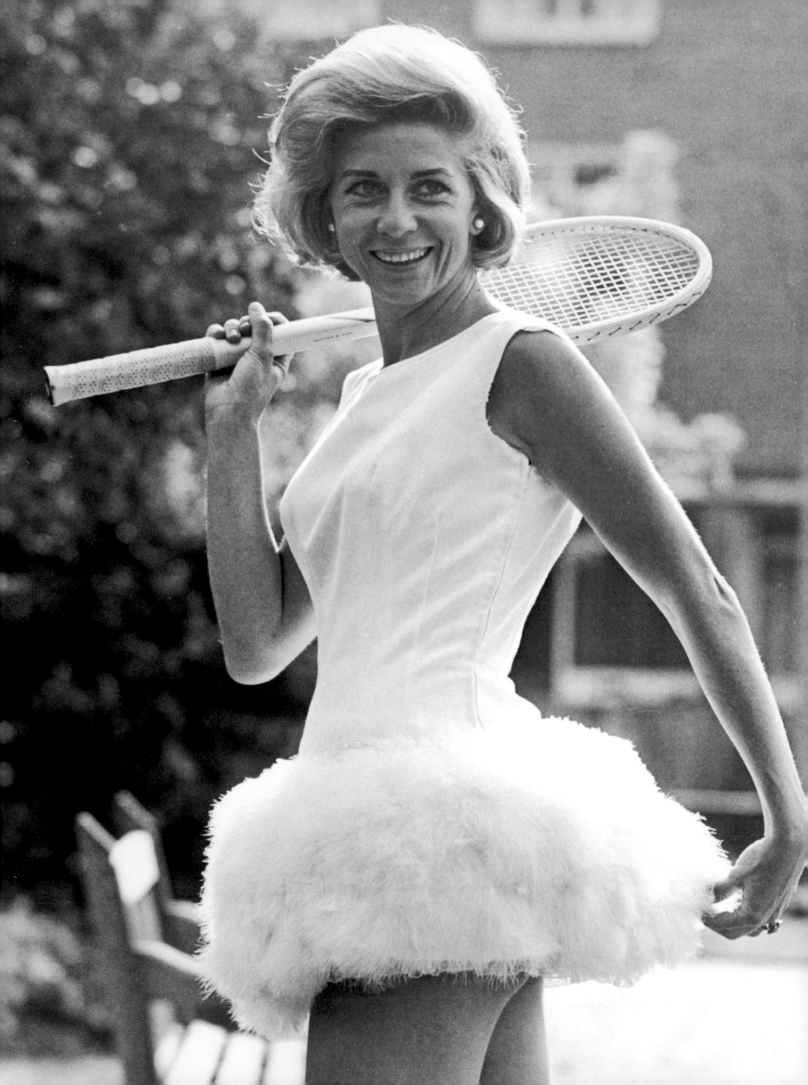

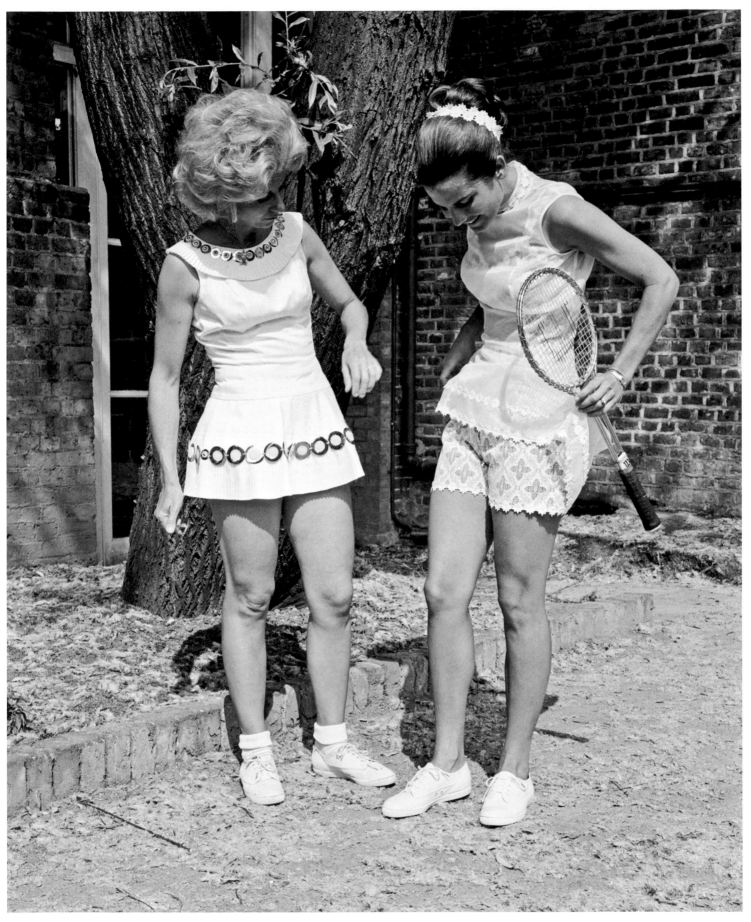

Previous pages, from left: *Tennis-inspired looks at Oscar de la Renta's spring 2005 fashion show; men's tennis fashion on display at the 2011 Wilson Racquet Sports fashion show.* This page: *Lea Pericoli and Carol Kalogeropoulos model extravagant tennis wear at the Belvedere Restaurant in London, 1970.* Opposite: *Pericoli sports a whimsical tennis dress trimmed with feathers, 1964.*

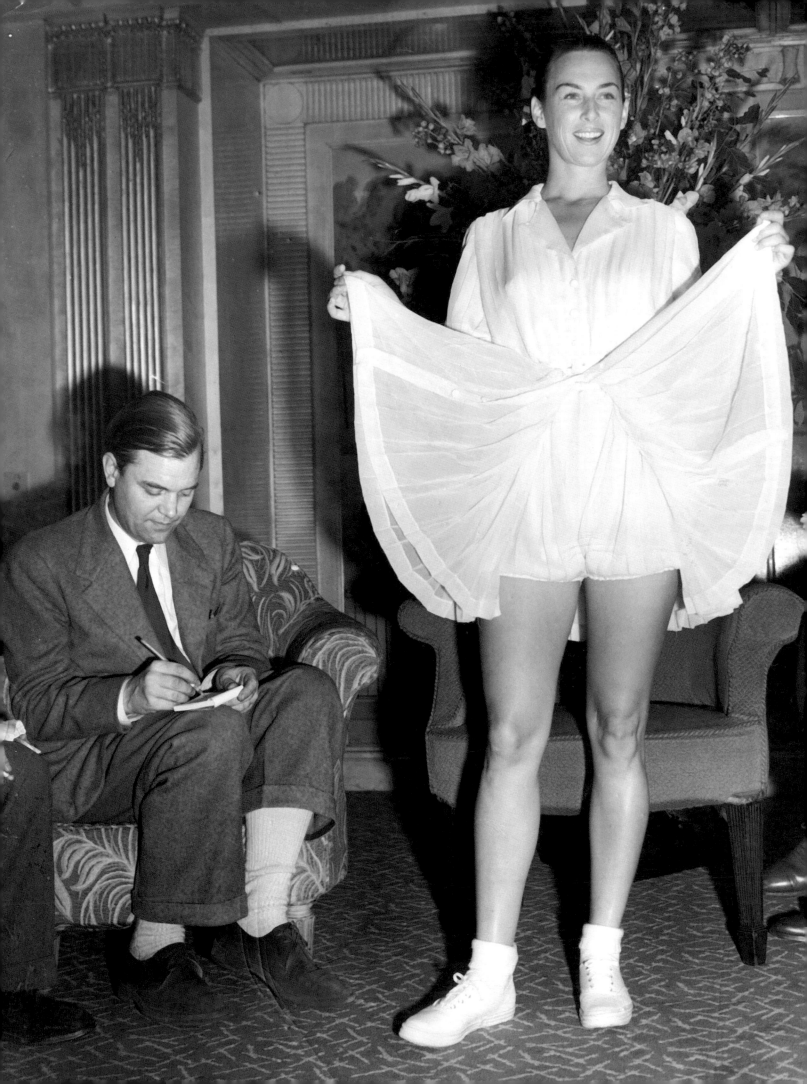

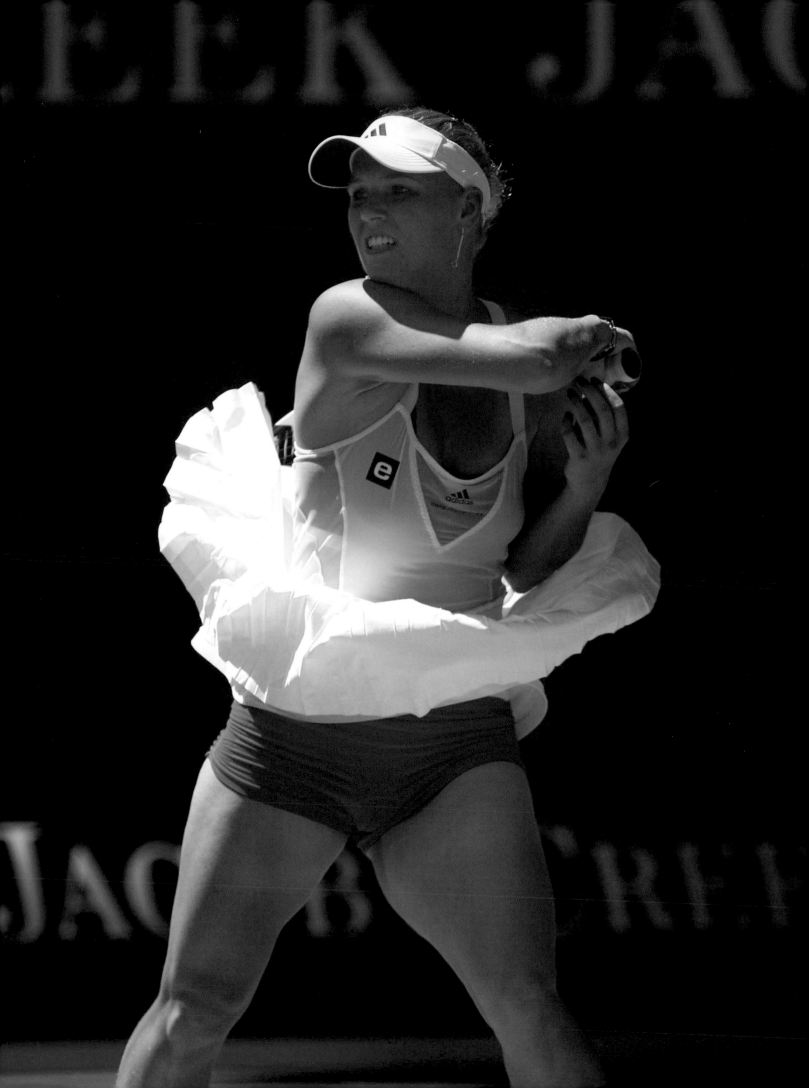

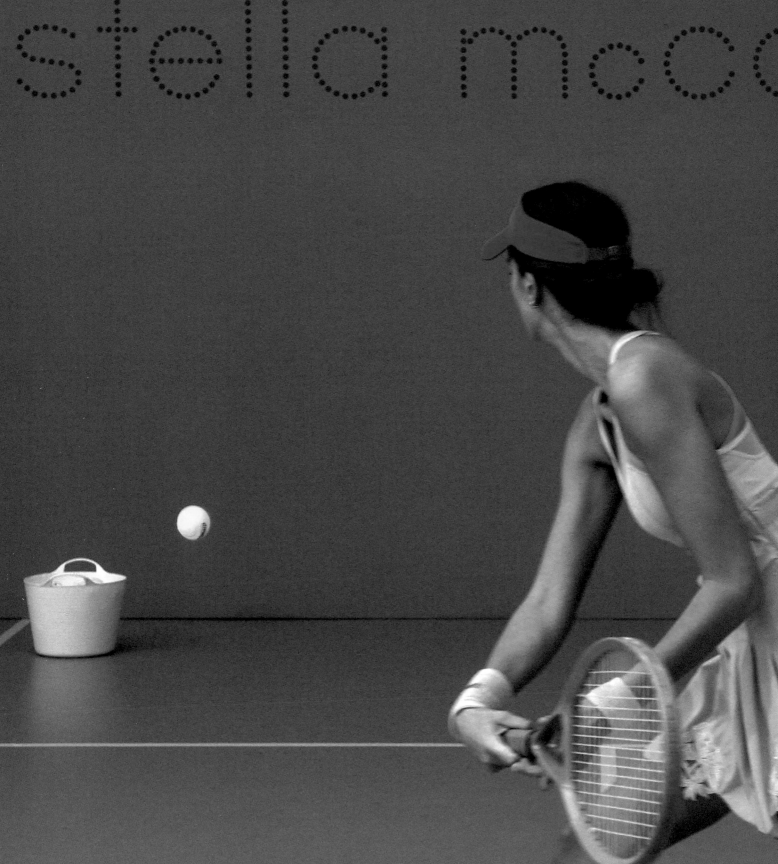

Previous pages, from left: *Pierre Balmain specially designed this bloomer-esque tennis outfit for Gertrude "Gussie" Moran, circa 1950s; Caroline Wozniacki in a Stella McCartney outfit at the 2011 Australian Open.* Opposite: *A model plays tennis at the Adidas by Stella McCartney fashion show in London, 2008.*

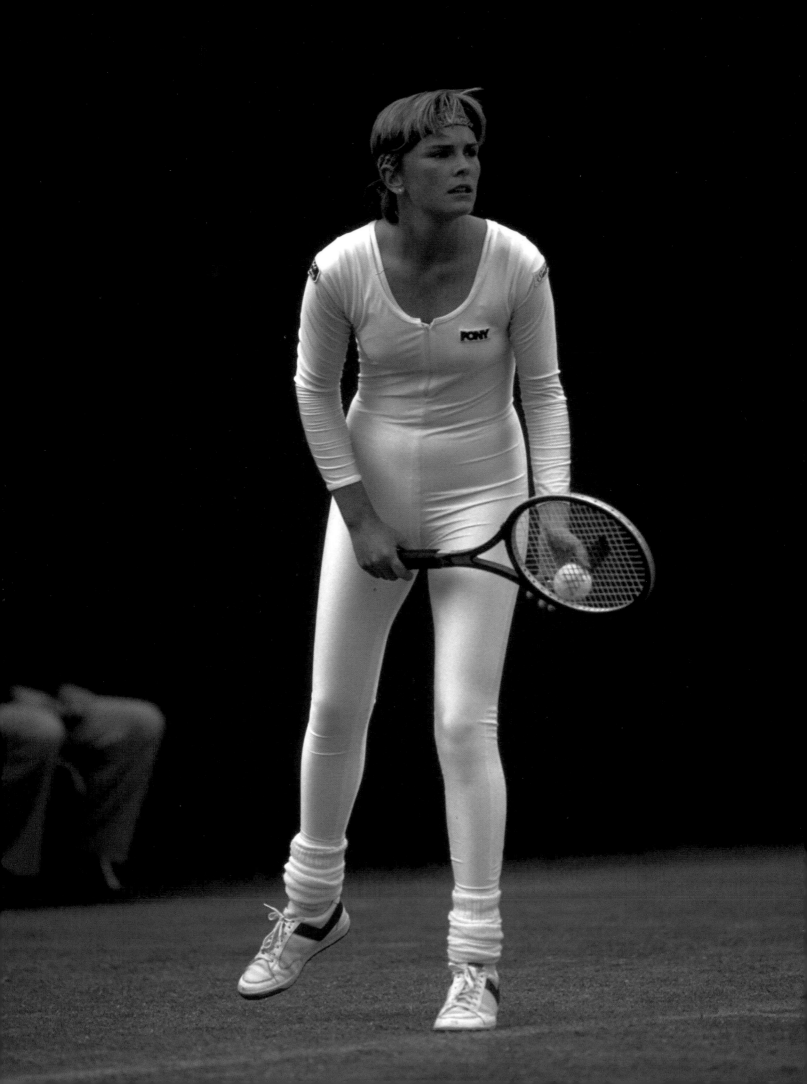

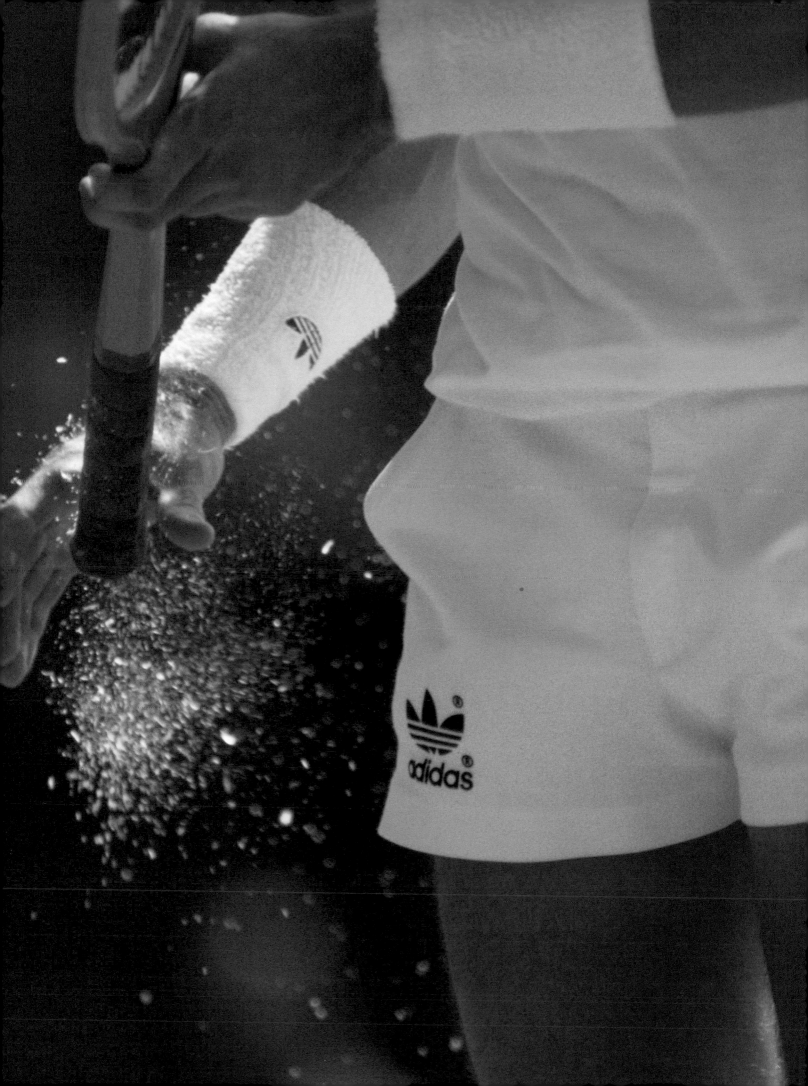

Previous pages, from left: *Player Anne White exemplifies 1980s tennis style with a one-piece tennis outfit; Ivan Lendl wears shorter-than-short tennis shorts at Wimbledon, 1987.* Opposite: *Tennis legend Stan Smith in the Adidas showroom in Milan, Italy, 2008.*

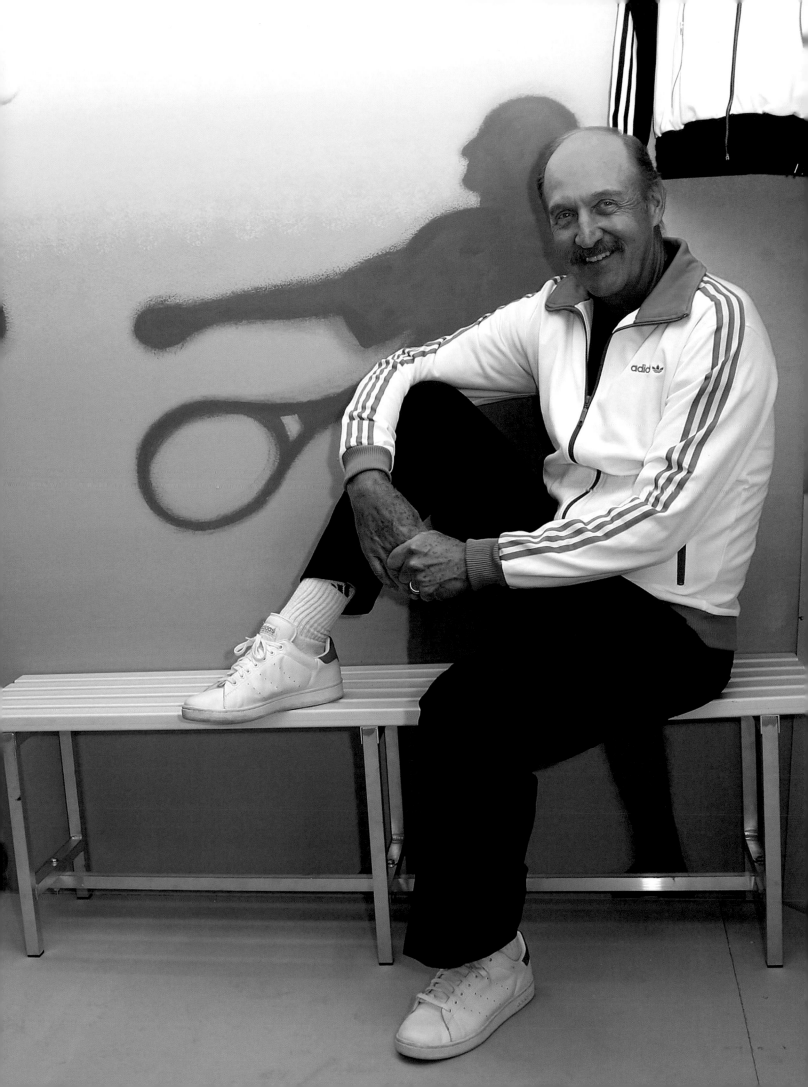

Clockwise from left: *Ralph Lauren regularly designs the preppy outfits for Wimbledon; Catherine, the Duchess of Cambridge, greets ball boys and girls at the Wimbledon Championships, 2019; detail of a Wimbledon jacket designed by Ralph Lauren.*

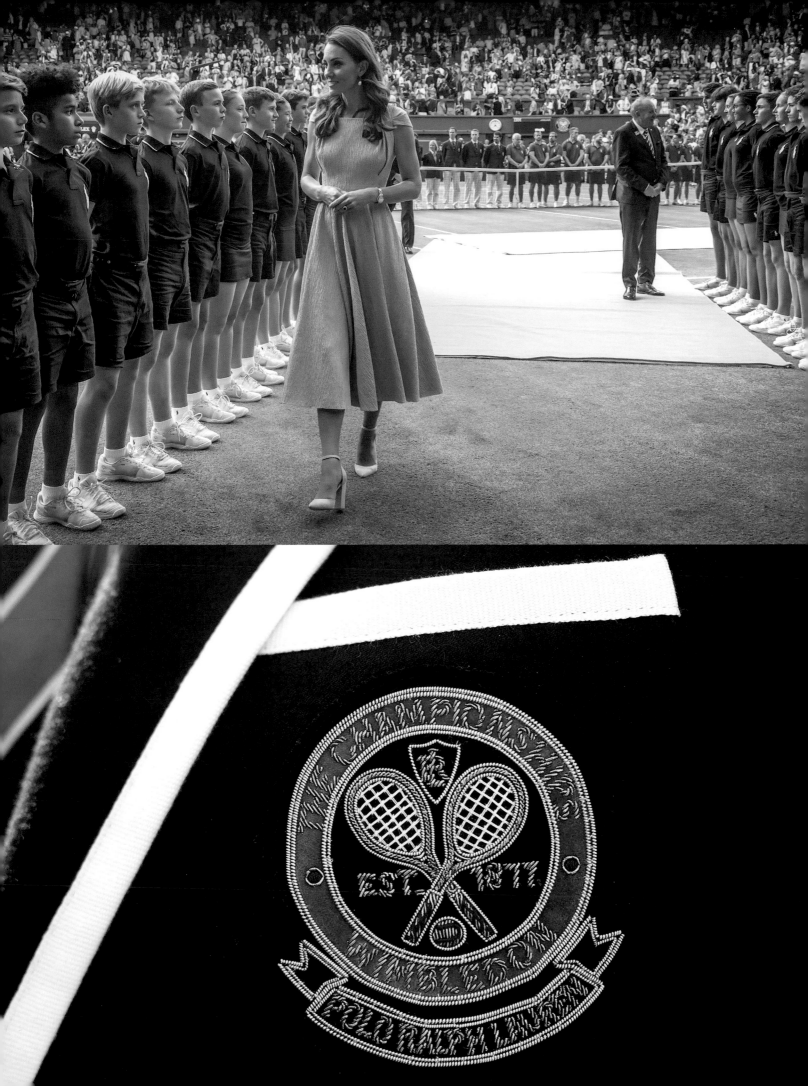

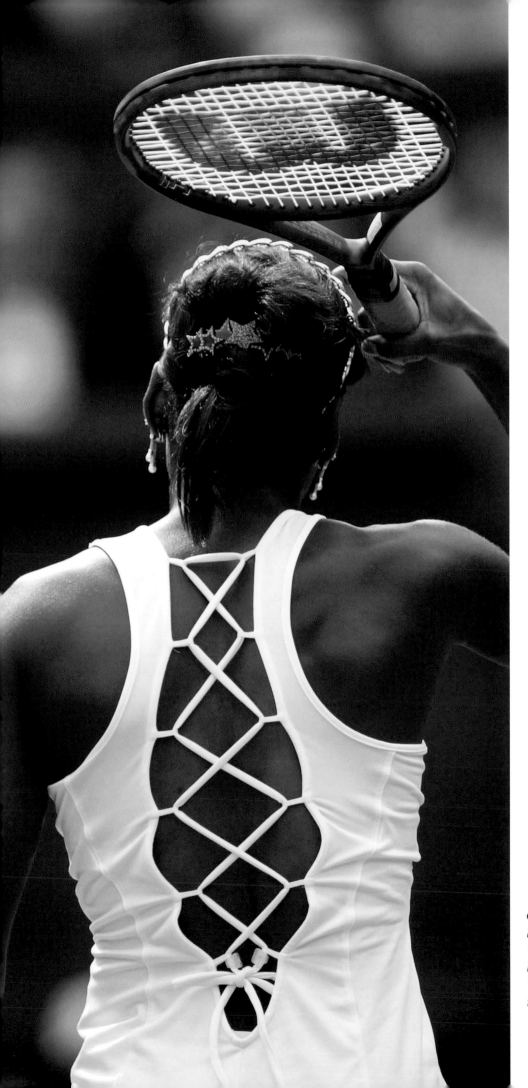

Clockwise from top left: *Serena Williams boasts a glittery manicure during the 2013 Wimbledon Championships; the detailed back of Venus Williams frock of choice at Wimbledon, 2003; bold-hued shoes seen at the 2009 U.S. Open.*

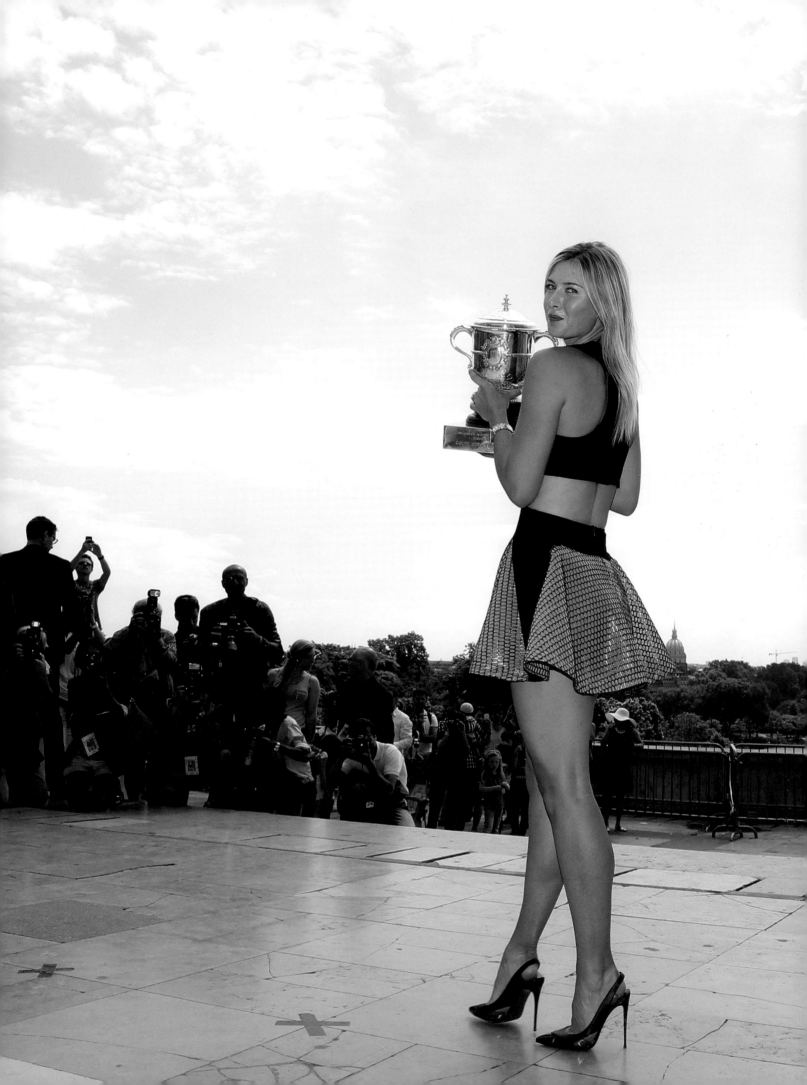

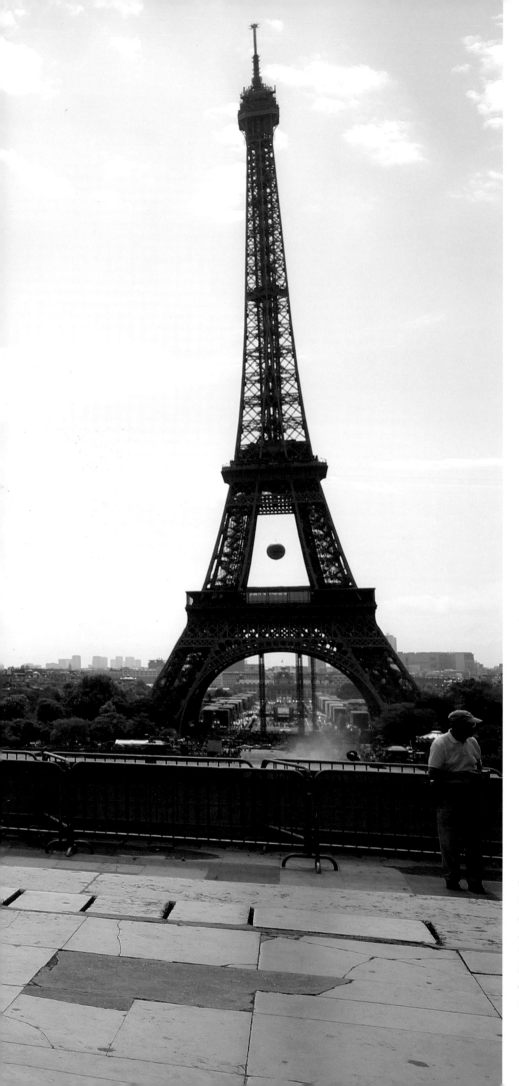

Opposite: *A stylish Maria Sharapova poses in front of the Eiffel Tower with the Coupe Suzanne Lenglen that she won at the 2014 French Open. Following pages, from left: Champion Kay Stammers wears a chic leopard-print coat off the tennis court, 1936; Serena Williams also wears a leopard-print top at an event with Anna Wintour in 2014.*

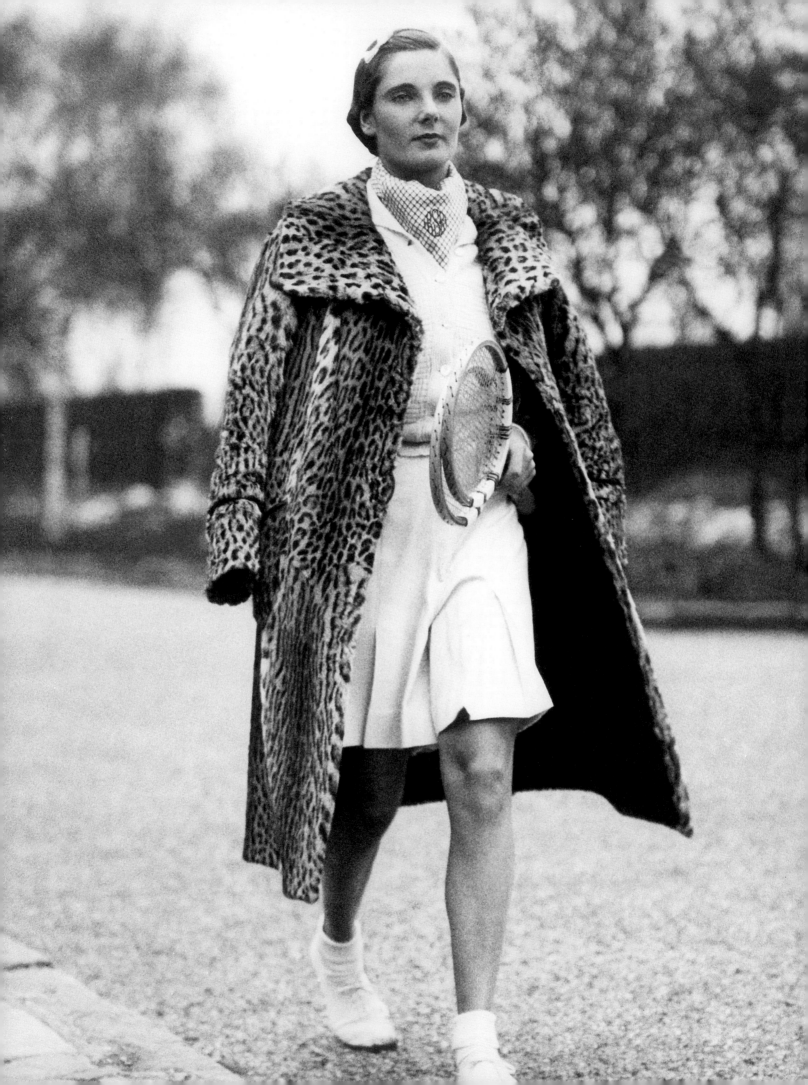

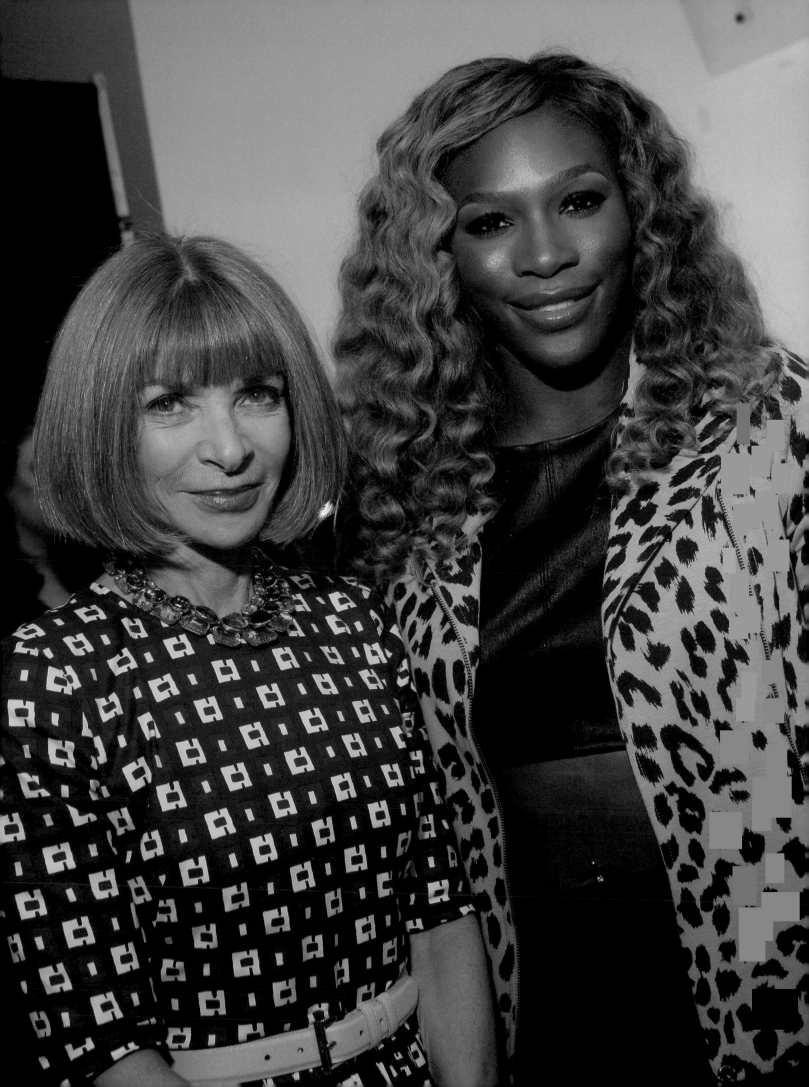

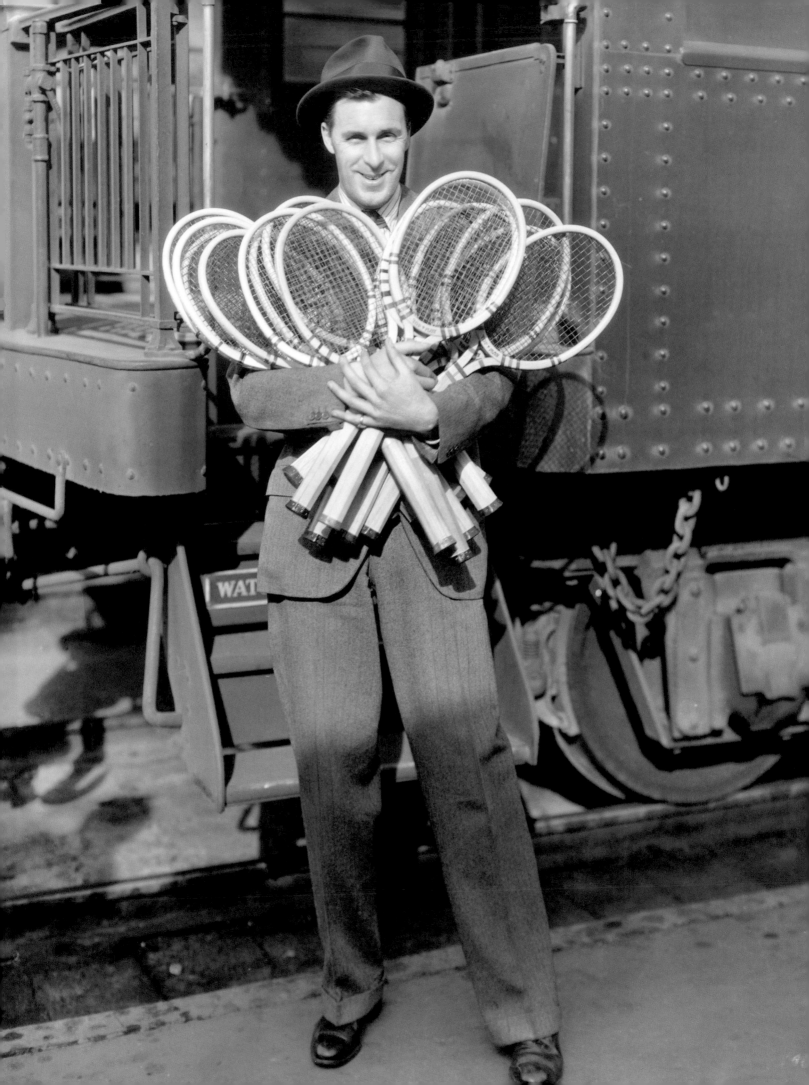

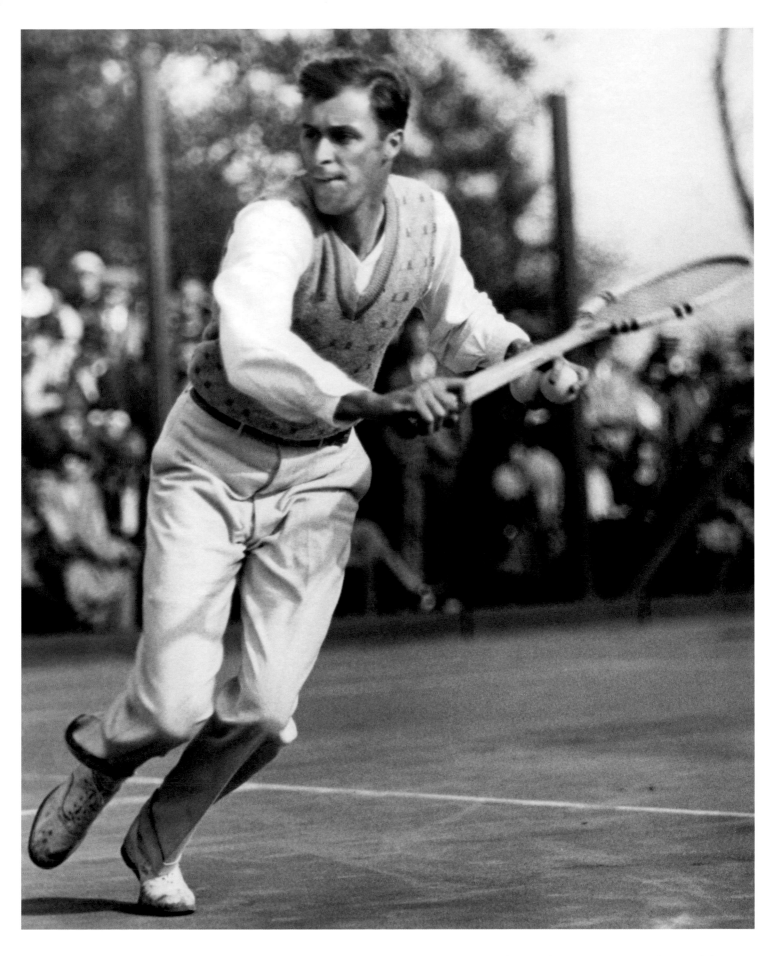

This page: *Bill Tilden embodies dapper tennis style while playing a match at the New York Athletic Club, 1925.* Opposite: *Tilden with his hands full with tennis rackets.*

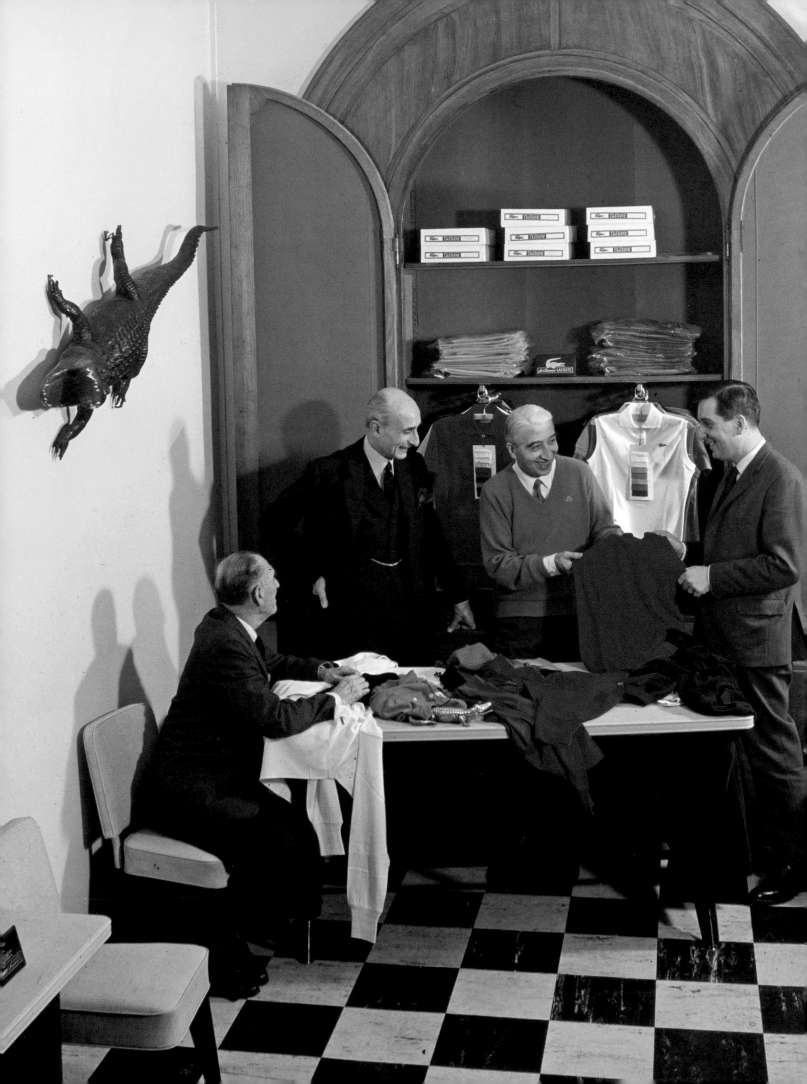

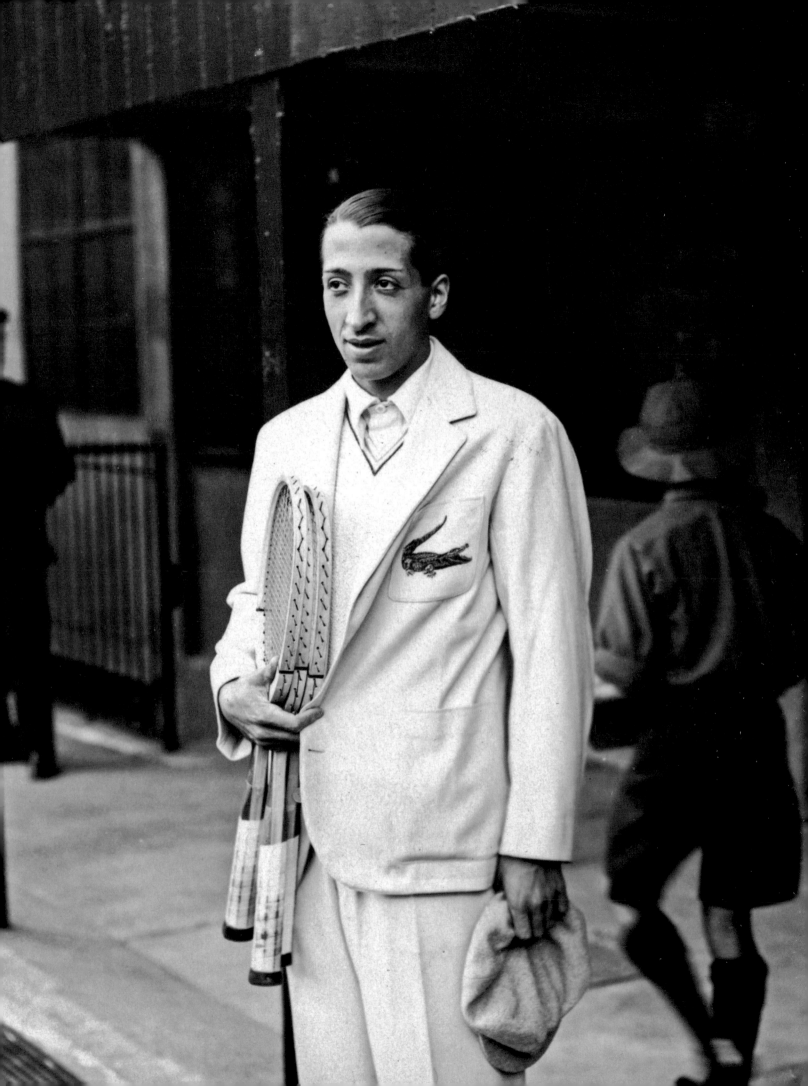

Previous pages, from left: *A rendezvous with René Lacoste (center), 1966; René Lacoste in his iconic embroidered crocodile motif, circa 1930s.* This page: *An alligator motif on a sweater from the Fall/Winter 2019–20 collection.* Opposite: *A model walking the runway from the collection's fashion show held at the Tennis Club de Paris.*

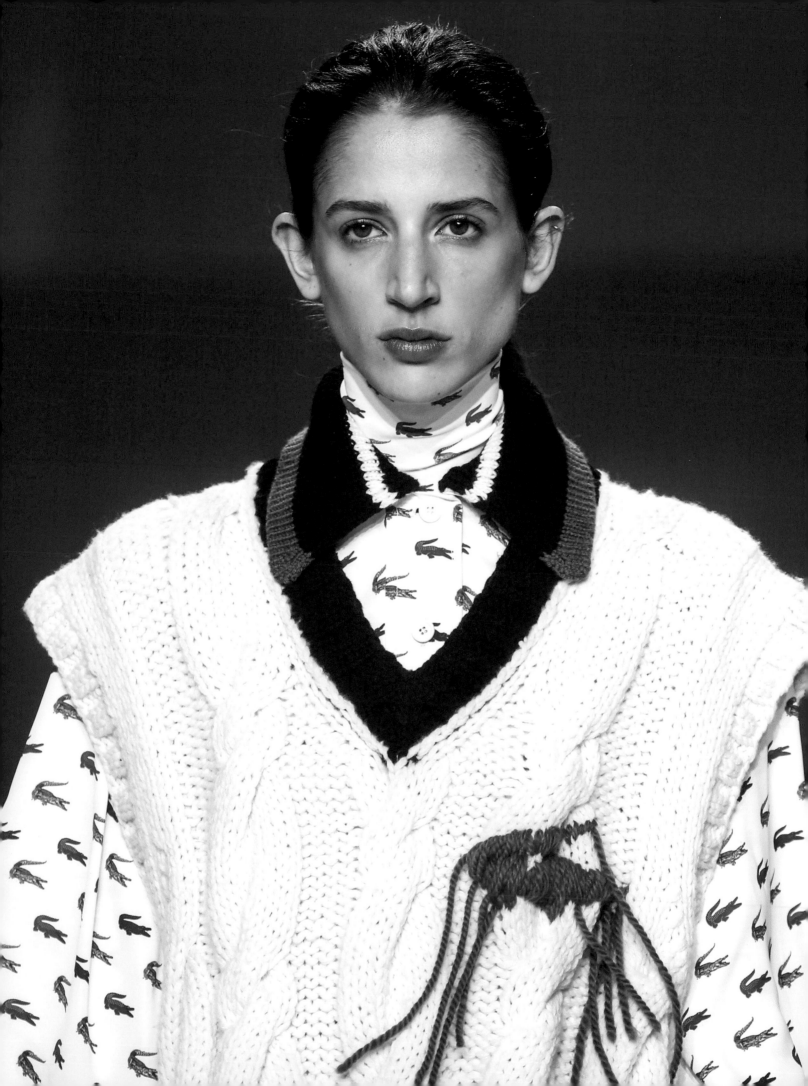

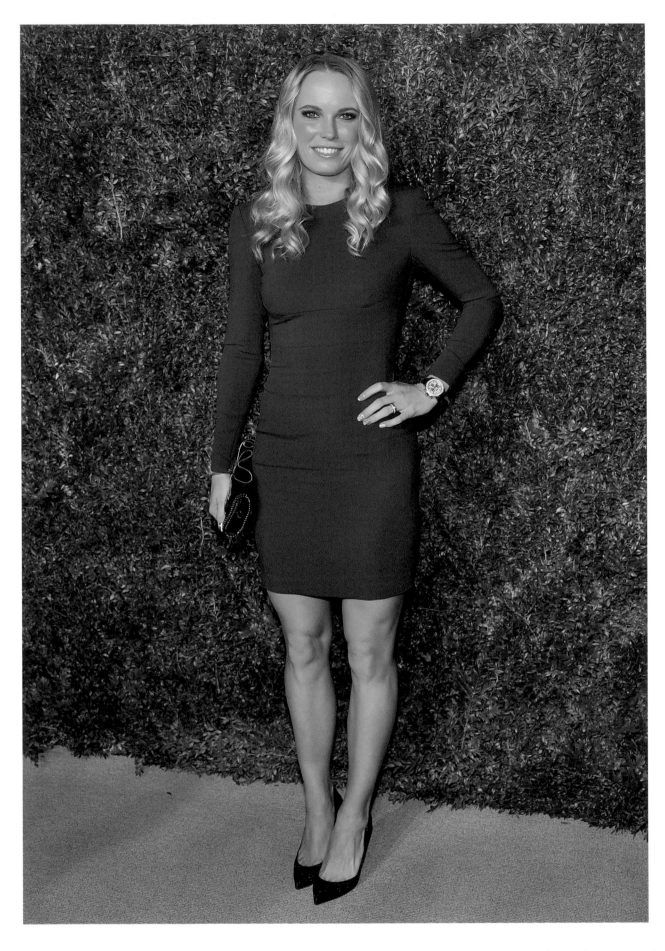

This page: *Caroline Wozniacki wears a form-fitting fuchsia dress to the 11th annual CFDA/Vogue Fashion Fund Awards in New York, 2014.*
Opposite: *Suzanne Lenglen relaxes between games at the 1926 Wimbledon Championships.*

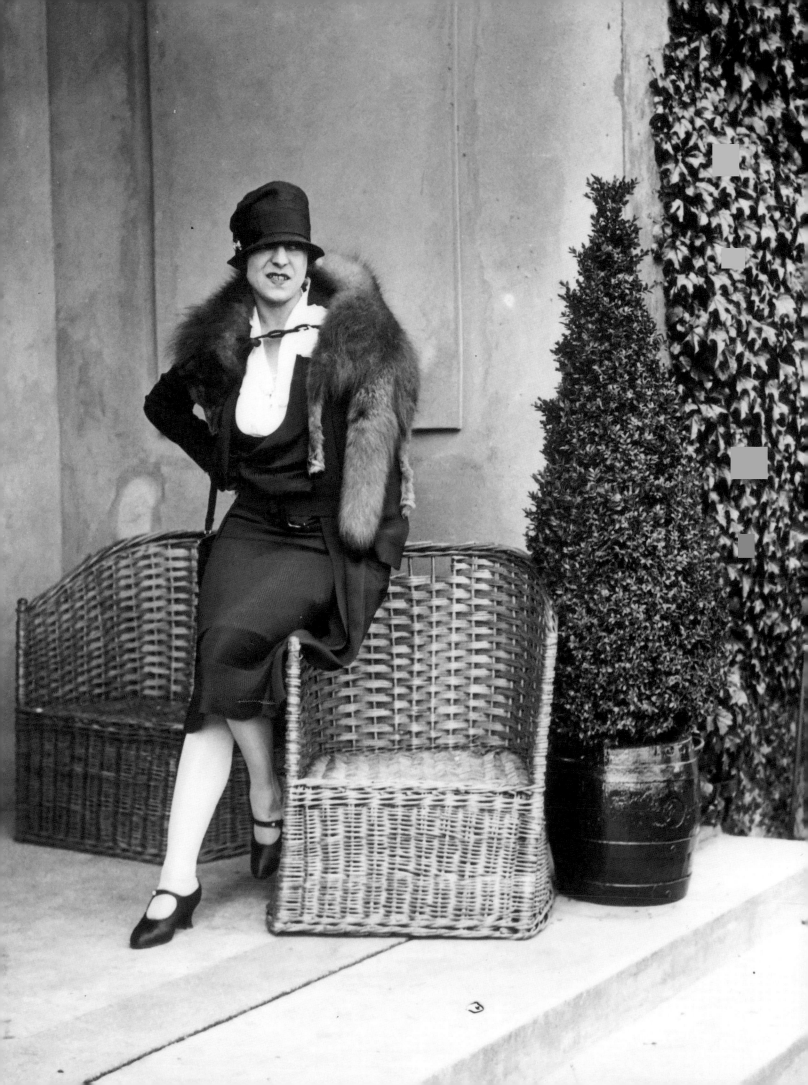

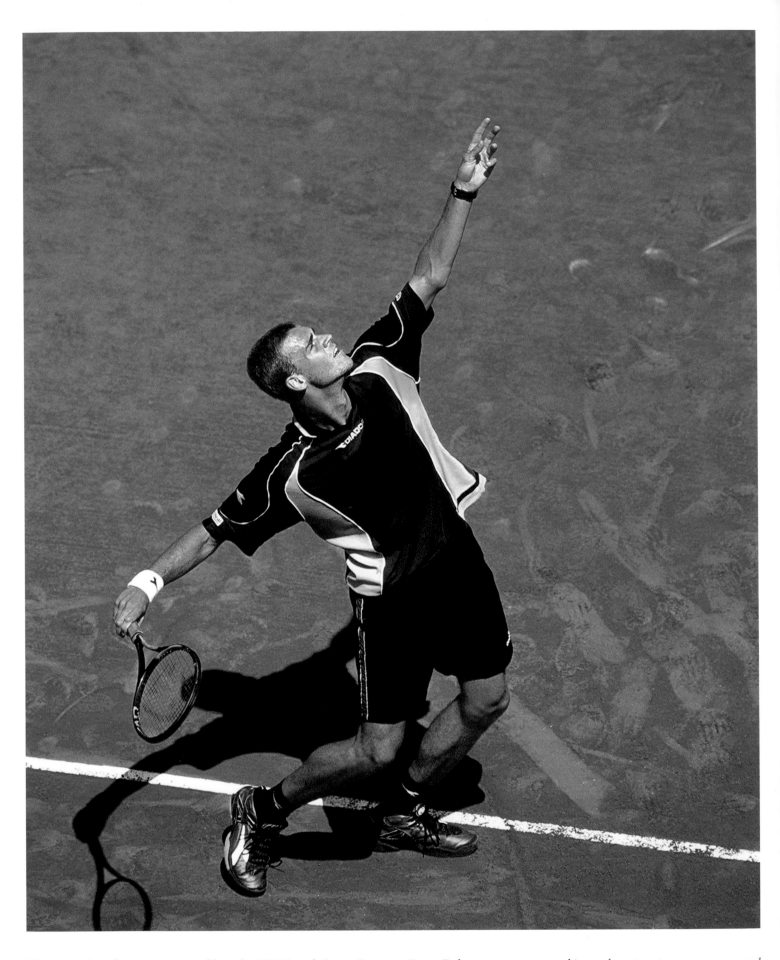

This page: *A modern, sporty ensemble at the 1999 French Open.* Opposite: *Roger Federer waves to a crowd in an elegant custom-monogrammed blazer at Wimbledon, 2007.*

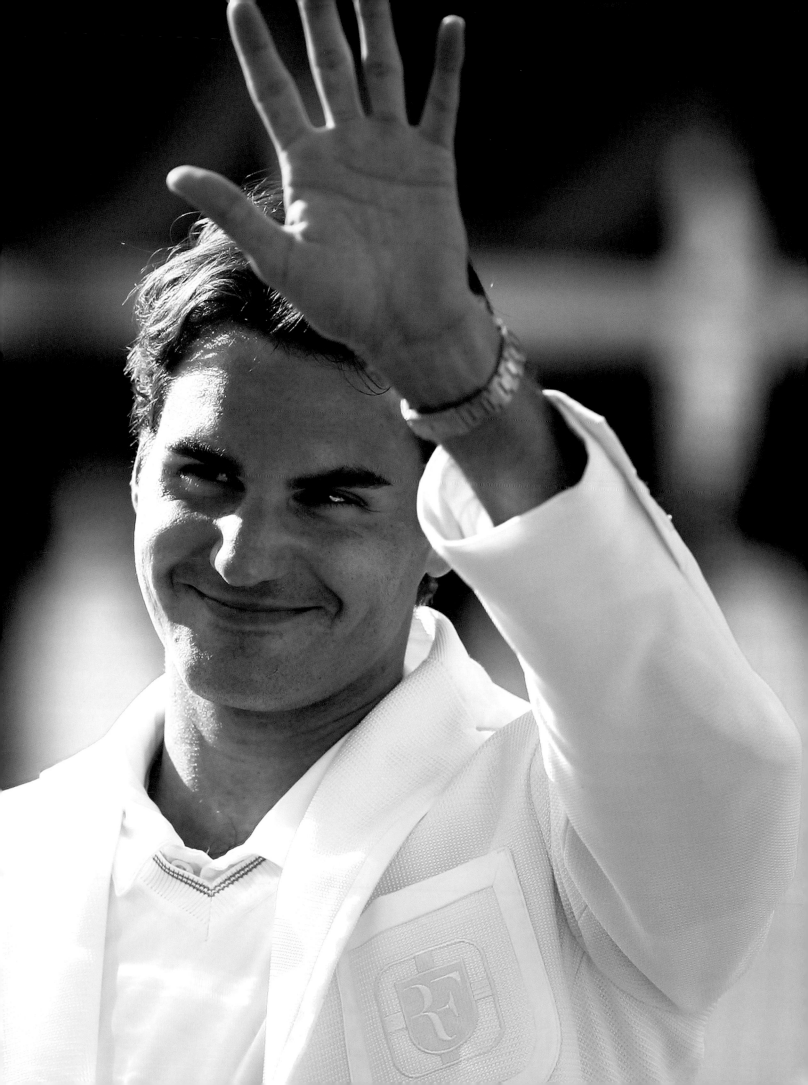

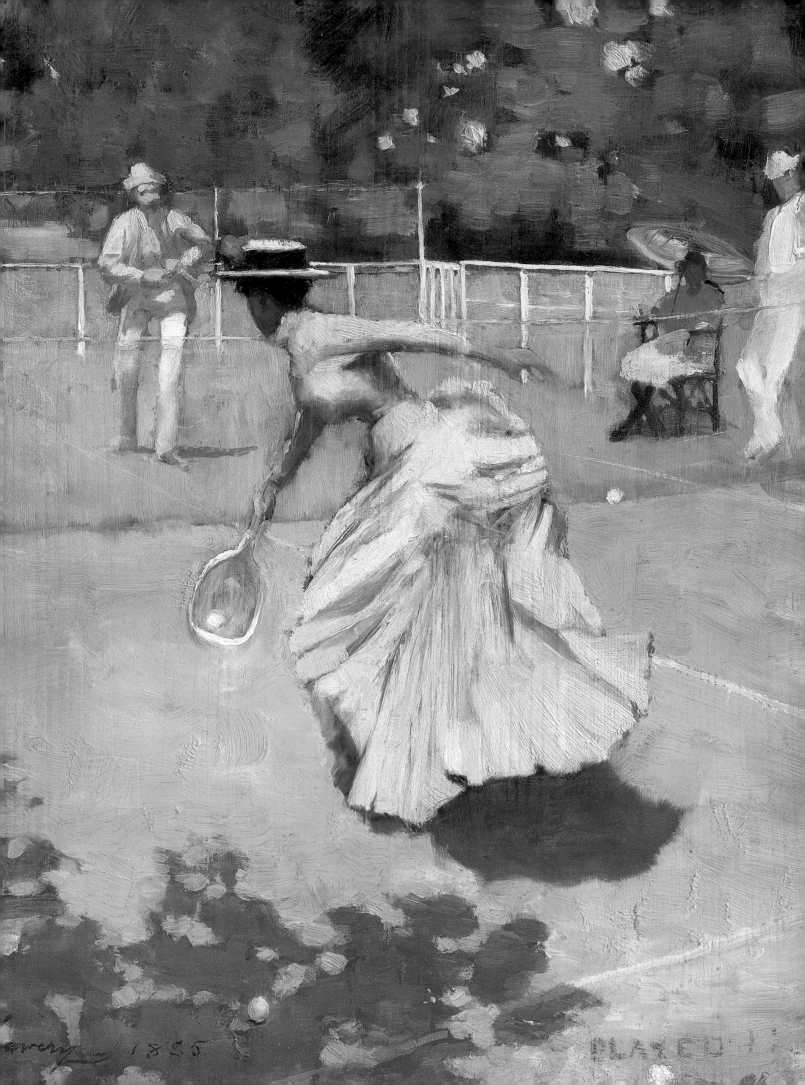

ART, DESIGN & CULTURE

WHEN SPORT INSPIRES ART

With its elegance, geometry, and dramatic tension, it's no surprise that tennis attracts artists and designers. From its earliest incarnations, tennis became a popular subject for art, both in the foreground as well as a complementary component to elevate various types of art, ranging from classical fine arts to film and architecture.

John Lavery, a nineteenth-century Irish painter, was one of the first artists to be enamored with tennis after seeing the game for himself in suburban Scotland. His 1885 painting *Played!!* is one of the best early depictions of the sport, capturing its dynamic movement and grace. *Played!!* focuses on a woman playing in traditional tennis fashions (including a fully brimmed hat and a long, billowing skirt) reaching forward for a short volley. In 2011, the work sold at auction for £657,250.

Lavery also created several other paintings featuring tennis and showcasing its place in high society, including *A Rally*, *Tennis*, *The Tennis Match*, and *The Tennis Party*. Many of his paintings not only depict the enjoyment gained from playing tennis, but also watching it from the sidelines. Even in the late 1800s, tennis was already gaining fans.

Opposite: *John Lavery's 1885 painting,* Played!!*, shows a leisurely game of tennis.*

The English painter Horace Henry Cauty was also one of the earliest artists to gravitate toward tennis. Using vibrant colors, his painting *Tennis Players* makes the game feel alive and accessible. With a messy array of racquets and balls in the foreground, tennis feels fun and not as stodgy as many in the era (and even still) perceived it to be.

Christopher Wood's 1921 painting *The Tennis Players* shows the sport (and art world) progressing. Depicting two women in revealing outfits relaxing before or after a game, Wood's work reflected the modernism of his better-known contemporaries Pablo Picasso and Henri Matisse and proved that tennis could survive and thrive in any milieu.

Art including tennis was not always used for art's sake, but also in marketing. From coastlines to mountains, tourism posters for glamorous resort destinations often included tennis in their design, immediately promising refined leisure with the simple enticement of a tennis racquet.

It's not only in still art that tennis has been featured. While filmmakers have not used it as the primary subject for films as much as other sports (boxing, baseball, football), tennis scenes or themes are often present in popular movies.

In Alfred Hitchcock's 1951 thriller, *Strangers on a Train*, a star amateur player becomes embroiled in a web of murder after a chance meeting. The film includes scenes at Forest Hills, which was then the site of the U.S. Open. In the 1977 classic *Annie Hall*, Alvy (played by Woody Allen) meets the title character played by Diane Keaton at a tennis court, and the two then play mixed doubles with two other characters. Tennis became a more central theme of a later Allen film, 2005's *Match Point*, in which themes of luck and chance on the court carry through to the main character's life.

Tennis has also been touched upon in more comedic settings. In *The Royal Tenenbaums*, (2001), the youngest brother of the family, Richie (Luke Wilson), is

a tortured tennis pro who has a meltdown during a blowout defeat. In the 2011 comedy *Bridesmaids*, Annie (Kristen Wiig) and Helen (Rose Byrne) express their mutual dislike via a doubles match by drilling the ball at one another repeatedly—and with great satisfaction.

While tennis courts are often adjacent to some of the world's finest mansions and resorts, the sport has also been seamlessly blended into iconic architecture. There is an active tennis court hidden inside New York City's bustling Grand Central Station, where the Vanderbilt Tennis Club has its unlikely location.

In modern architecture, Santiago Calatrava's sprawling, futuristic City of Arts and Sciences in Valencia, Spain, is home to an annual ATP tournament. Held in the L'Agora building, the court is covered by a series of white fins that almost resemble a ribcage; the back-and-forth rhythm of the tennis ball underneath serves as the building's heartbeat.

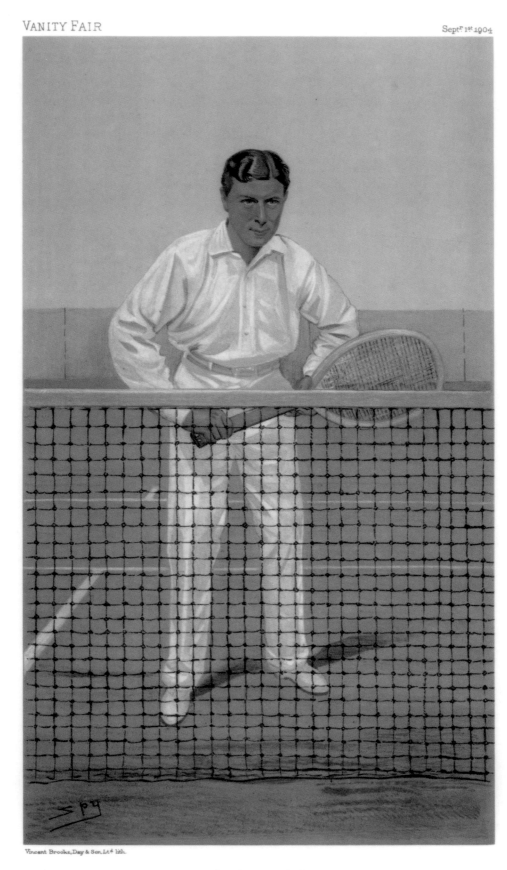

"Thrice Champion"

This page: *A 1904 illustration of "Thrice Champion" Lawrence Doherty from* Vanity Fair. Opposite: *A fashionably dressed couple depicted on a sports postcard from circa 1900.*

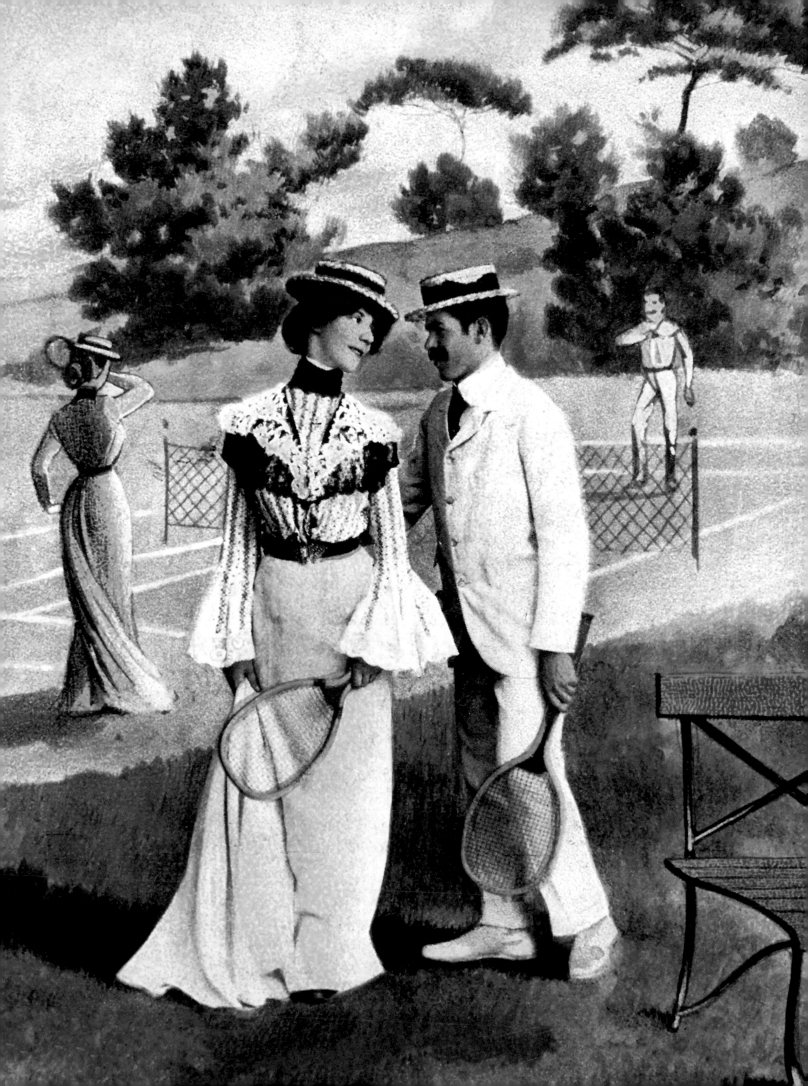

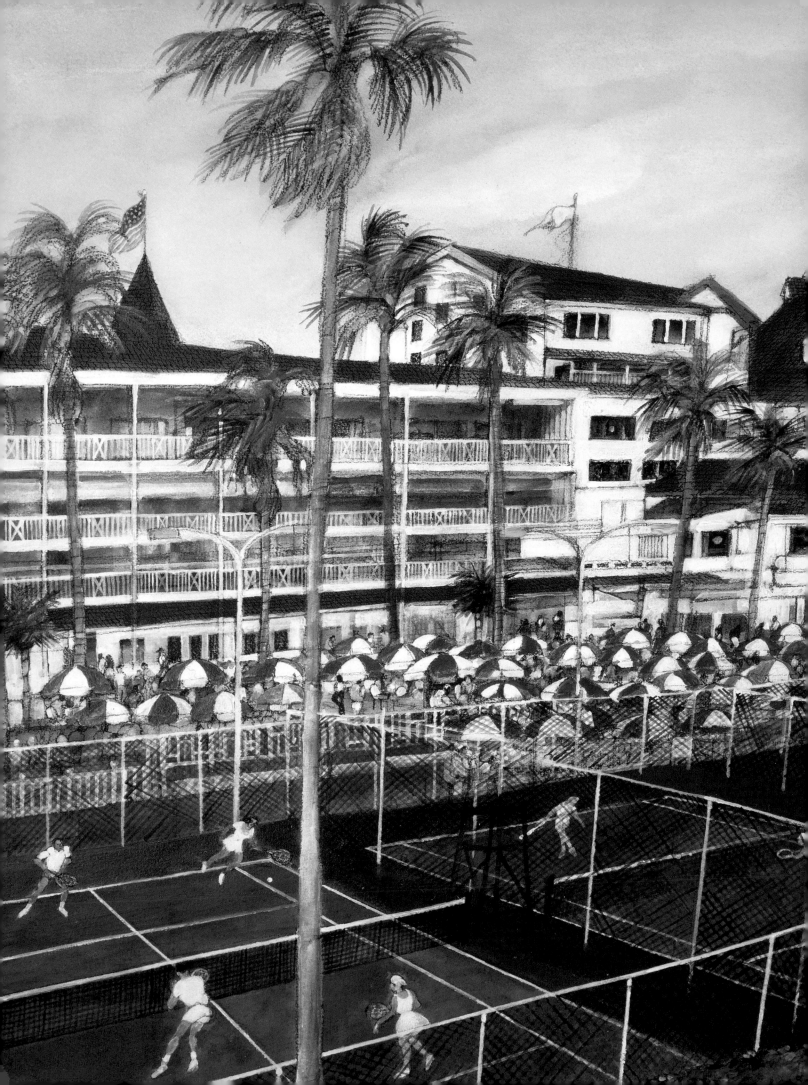

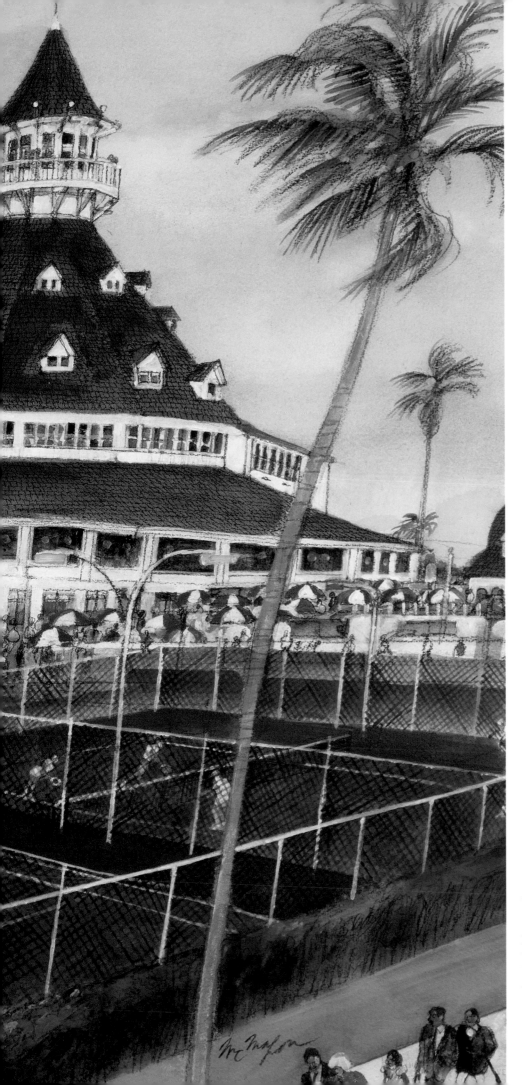

Opposite: *Painting of tennis courts at the Hotel Del Coronado in California by Franklin McMahon.* Following pages, from left: *A painting of female tennis champion Chris Evert by Ed Vebell; tennis star Don Budge was also depicted by Ed Vebell in this work.*

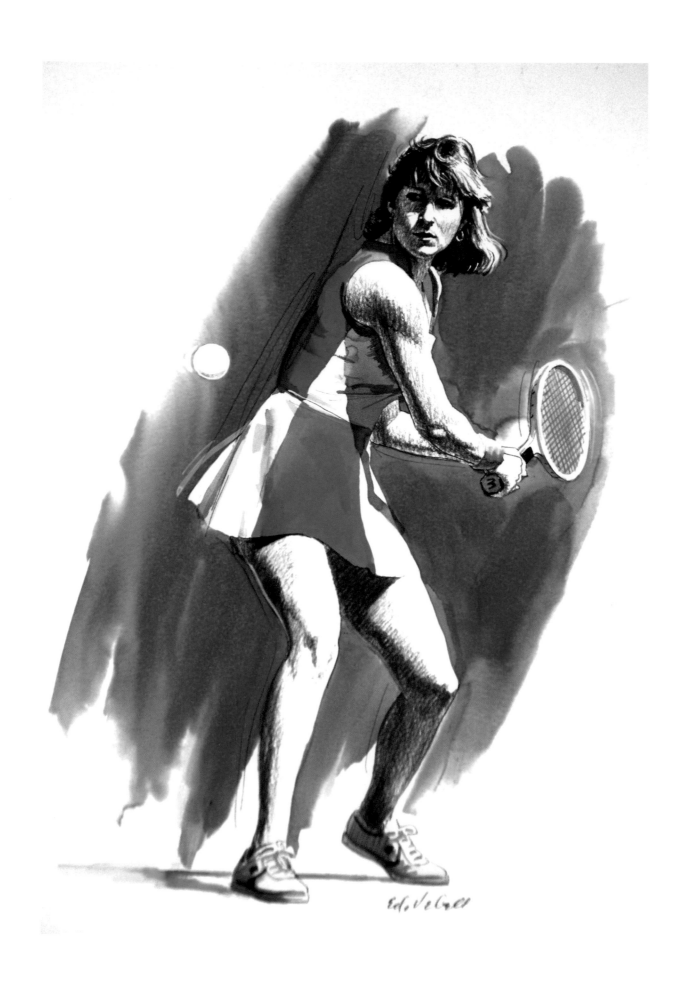

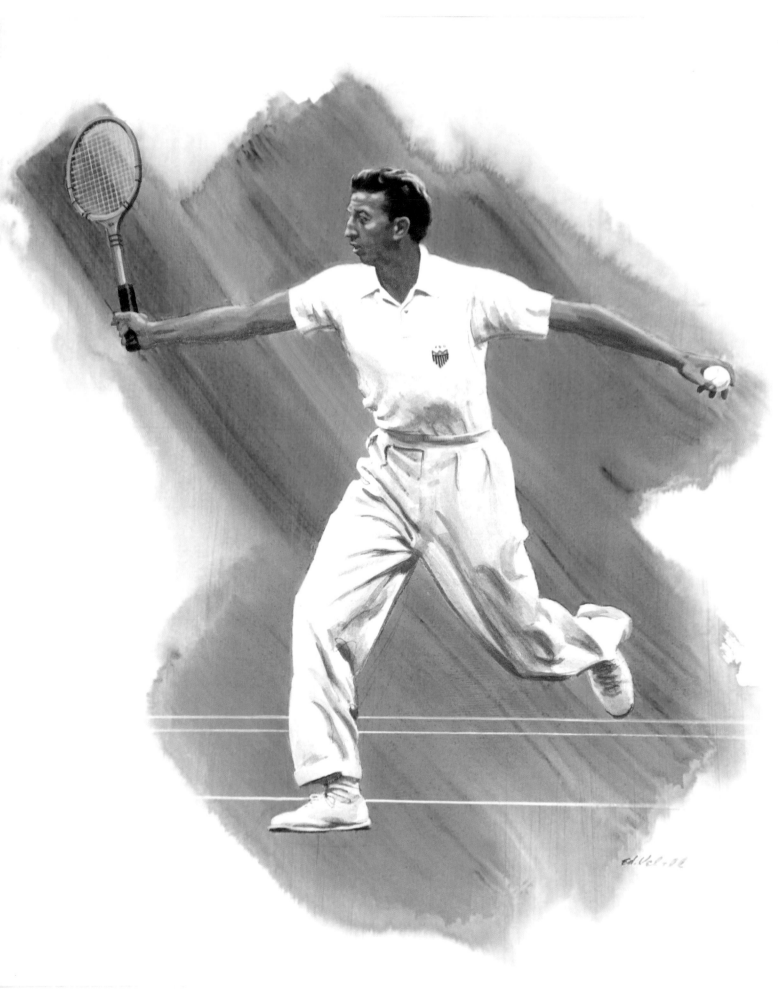

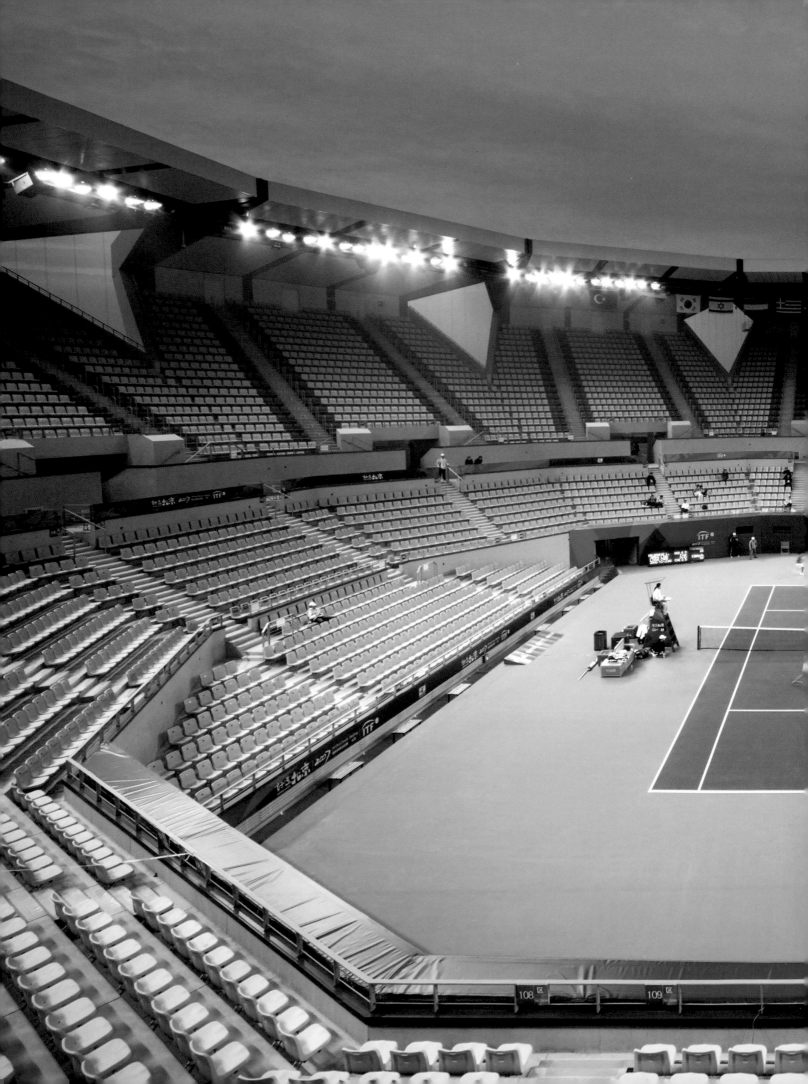

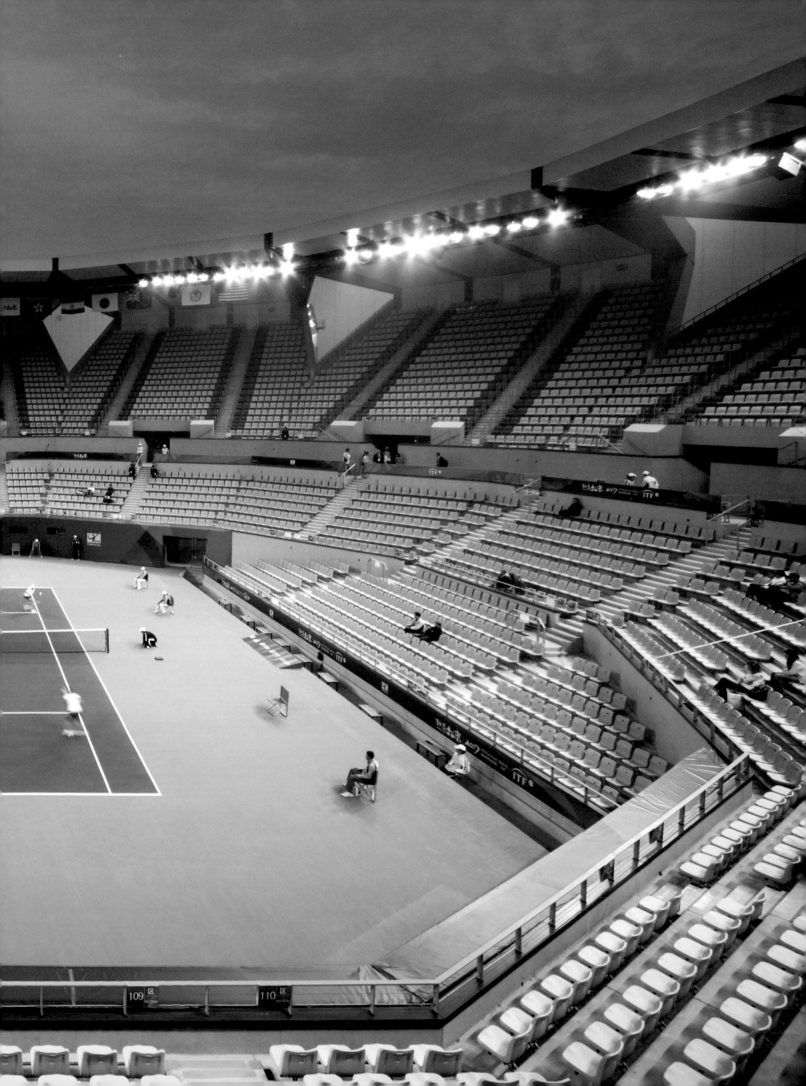

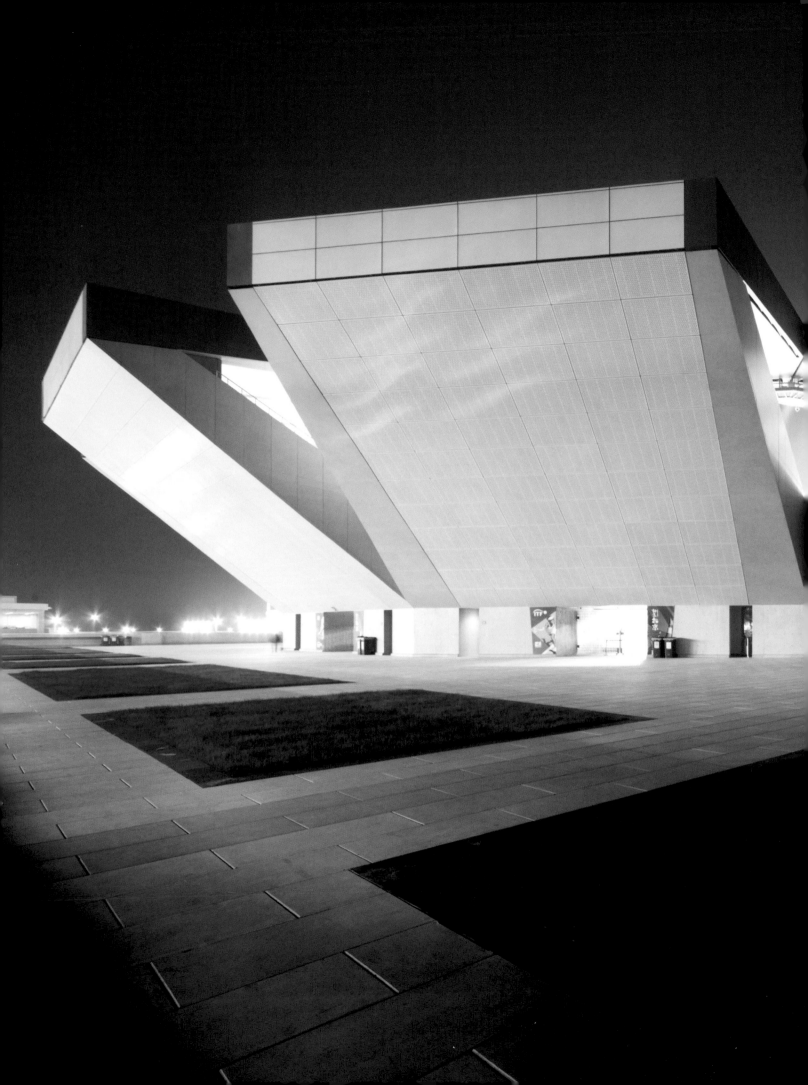

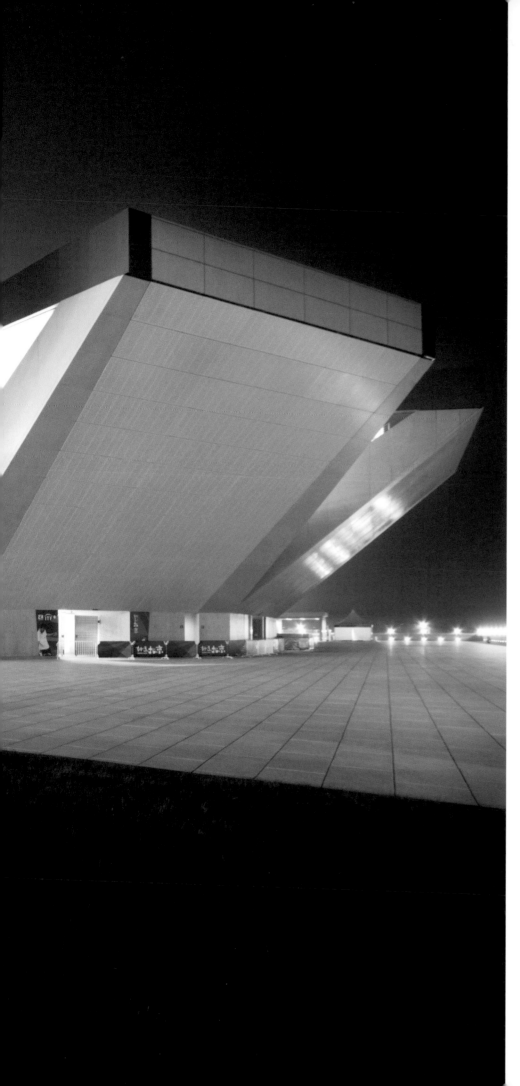

Previous pages: *Interior modern tennis stadium at the 2008 Beijing Olympics.*
Opposite: *The stunning architecture of the Beijing Olympics stadium exterior.*

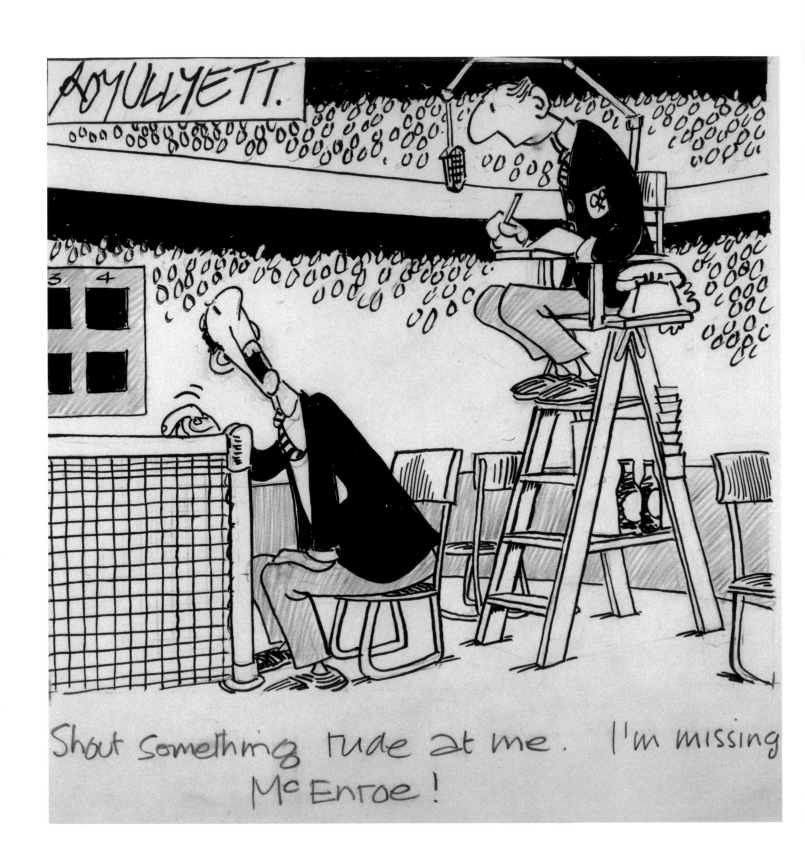

This page and opposite: *Tennis cartoons by Roy Ullyett for the* Daily Express *from 1968 and 1983.*

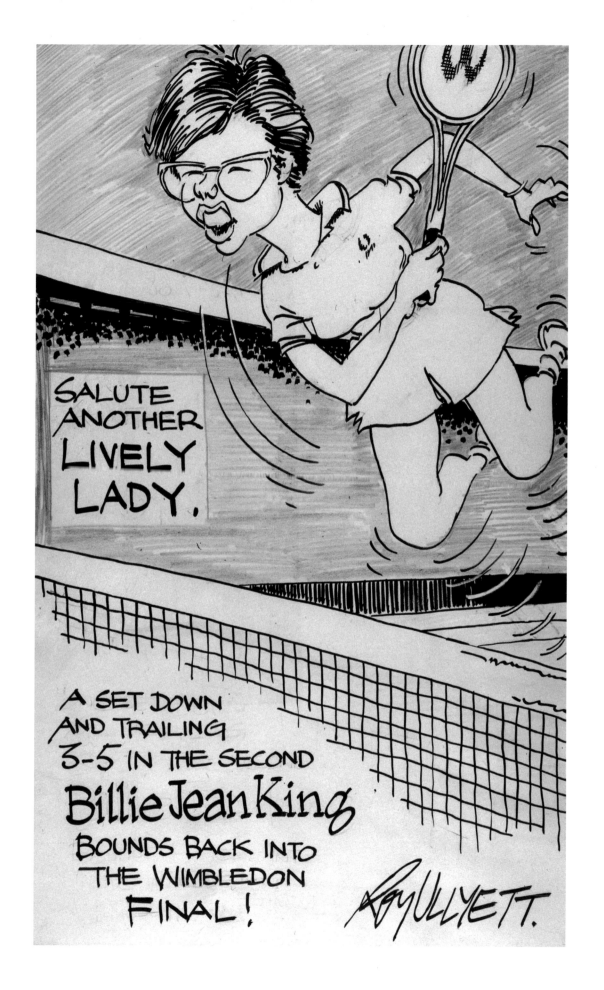

Following pages, from left: *"Play the Game" poster by Lucile Patterson Marsh, circa 1920s; "Be A Good Loser" poster from 1938.*

PLAY
the GAME

Judie Patterson Marsh

RODE & BRAND LITHOGRAPHERS, N.Y.

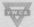

BUREAU OF SOCIAL EDUCATION
NATIONAL BOARD OF
THE YOUNG WOMEN CHRISTIAN ASSOCIATION
600 LEXINGTON AVE., N.Y.C.

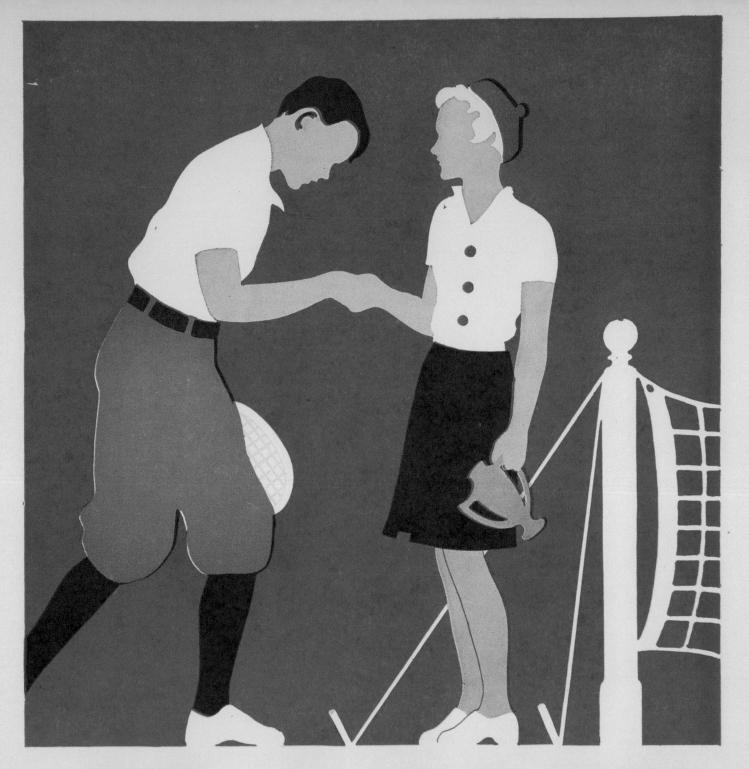

BE A GOOD LOSER

WALTER H. KLAR - SPRINGFIELD, MASS.

NUMBER 4

CHARACTER-CULTURE-CITIZENSHIP GUIDES
Copyright 1938
T. G. Nichols Co., Inc., Kansas City

SEPTEMBER

This page: *A sketch by Adolph von Menzel depicting players and spectators socializing after a tennis game, 1898.* Opposite: *Tennis star and artist Helen Wills Moody examines some of her drawings, circa 1930s.*

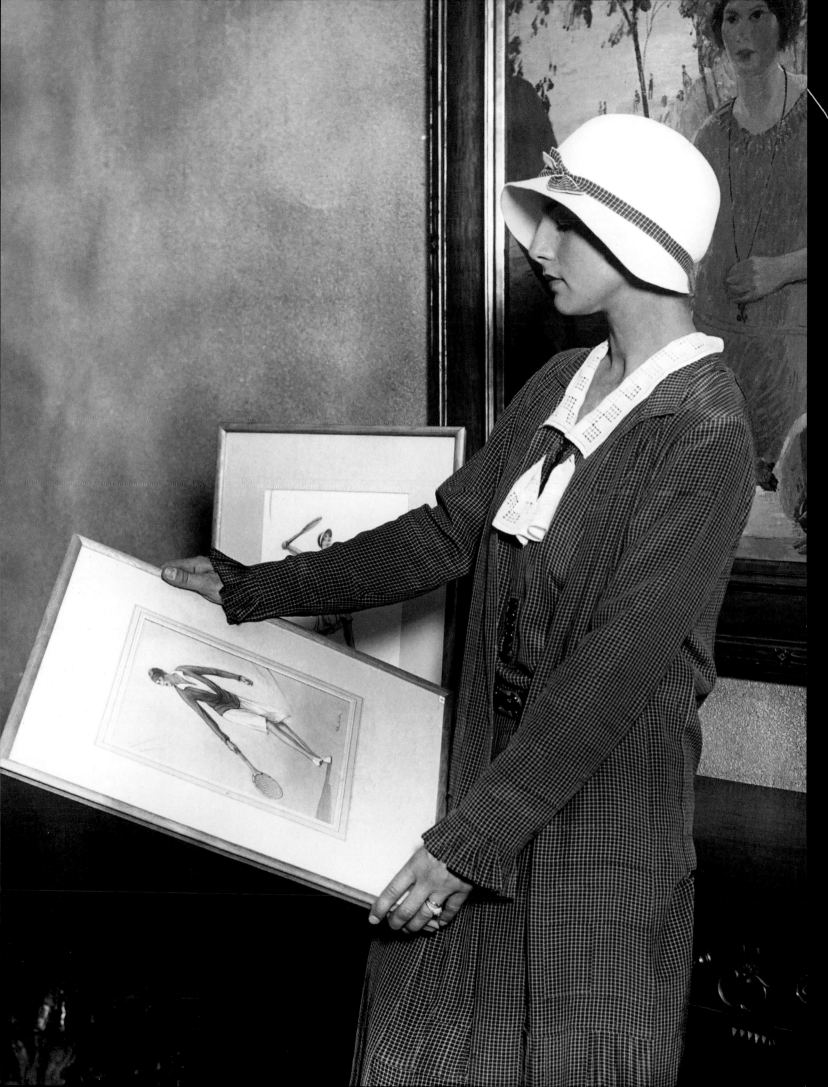

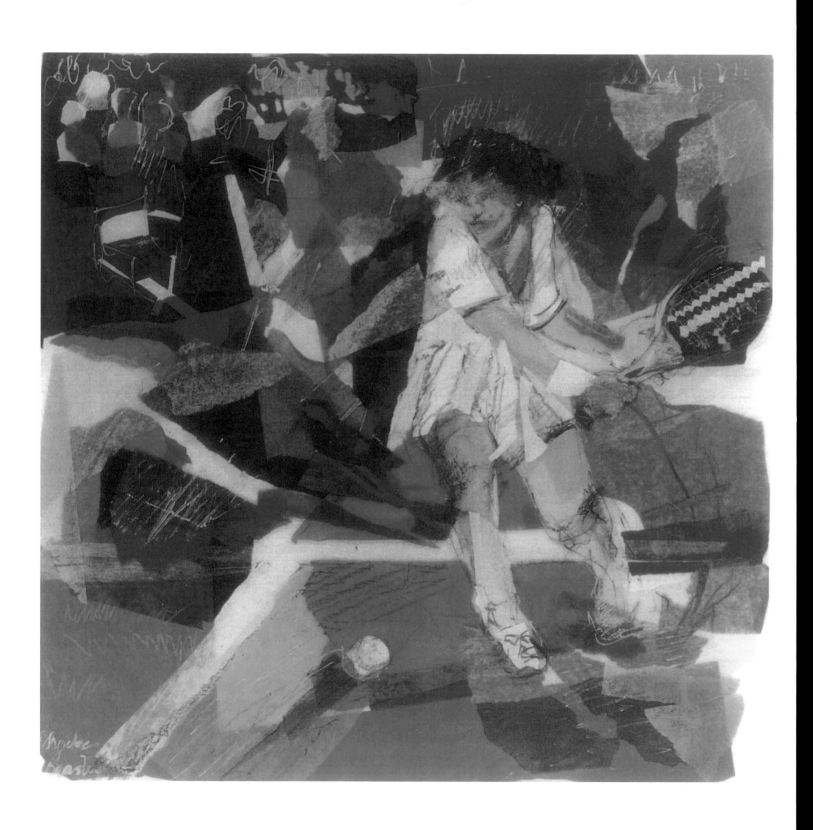

This page: *Bright colors pop in this collage painting entitled* Back Hand Return. *Opposite: An oil on canvas portrait of Max Décugis by François Flameng.*

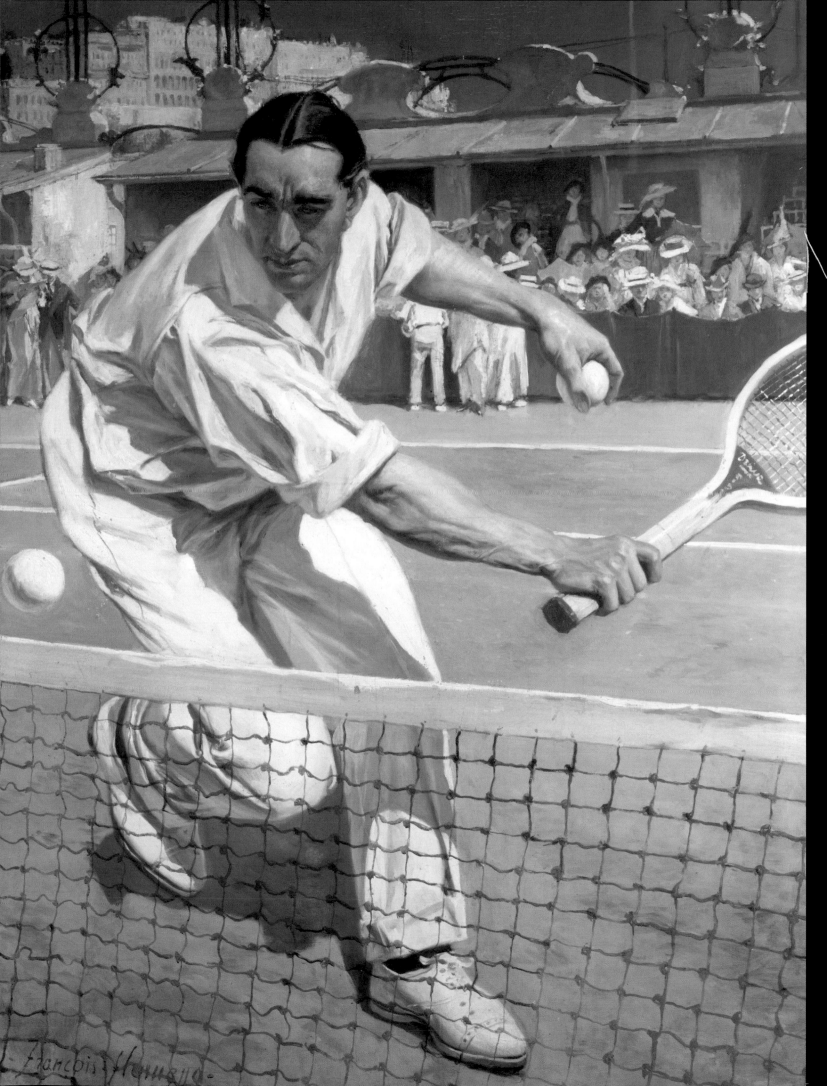

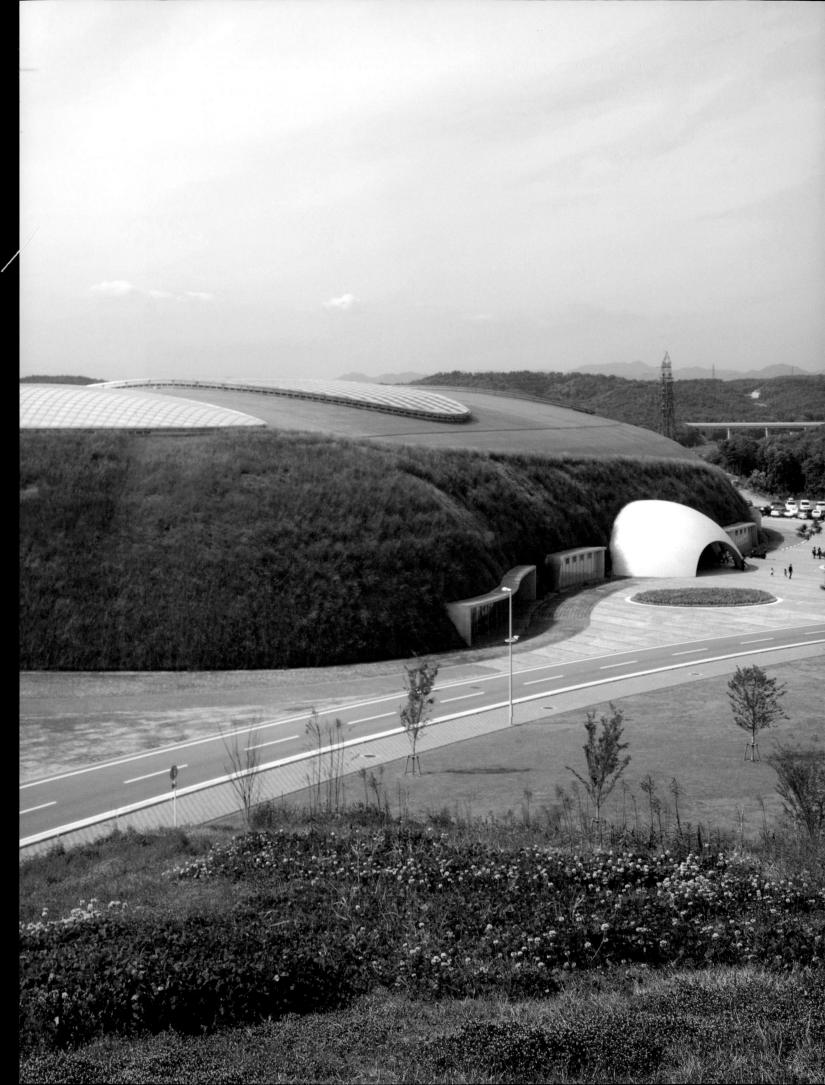

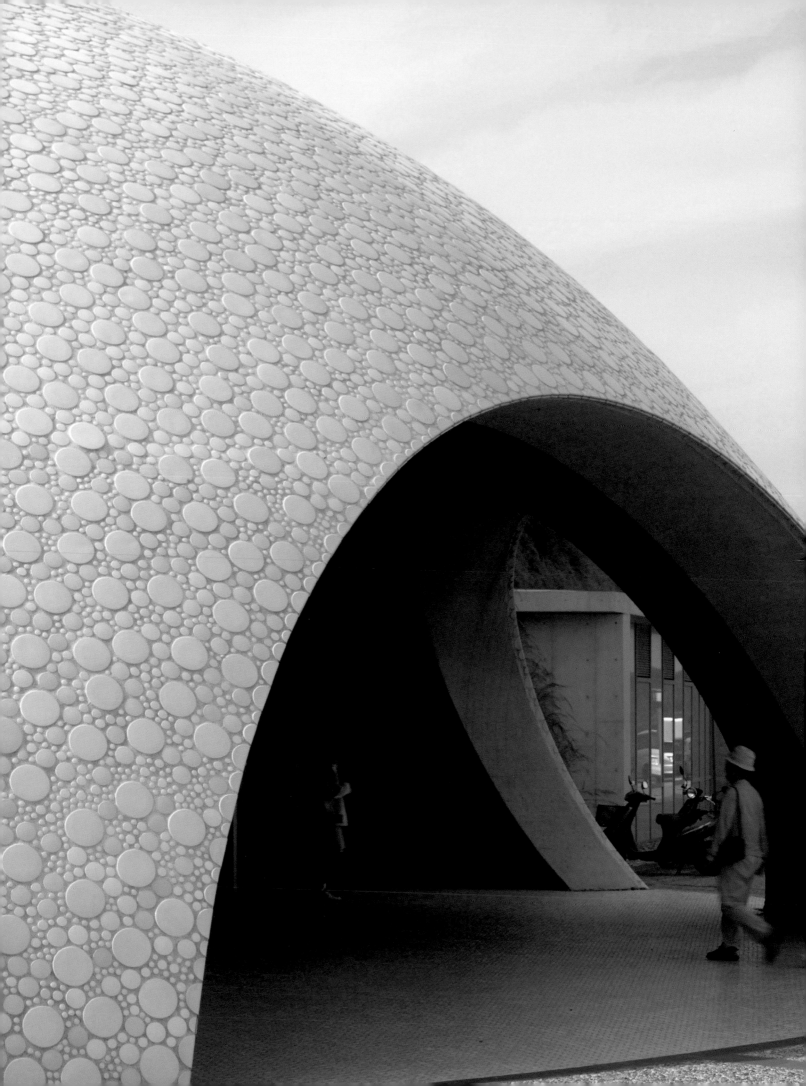

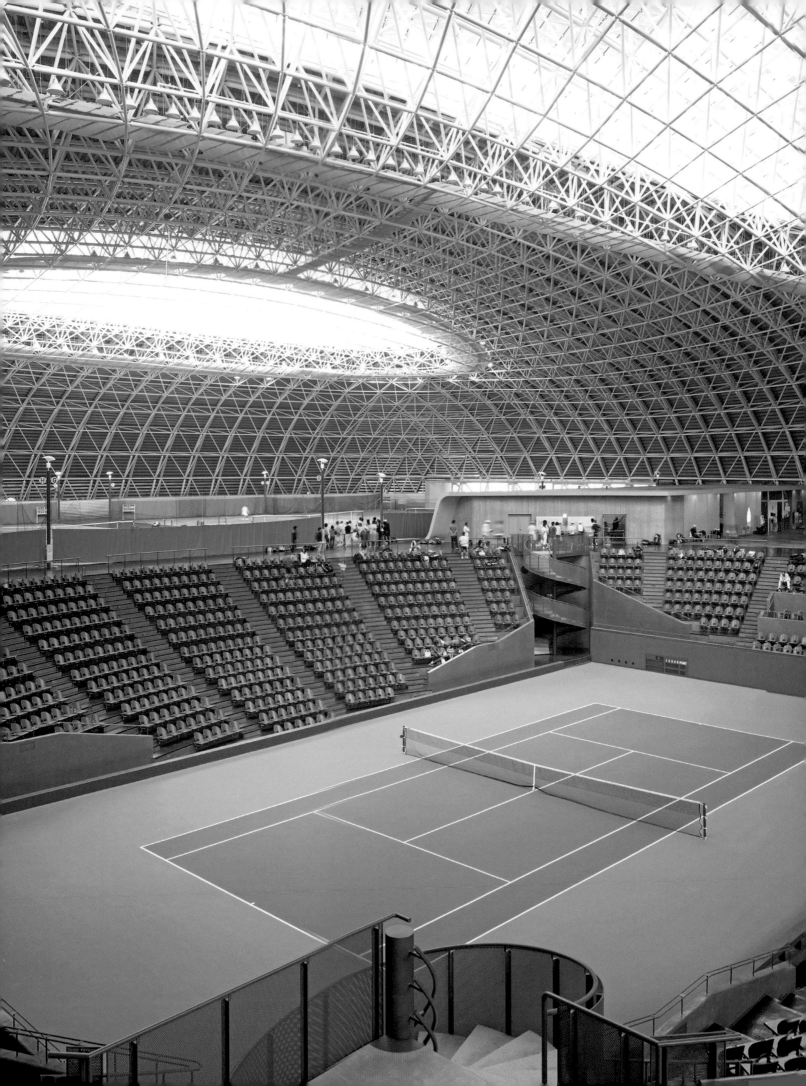

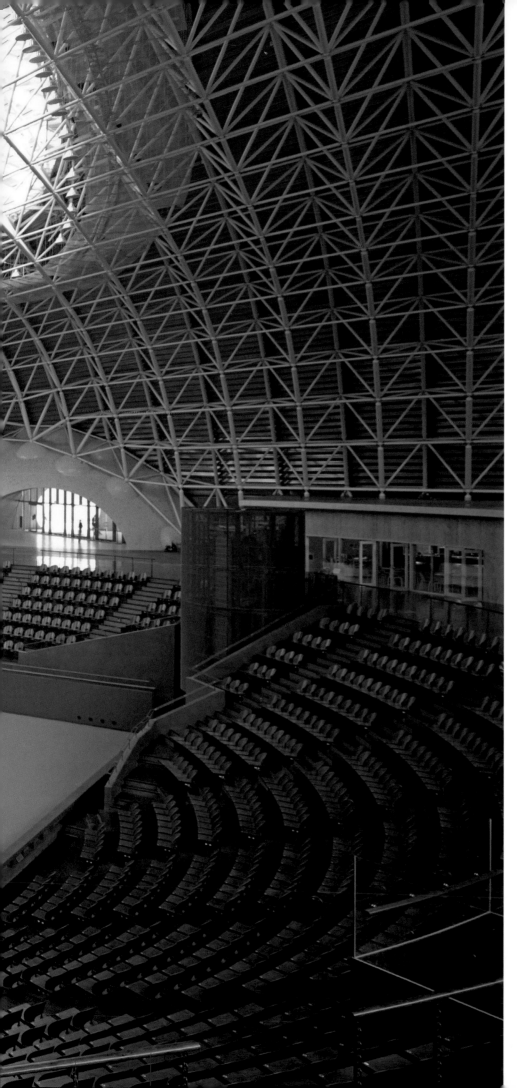

Previous pages, from left: *A tennis stadium in Miki City, Japan, designed by Endo Shuhei Architect Institute; the entrance recalls a giant tennis ball.* Opposite: *The hyper-modern and spacious interior.* Following pages, from left: *An Art Deco–style French travel poster, circa 1920s; a Monte Carlo poster by Roger Broders, 1930.*

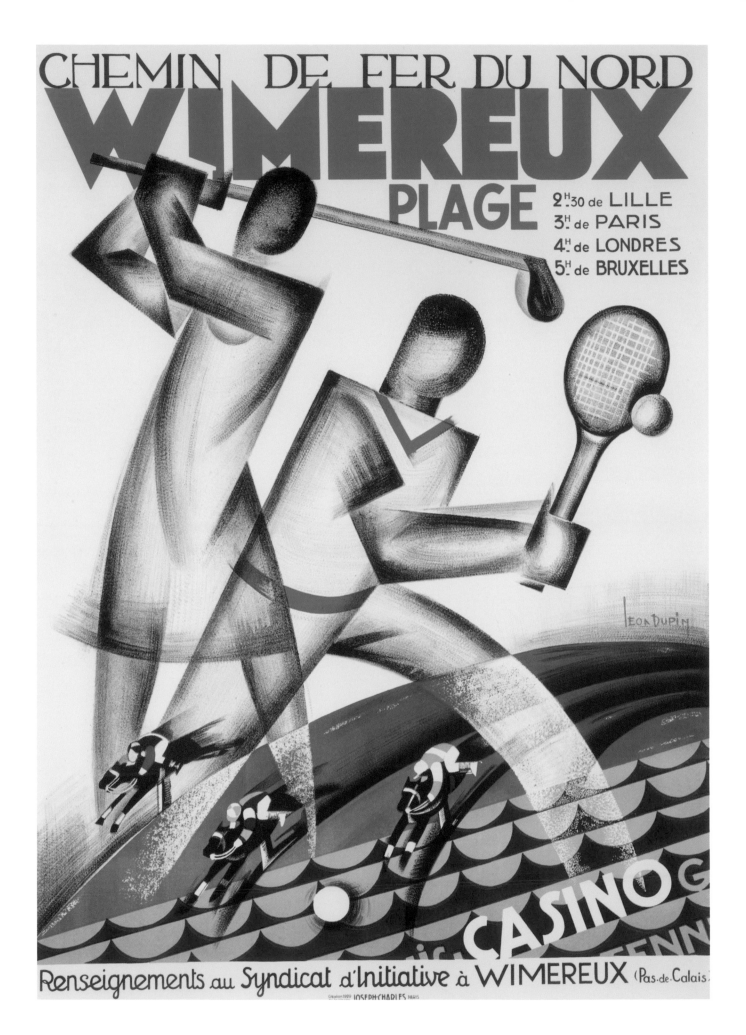

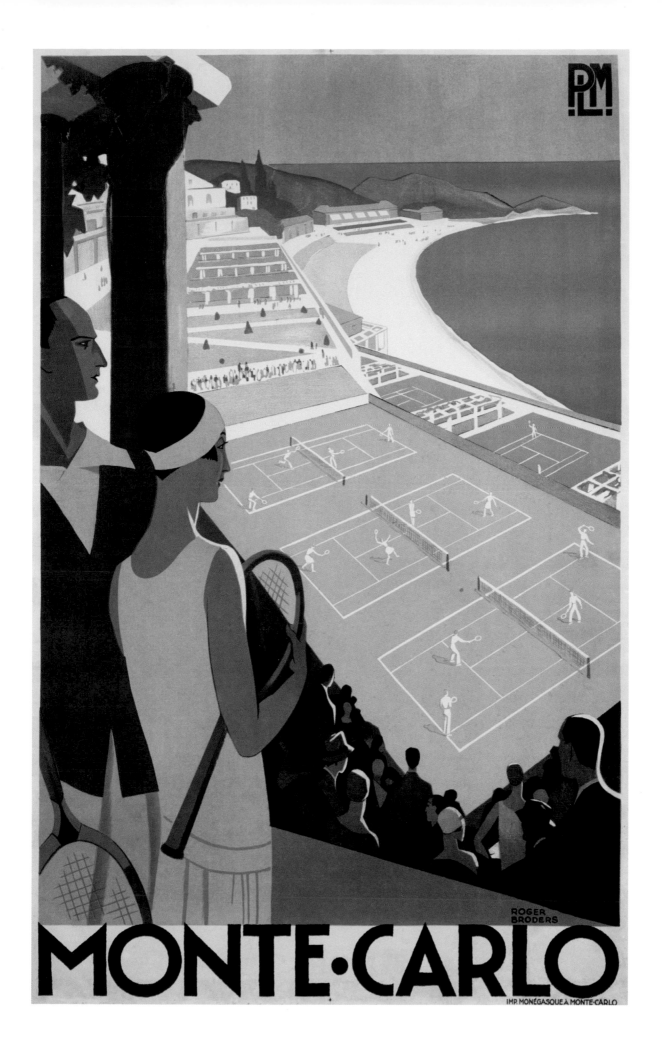

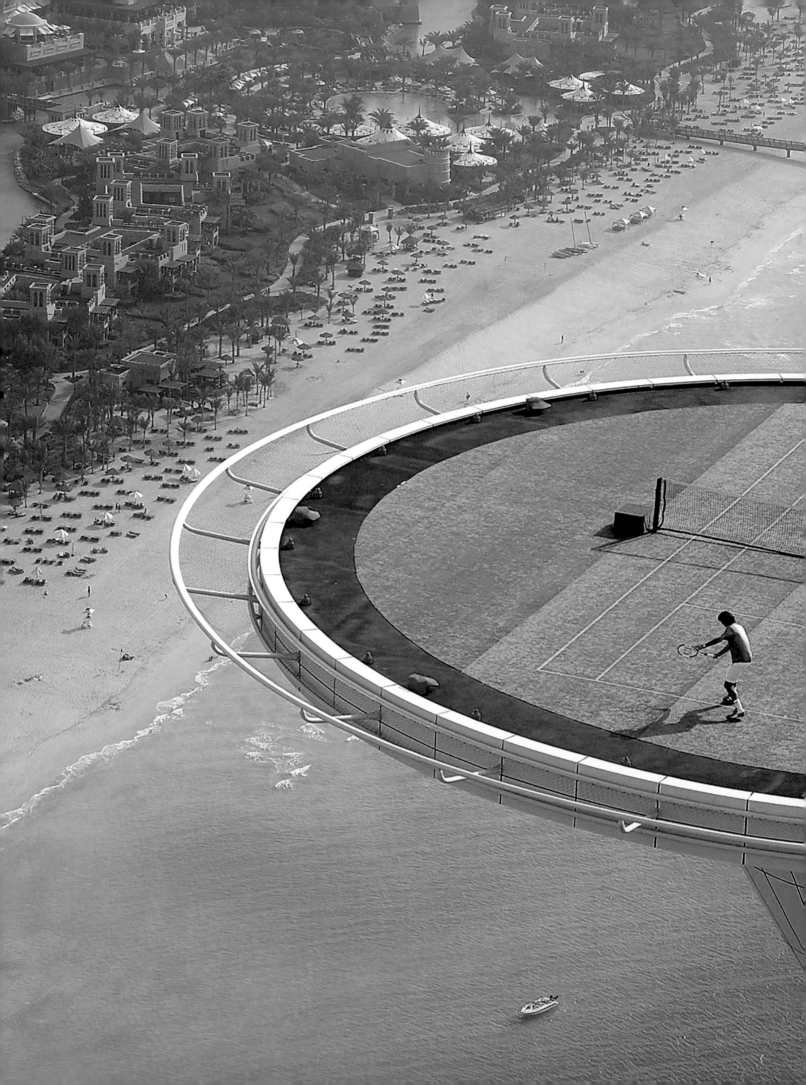

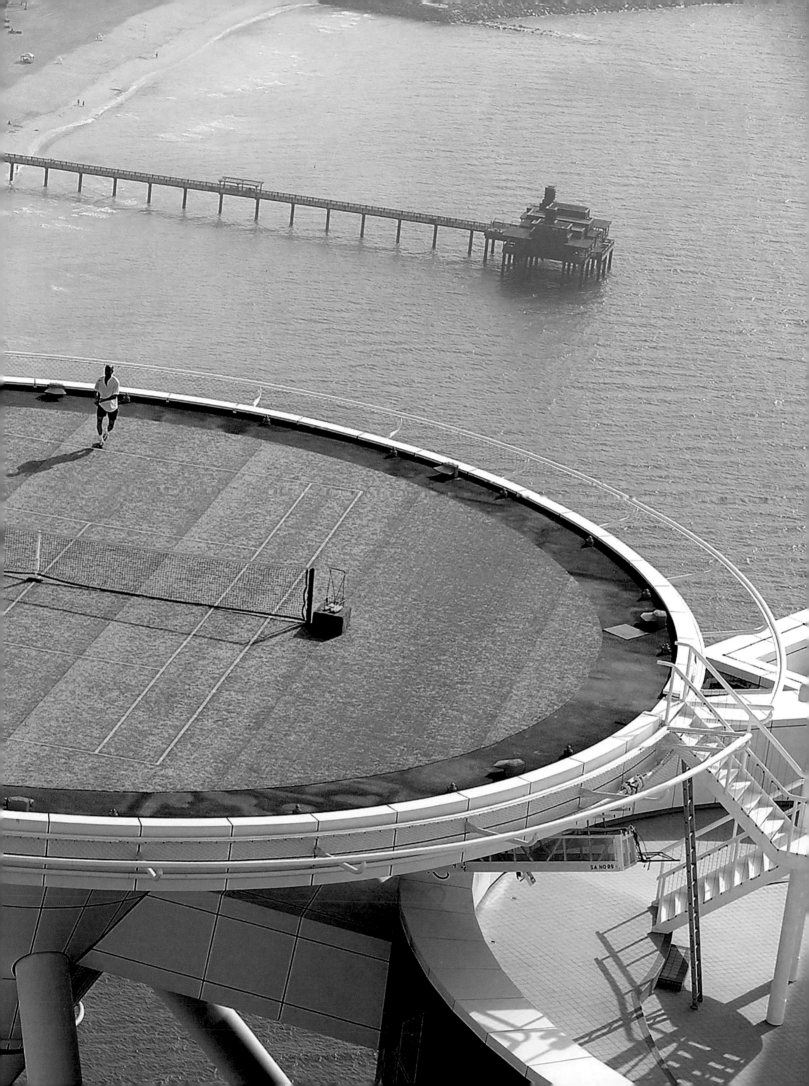

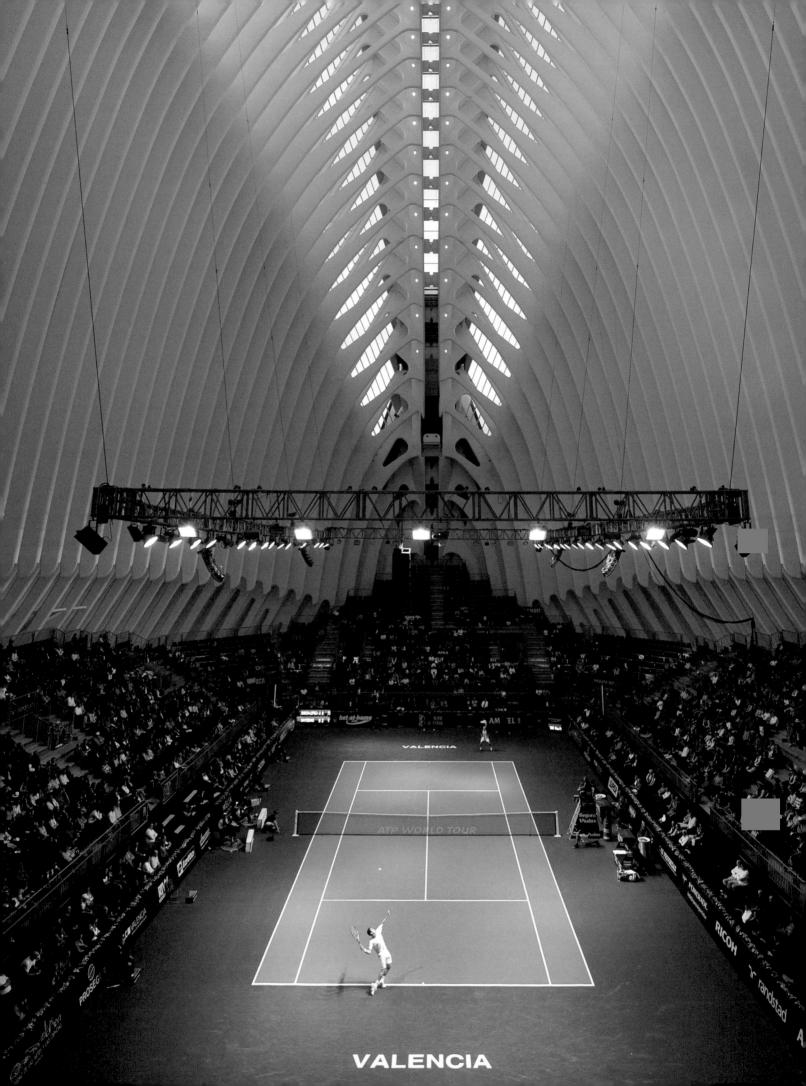

VALENCIA

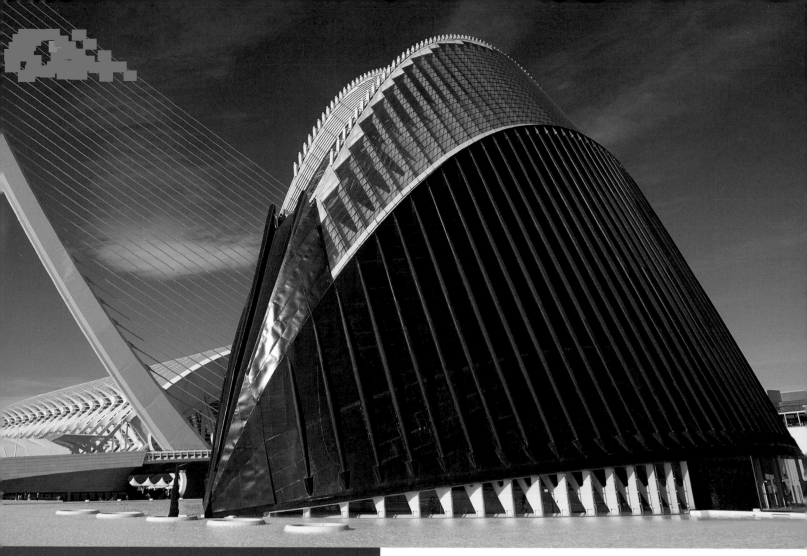

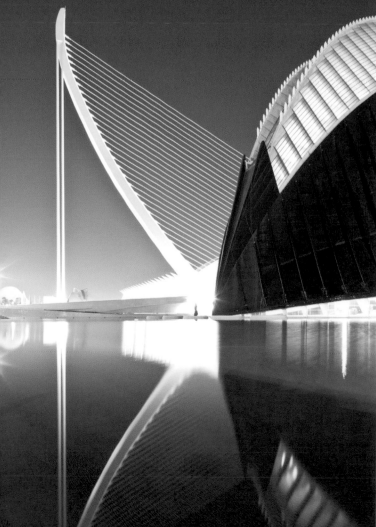

Previous pages: *The Helipad of the Burj Al Arab in Dubai is perhaps the world's most unique tennis court.* Opposite, clockwise from left: *Guillermo Garcia-Lopez serves a ball at the 2009 Valencia Open held in the L'Agora building; the building is part of the futuristic City of Arts and Sciences designed by Santiago Calatrava in Valencia, Spain.*

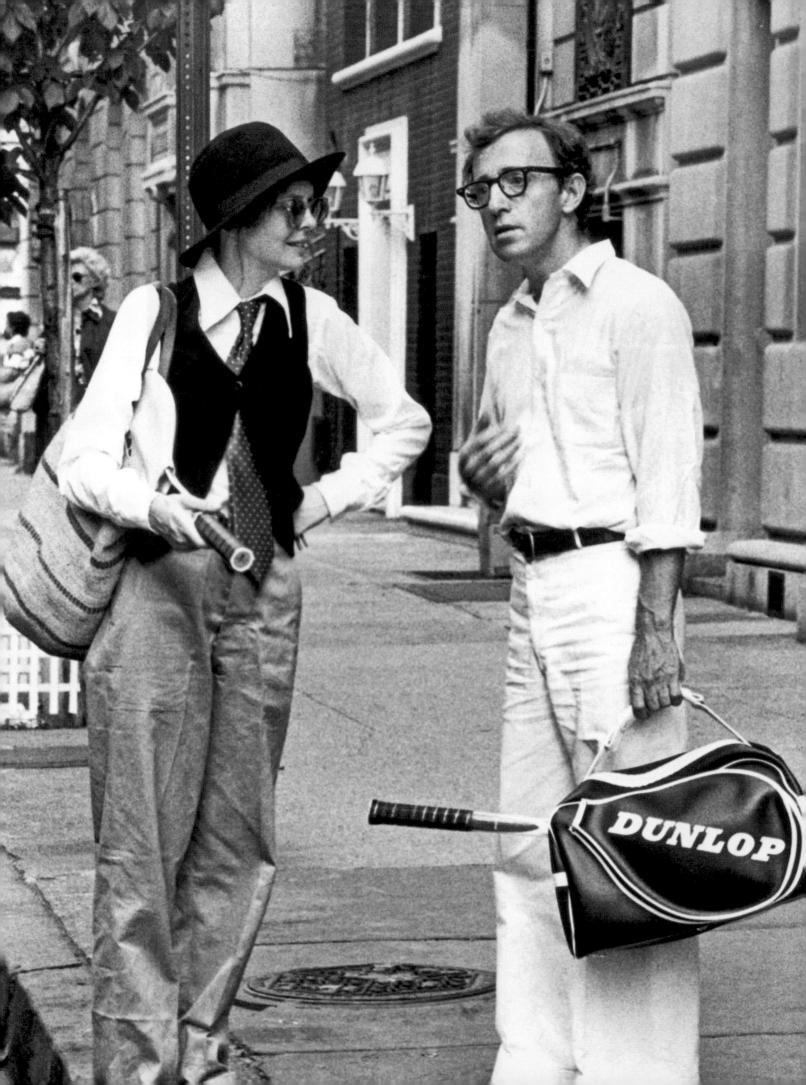

This page: *Actor Farley Granger in a film still from Alfred Hitchcock's 1951 movie,* Strangers on a Train. Opposite: *Woody Allen holds a tennis racket bag in a scene with Diane Keaton in* Annie Hall, *1977.*

SOLARIUM

Altitude 1400 m

LE ROYAL HOTEL

CURE d'AIR et de REPOS — PENSION depuis 30 F

AUBRAC-AVEYRON — GARE AUMONT-AUBRAC

MÊME MAISON: ASTORIA - PALACE — VICHY —

REPRODUCTION INTERDITE

OMNIUM FRANÇAIS DE PUBLICITÉ | ANC⁰ ÉTABL⁺ COURBET | 46, Rue Basfroi PARIS